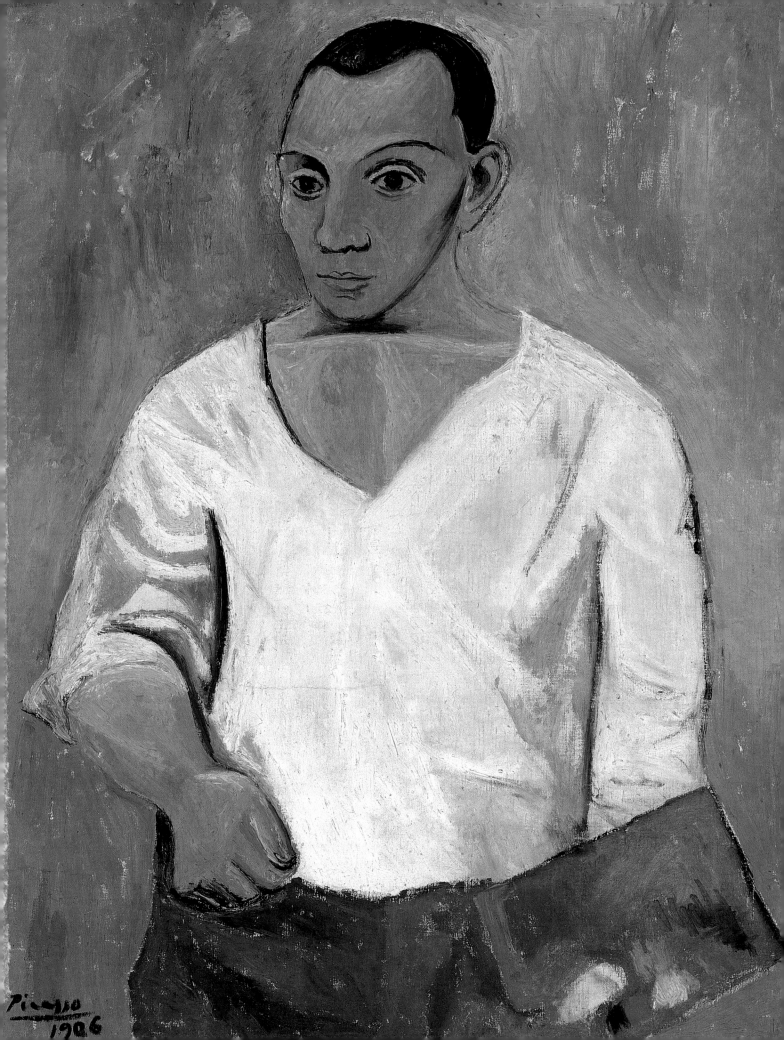

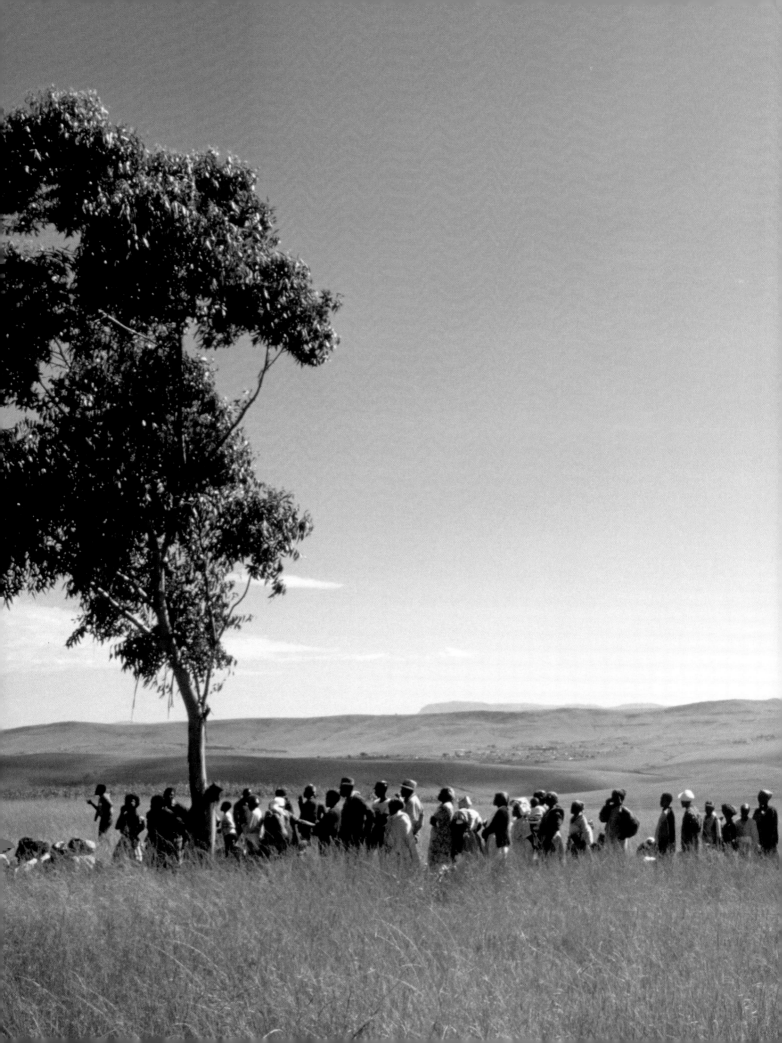

LIFE

100

PEOPLE WHO CHANGED THE WORLD

LIFE Books

MANAGING EDITOR Robert Sullivan
DIRECTOR OF PHOTOGRAPHY Barbara Baker Burrows
ART DIRECTOR Mimi Park
DEPUTY PICTURE EDITOR Christina Lieberman
WRITER-REPORTERS Hildegard Anderson (Chief), Marilyn Fu
COPY EDITORS Parlan McGaw (Chief), Danielle Dowling,
Barbara Gogan
CONSULTING PICTURE EDITORS
Mimi Murphy (Rome), Tala Skari (Paris)

PRESIDENT Andrew Blau
BUSINESS MANAGER Roger Adler
BUSINESS DEVELOPMENT MANAGER Jeff Burak

TIME INC. HOME ENTERTAINMENT
PUBLISHER Richard Fraiman
GENERAL MANAGER Steven Sandonato
EXECUTIVE DIRECTOR, MARKETING SERVICES Carol Pittard
DIRECTOR, RETAIL & SPECIAL SALES Tom Mifsud
DIRECTOR, NEW PRODUCT DEVELOPMENT Peter Harper
ASSISTANT DIRECTOR, BOOKAZINE MARKETING Laura Adam
ASSISTANT PUBLISHING DIRECTOR, BRAND MARKETING Joy Butts
ASSOCIATE COUNSEL Helen Wan
BOOK PRODUCTION MANAGER Suzanne Janso
DESIGN & PREPRESS MANAGER Anne-Michelle Gallero
BRAND MANAGER Roshni Patel
EDITORIAL OPERATIONS Richard K. Prue (Director),
Brian Fellows (Manager), Keith Aurelio, Charlotte Coco,
Tracey Eure, Kevin Hart, Mert Kerimoglu, Rosalie Khan,
Patricia Koh, Marco Lau, Brian Mai, Po Fung Ng,
Rudi Papiri, Robert Pizaro, Barry Pribula, Clara Renauro,
Hia Tan, Vaune Trachtman

SPECIAL THANKS TO Christine Austin, Jeremy Biloon,
Glenn Buonocore, Susan Chodakiewicz, Jim Childs,
Rose Cirrincione, Jacqueline Fitzgerald, Carrie Frazier,
Lauren Hall, Jennifer Jacobs, Brynn Joyce, Mona Li,
Robert Marasco, Amy Migliaccio, Brooke Reger,
Dave Rozzelle, Ilene Schreider, Adriana Tierno,
Alex Voznesenskiy, Sydney Webber, Jonathan White

ISBN 10: 1-60320-122-X
ISBN 13: 978-1-60320-122-3
Library of Congress Control Number: 2010921641

"LIFE" is a trademark of Time Inc.

We welcome your comments and suggestions
about LIFE Books.
Please write to us at: LIFE Books
Attention: Book Editors
PO Box 11016
Des Moines, IA 50336-1016

If you would like to order any of our hardcover
Collector's Edition books, please call us at 1-800-327-6388
(Monday through Friday, 7:00 a.m.–8:00 p.m.,
or Saturday, 7:00 a.m.–6:00 p.m., Central Time).

PAGE 1: A 1906 self-portrait by the painter Pablo Picasso.
(Please see page 102.)
© 2010 Estate of Pablo Picasso/Artist Rights Society/ARS/NY/
Courtesy Philadelphia Museum of Art
PAGES 2–3: South Africans line up to vote for Nelson Mandela
in their nation's first democratic elections in 1994.
(Please see page 45.)
Peter Turnley/Corbis
THESE PAGES: The Great Pyramid that King Khufu ordered
built as his tomb. (Please see page 26.)
Roger Ressmeyer/Corbis

CONTENTS

INTRODUCTION: THOSE WHO SHAPED HISTORY 6

RELIGIOUS FIGURES & PHILOSOPHER KINGS 8

LEADERS, ELECTED & NOT 24

SCIENTISTS, INVENTORS & INNOVATORS 52

CULTURAL ICONS 80

JUST ONE MORE 128

THOSE WHO SHAPED HISTORY

R ight off the bat, let us be eminently clear: We do not claim that the people you are about to meet—or be reintroduced to—are *the* 100 People Who Changed the World. Many thousands more than a mere one hundred have effected real and lasting change, and to claim that any hundred are the Top 100, as if this is the Hit Parade or the Billboard chart, would be, in our estimation, an exercise in either futility or absurdity (or both).

Let's see, who changed the world more, Genghis Khan or Alexander the Great? And are we talking about the world in his time or our world today? *Which nurse's contributions do we value more, Florence Nightingale's advances in care-giving or Clara Barton's creation of the American Red Cross?* Hmm. *Who has had a greater cultural impact overall, Ludwig van Beethoven (ba-ba-ba-dummm!) or P.T. Barnum?*

Think before you answer.

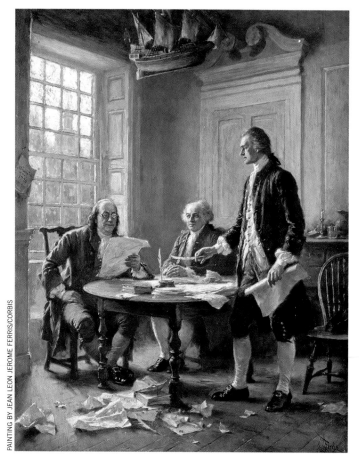

PAINTING BY JEAN LEON JEROME FERRIS/CORBIS

S o while we at LIFE Books do enjoy lists and rankings, as many of you might know, this volume, while it has a list, does not represent a ranking. What it is, we hope, is a fascinating look at a group of crucial individuals, and also a vivid and lavishly illustrated history of how we got from there, which is the very distant and often unknowable past (Did Homer actually exist?), to here: the here and now.

We have placed each of our subjects in one of four realms—philosophy (including religion), politics (including the politics of war or dominion), invention and culture—and then we have traveled through those realms, person by person, in chronological fashion. So what we have here are four separate but carefully integrated marches through history, with each new category building upon the last: Mankind's religious and philosophical development informs its political progress, which encourages (or stifles) entrepreneurial and artistic creativity. We hope the reader can see this big picture and also come to understand human progress in each of the four spheres independently. Galileo Galilei stands on Nicolaus Copernicus's shoulders, and Isaac Newton stands on Galileo's in turn—and this spins on and on to Albert Einstein. Michelangelo establishes standards never to be surpassed, but Pablo Picasso breaks old rules and sets new ones. The Crusades launched by Pope Urban II against the Muslims could (and do) have echoes, so many centuries later, in the jihad launched by Osama bin Laden against those he considers to be Western infidels.

We couldn't include everyone, and three who helped change the world but didn't make the cut were Ben Franklin, John Adams and Thomas Jefferson, here working on that earth-shattering document, the Declaration of Independence.

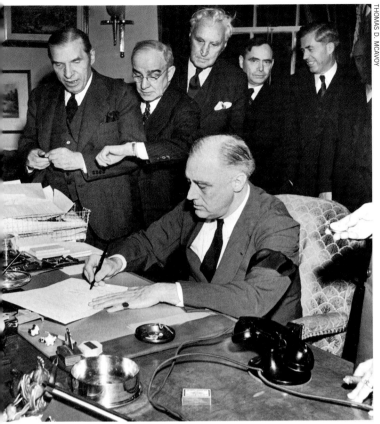

To tell the story of World War II, we selected Winston Churchill and Adolf Hitler,
but it certainly it can be argued that President Roosevelt and Admiral Yamamoto were also integral to how the world was reshaped in the 1940s.

So how did we choose our 100?

This is another way of asking: "Hey, where's Thomas Jefferson? Where's FDR?"

Well, we reread our histories, and tried to find the through-line of what led to what, while always keeping an eye cocked for the historical figure (P.T. Barnum!) who had a real impact on the world that we experience day to day, but who might look a little odd in company with such as Queen Elizabeth I, Tolstoy, Einstein and Churchill. There have been other books not entirely unlike ours, and we considered their opinions on the matter. *Time* magazine, our sister publication, selected, just a few years ago, its 100 Most Influential People of the 20th Century, and we found some of *Time's* arguments compelling. Michael H. Hart has written a thoughtful, entertaining and provocative book called *The 100* that aspires to a goal perhaps loftier than our own: to rank, in order, the 100 most influential individuals of all time. Now, this might seem like we're splitting hairs, but we would say that the people who "changed the world" in their own day are not necessarily, these years later, the most currently influential, and so they defy ranking. Hart might disagree, and at the end of each of his essays he takes pains to explain why he placed a subject so high or so low. But anyway: We took Hart's opinions under advisement along with those of other historians, and then we deliberated.

The product of these deliberations is now in your hands. Jefferson isn't here, though he missed the cut quite narrowly (Benjamin Franklin's hand and mind are also omnipresent in the Declaration of Independence, and the general ideas contained therein were already on the table). FDR isn't here, because the story we wanted to tell when we arrived at World War II concerned the Allies, as finally formulated, defeating the Axis. Early on, there was Hitler instigating hostilities (and greatly changing Europe) and, after France fell, Great Britain resisting. Winston Churchill saw the triumphant future if only he could put together an alliance (which would, of course, include the Soviet Union as well as the United States); and it is our conclusion, and that of many historians whom we trust, that, because of him, the U.S. was already all but in the war and would have been fully in soon enough even without December 7, 1941. We came close to including in this book the Japanese Admiral Isoroko Yamamoto, the mastermind behind the strike on Pearl Harbor. That assault certainly was a game changer, and Yamamoto might have been a tasty surprise for our readers. But we decided at last that it was Hitler, already on the move, and Churchill, lobbying Washington while encouraging his own people to fight another day, who represented the fulcrum.

That's a quick look at our decision-making process. Much of it was, we freely admit, pure pleasure. When you delve deeper into an Alan Turing or a Norman Borlaug or a Lady Mary Pierrepont Wortley Montagu, you wind up nothing but delighted. Here were people who changed the world and about whom much of the world doesn't know anything. Wow, we thought: We're in a position to tell them. That's fun.

And so is our new book, we dearly hope.

We're sure that it looks nice: We've chosen the pictures with customary care, soliciting from the world's best shooters past and present, as well as our own deep archives, always conscious of LIFE's legacy. The book is visually splendid. Whether or not it's persuasive . . . well, that is up to you. Let the debate begin!

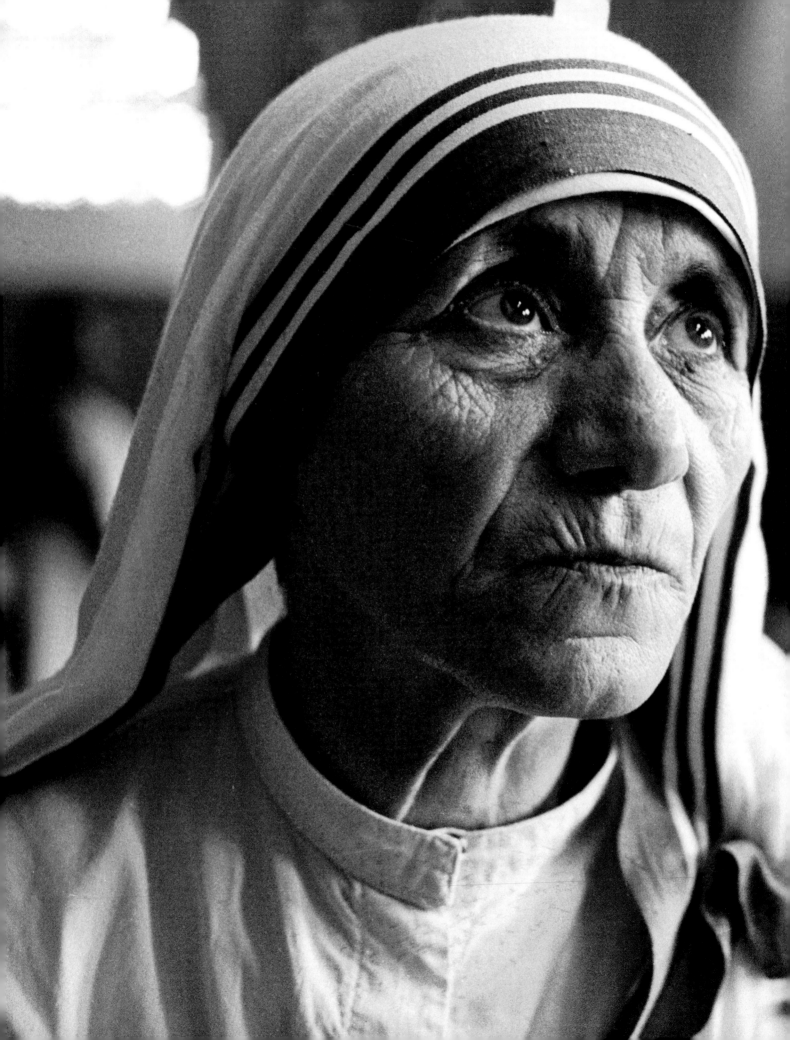

RELIGIOUS & PHILOSPHER
FIGURES KINGS

In 1969 Mother Teresa visits a hospice for
the destitute and dying in Calcutta, India.
(Please see page 20.)

9

ABRAHAM

CIRCA 2100–1500 B.C.

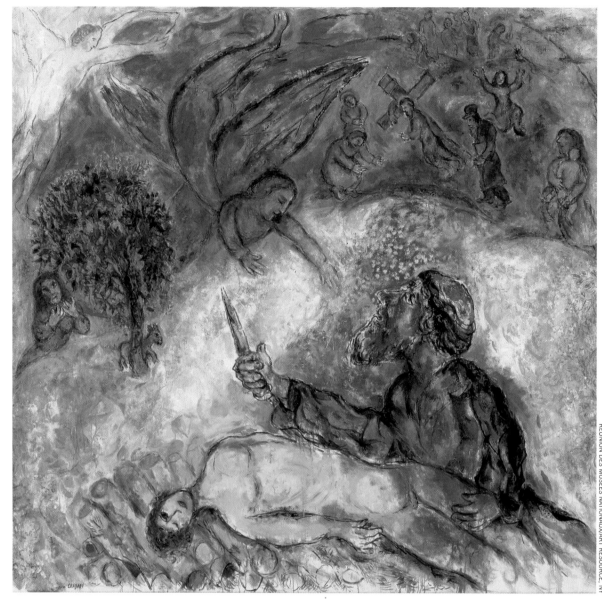

In the early 1960s the Jewish artist Marc Chagall rendered, in *The Sacrifice of Isaac,* the famous biblical episode wherein an angel stays Abraham's hand. The site below, in Israel, is supposedly the mount to which God led Abraham.

RÉUNION DES MUSÉES NATIONAUX/ART RESOURCE, NY

Before the rise of Judaism, Christianity and Islam, the world's dominant monotheistic religions, it was the rare human who believed in one supreme being rather than in a plurality of gods and goddesses. Today, by contrast, more than half the planet adheres to a one-god theology, with 2 billion Christians, 1.5 billion Muslims and nearly 15 million Jews outnumbering the followers of polytheistic religions. The shared beliefs of these often at odds monotheisms include a single god, Adam and Eve, and a common roster of holy ancestors—most important, Abraham. If he did in fact exist, a thing that is impossible to prove but that is strenuously asserted not just in the Hebrew and Christian bibles but in the Koran, Abraham (or Abram, as he appears in the earliest citations) was born in the Mesopotamian city of Ur (in the most prominent theory, Ur is Iraq's Tall al-Muqayyar, lying 200 miles southeast of Baghdad). His were a nomadic people, and Abraham migrated throughout what would become known as the Holy Land. In his seniority, he entered into a pact with God and traveled yet farther, forwarding the message of his deity and gaining adherents, eventually earning the status of his name's meaning: "father

of many nations." His sons Isaac and Ishmael are the patriarchs of the Jewish and Muslim people, respectively. As for his place in the Christian world, no less an authority than Saint Paul, in ardent admiration of Abraham's righteousness and pristine faith, speaks of him as "the father of us all" (Rom. 4:16). The great religious saga in the Middle East—and, now, the wider world—started with him, with Abraham. Where it will lead, we still do not know.

ERICH LESSING/ART RESOURCE, NY

BUDDHA
CIRCA 563–483 B.C.

He was born in India to wealth and power as Prince Siddhartha Gautama. Shortly after his birth, a visiting seer predicted that Siddhartha would become either a *chakravartin* ("universal monarch") or a fully enlightened being who would lead others to spiritual awakening. His father, King Suddhodana, wanted him to follow in his footsteps, and so to keep him on the secular track, he confined the prince to the palace and a life of luxury and ease, surrounded by beauty and every kind of sensual pleasure. Siddhartha grew up, married and had a son. Yet thirsting for knowledge of the world around him, he eventually sneaked out of the palace and saw for the first time a sick person, a geriatric and a corpse. This encounter with human misery shook him, and when he learned that even royalty could not escape disease, decay and death, he abandoned palace life and determined to find an end to suffering. For six years he pursued a course of harsh asceticism. When these extremes led nowhere, he set upon a Middle Way, between indulgence and self-denial, and he began to examine his own mind through the practice of meditation. One night, at age 35, in the village of Bodh Gaya, he sat in contemplation under a tree and resolved to remain there until he found the fundamental cause of suffering and a way to transcend it. He attained enlightenment and became a Buddha, or "awakened one," finding within himself an ever-present basis of compassion and equanimity. During the remaining 45 years of his life, Gautama Buddha traveled throughout northern India, proclaiming the existence of inherent wisdom and compassion in every human being and teaching the technique of mindfulness meditation as a means to awaken this potential. His teachings spread throughout Asia, and today they exert a growing influence in the West as well. Many of the Buddha's discoveries about the inner workings of the mind are being confirmed by neuroscientists, and mindfulness meditation is now used by hospitals, schools, prisons and athletic teams to alleviate stress, promote healing and enhance performance and creativity.

STEVE McCURRY/MAGNUM

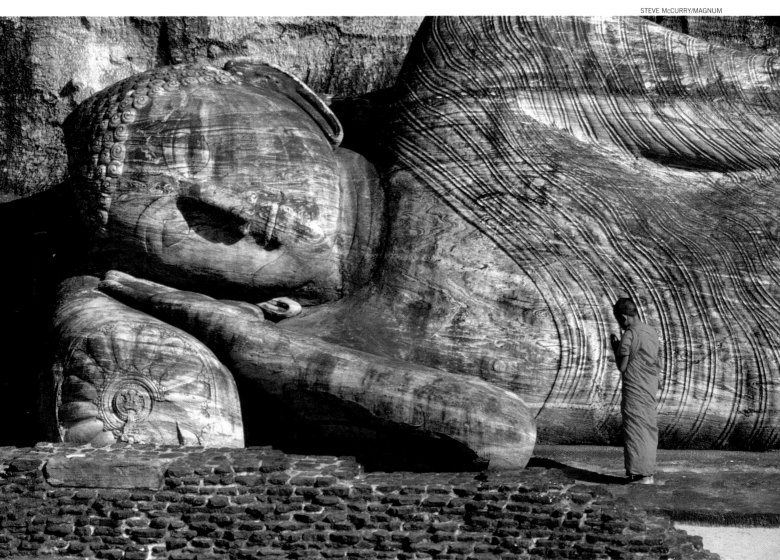

In Sri Lanka, where approximately 70 percent of the populace is Buddhist, a monk prays at a giant statue of a reclining Buddha.

CONFUCIUS

551–479 B.C.

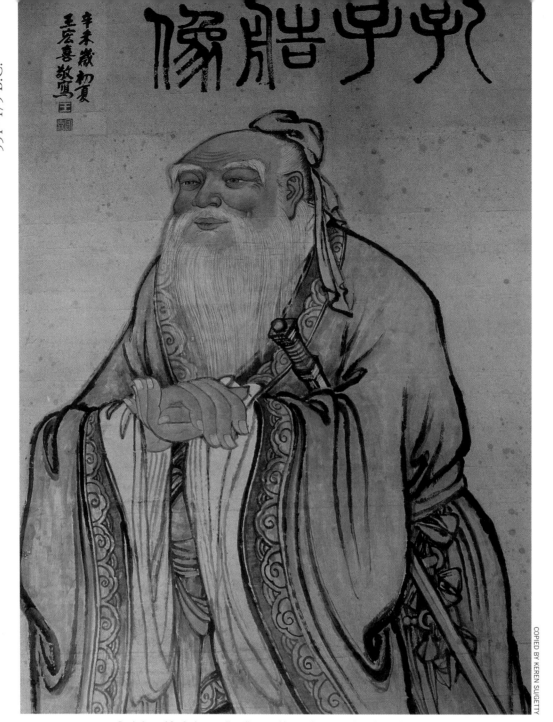

Depictions of Confucius usually reflect, as this one does, a teacher wise and serene.

COPIED BY KEREN SU/GETTY

For more than two millennia, the straightforward, appealing and highly moral philosophy of this often misunderstood man dictated the political behavior of his homeland, China. Today his influence is questionable. Though his adages—care for one's fellow man, honor your ancestors, don't do to others what you wouldn't want done to yourself—might seem piquant, as a basis for governing a nation they were useful. The sayings and writings of Confucius, with their ethical underpinnings, also seem obliquely and sometimes not so obliquely religious; some excerpts from Confucianism—"Forget injuries, never forget kindnesses"—can read like Christian teachings, written five centuries before Jesus was born. But Confucius was not strictly a spiritual leader, he was a teacher and a philosophical statesman. Born into poverty and raised by a widowed mother in northeastern China, he served briefly in government then dedicated 16 years to teaching. Word of this philosophical fellow spread, and he was tapped for a high post in the administration of his home state, Lu. He lasted only four years before being undone by adversaries in the government, and he returned to his former profession. He died in 479 B.C., but his writings lived on and gained power. Confucius asked his fellow citizens about their obligations to the nation and to one another, and this resonated with the Chinese. His way of thinking spread over time throughout Asia. Today, much of what is considered Asian custom can be traced to Confucius. Sadly, in his own country, the strongest messages of Confucianism—"Everything has its beauty but not everyone sees it"—have been trammeled by a communist regime focused more on power and control than on a strong interdependent citizenry.

ARISTOTLE
384–322 B.C.

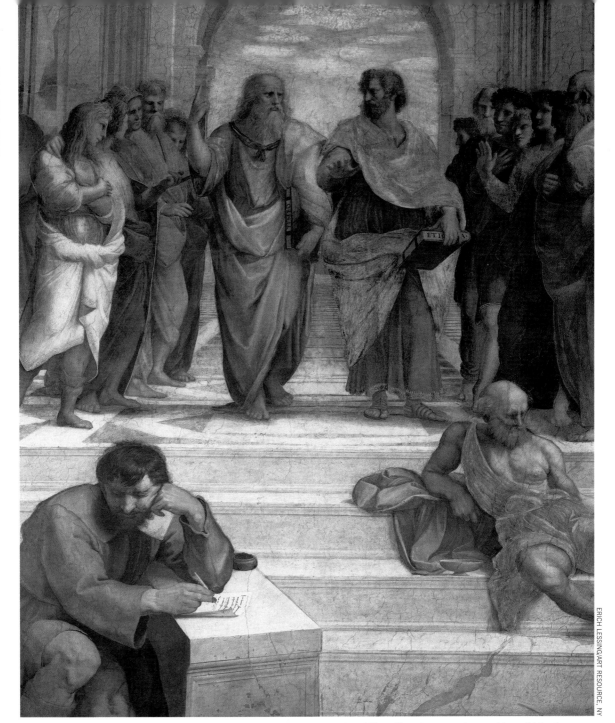

In the painting *The School of Athens* by the Renaissance master Raphael, graybeard Plato offers a lesson-on-the-go to his pupil Aristotle.

ERICH LESSING/ART RESOURCE, NY

This is the original case of the brilliant pupil outshining the brilliant teacher. In ancient Greece, Aristotle studied under Plato (who in turn had been mentored by Socrates) for two decades, beginning at what we would consider his "college age" of 17 in 366 B.C. and continuing until the master's death in 347 B.C. If Plato is rightly seen as the father of Western political and ethical thought, Aristotle, who disagreed with his professor on crucial points, was the one who, in perhaps as many as 170 books on all manner of subjects, was the philosopher who consolidated the new way of looking at the natural order. He agreed with Plato that the universe was an ideal world, but felt that form and matter were inseparable; this crucial departure was at the root of his theories on motion and change that, while not universally correct, would inform Western science for centuries. He divided nature into four elements—earth,

air, fire and water—which wasn't exactly fact but pointed a way forward. In arguing ethical points, he said the goodness of a thing lay in its realization of its specific nature. He handed down these notions, beginning in 343 B.C., to the Macedonian king's son, a young teen who would go on to become Alexander the Great. Aristotle eventually would find himself in opposition to Alexander's imperial ways, and some historians maintain that this nearly cost him his life. Regardless, he influenced evolving political thought just as he influenced everything else, from astronomy to zoology. His books include *Metaphysics, On the Heavens, History of Animals, On the Soul, Politics, Rhetoric, Poetics* and *Organon,* which comprises six treatises on logic. Aristotle encouraged his followers to think for themselves and taught them how, and much of his philosophy became deeply embedded in subsequent Jewish and Christian tradition.

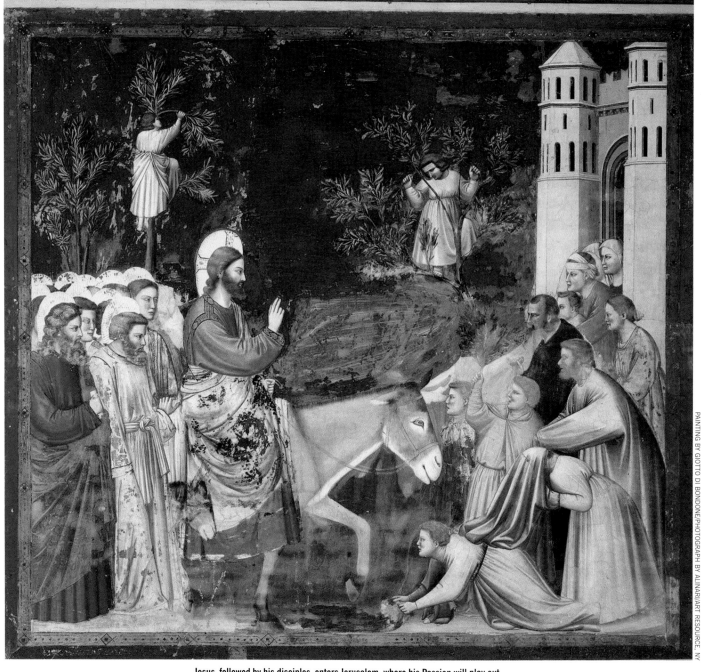

Jesus, followed by his disciples, enters Jerusalem, where his Passion will play out.

JESUS

CIRCA 5 B.C.–A.D. 29

He was descended from Abraham through the line of Isaac, as it extended through David. So says the New Testament of the Christian Bible, which concerns itself with the life of Jesus: born to Mary and Joseph, the Christ, God's son made flesh. His people were from Nazareth, but two Gospel authors are agreed that he was born in Bethlehem. Angels and a shining star signaled that his was a special nativity; still, nothing in Jesus' life presages the phenomenon that would come after his brief time on earth, which may have been as short as 33 years. To quickly look at that remarkable existence: The son of the wife of a carpenter, Jesus seemed ready to take up the family trade but then showed a precocity for philosophy and teaching, lecturing even his elders and senior clerics. If his message offended some, it was alluring to others; he was, in an era crowded with prophets, soothsayers, doomsayers and Zealots, especially charismatic.

Jesus' thinking was radical. At a time when there was not only strong-arm rule by kings but also, in the streets, greed, violence and lawlessness, notions of pacifism and charity were alien. The idea of giving one's cloak to a needy stranger—a brother, Jesus suggested—did not have much currency in Palestine then. After he had been martyred, crucified by the authorities when his cult of personality grew disruptive, disciples carried forth his principles bravely and clandestinely. Christianity, though persecuted vigorously in its early years, proved unstoppable. After a converted Jew named Paul and the first pope, Peter, took the theology to Rome, it slowly rose to become the ruling faith of the empire. Christianity has since fractured and fissured with various orthodoxies and Protestant denominations rejecting the rule of Roman Catholicism, but in the 21st century—as Christians measure time—it remains a dominant force.

MUHAMMAD

CIRCA 570–632

In a volatile age there emerged a serene, strong leader who bequeathed to his people a treatise so moving and wise that it became the bedrock of one of the world's great faiths, Islam. Muhammad said that he was merely the agent. The Koran was the word of Allah, offered to him by an angel. Who was Muhammad, and how did he come to be selected? He was descended from Abraham through Ishmael in a line that included many prophets—but none after him, for he was destined to be the Seal of the Prophets. Muhammad was born nearly six centuries after another great philosopher, Jesus of Nazareth, had spawned a cult that bloomed into a durable religion. As with Jesus, there was little—except perhaps his name, which means "highly praised"—in Muhammad's early years to indicate that this man would found a discipline for the ages. Mecca, a desert city in what is now Saudi Arabia, was a sea of strife in the late 6th century, and when Muhammad's parents died while he was still a boy, he was adopted by an uncle. Muslim tradition tells us that Muhammad's heart was infused in his youth with love, charity and all manner of virtuousness. A benign soul working in the caravan trade, he married at age 25; it would be another 15 years before he began preaching in earnest. What happened in the interval is crucial: He went regularly to a cave outside Mecca to contemplate, to question the beliefs of his age and to pray. In the cave, an angel came to him and charged him to "Proclaim!" This Muhammad would do, in the words Allah dictated to him during the remaining 22 years of his life. In Medina he built his following, and eventually challenged Mecca for the soul of Arabia—and won. In 632 Muhammad died in Medina. During the next century, Muslim armies washed over Armenia, Iraq, Lebanon, Palestine, Persia, Spain, Syria and most of North Africa, including Egypt. Muhammad gave the Arabs a religion, and today it is the second largest in the world.

Above: In Mecca, Saudi Arabia, sunset prayers at the Sacred Mosque. Right: From a Persian manuscript, Muhammad, his face veiled to hide his glory, ascends to heaven.

POPE URBAN II
CIRCA 1035–1099

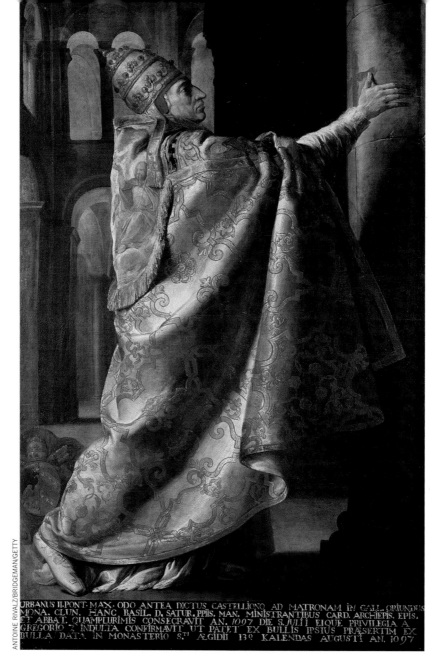

ANTOINE RIVALZ/BRIDGEMAN/GETTY

URBANUS II·PONT·MAX. ODO ANTEA DICTUS. CASTELLIONO AD MATRONAM IN GALL. ORIUNDUS
MONA. CLUN. HANC BASIL. D. SATUR. PPIIS. MAN. MINISTRANTIBUS CARD. ARCHIEPIS. EPIS.
ET ABBAT. QUAMPLURIMIS CONSECRAVIT AN. 1097 DIE S. JULII EIQUE PRIVILEGIA A
GREGORIO X INDULTA CONFIRMAVIT UT PATET EX BULLIS IPSIUS PRÆSERTIM EX
BULLA DATA IN MONASTERIO S.TI ÆGIDII 13º KALENDAS AUGUSTI AN. 1097

**Urban II consecrates
the Basilica of St. Sernin
in Toulouse, France.**

One other Catholic pope appears in our collection of 100 people who changed the world, and the reasons for John Paul II's inclusion may be self-evident to the reader. But it might well be wondered: Who's this Urban guy? What did this fellow Urban II do to merit his citation? The answer is, he put his Church and all of Western Christendom squarely in opposition to Islam by inciting the First Crusade. The ramifications in his time were great, and the repercussions even today are obvious. For two hundred years beginning in the late 11th century there was an endless series of holy wars between Christians and Muslims based in Europe and in the Holy Land—eight major Crusades during the period—and something like that is never forgotten. Urban II was born Otto de Lagery in France and, as a prelate, became a favorite of Pope Gregory VII, whose reforms (a strengthening of the papacy, an affirmation of priestly celibacy) he would continue to champion during his own regime, which began in 1088. He was approached in 1095 by Byzantine emperor Alexius I Comnenus, who asked for support against the Muslims in Anatolia (today, Turkey). Urban was receptive, to say the least. He convened a council that year at Clermont in his native country, and bishops from across Europe attended; some accounts have it that he preached to thousands. He gave an effective sermon, that much is certain. There are five versions of his speech, each written after the fact by men who may have been at the council or may have gone on a Crusade. They generally agree that Urban spoke of the violence in Europe, the need for peace, a willingness to help the Greeks, the righteousness of an armed pilgrimage and blessings for those who joined the fight. Beyond that, the transcriptions vary, and political motives are clearly at play. One version has Urban calling for Christians to destroy "that vile race . . . Christ commands it." Another has him promising "immediate remission of sins" for all who die in battle against the "pagans." Only one has the famous scene in which the crowd responds to his call for blood by shouting "God wills it!"—and so we must assume pro-Crusade propaganda rather than journalism. Nonetheless, it was Urban who sent them off, and the goal soon became not just assisting the Byzantine emperor against the Muslim Turks but the retaking of Jerusalem, which was accomplished on July 15, 1099. Urban died two weeks later, before word of the event had reached Rome.

JOAN OF ARC

CIRCA 1412–1431

She is today a saint; she was, in her time, a national heroine in her native France, and eventually a martyr second in renown perhaps only to Jesus. The one who would be called the Maid of Orleans, was the daughter of a farmer and his wife in Domrémy in the province of Lorraine, and began at a young age (she would never reach a middle age, never mind an old age) to hear voices. These belonged, she said, to Saint Michael, Saint Catherine and Saint Margaret, and they urged her to bring support to the dauphin, Charles VII, who was being kept from his rightful throne by the English. The teenage girl was ignored at first by French authorities, but eventually the military governor of Vaucouleurs, bowing to Joan's persistence, gave her permission to travel to see the dauphin at Chinon. There, in 1429, she told the would-be king of her mission and, after some persuasion, was given troops to lead. Initially, Joan was remarkably successful. She broke the siege of Orleans and secured positions along the Loire River, then helped to rout the English at Patay, brandishing her sword at the head of her army, which she commanded while wearing the male clothes she had adopted when first embarking on her intrepid enterprise. She marched on Rheims and stood there beside Charles as he was finally crowned. At this point in the remarkable tale, a woman who might have changed the world more greatly was stifled. Already she had turned the tide of the Hundred Years War, and she wanted to press her campaign. But the man she had helped put in power was an ineffectual leader and ordered her to calm down while he negotiated with the Duke of Burgundy, an ally of the English. In 1430, Joan was captured by the Burgundians who sold her to France's enemy; it is a measure of Joan's stature that she was worth 10,000 golden crowns to England. She was convicted of

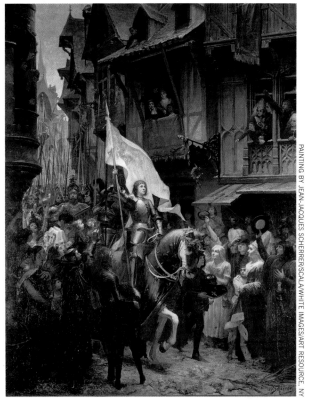

PAINTING BY JEAN-JACQUES SCHERRER/SCALA/WHITE IMAGES/ART RESOURCE, NY

Above: Joan enters Orleans in 1429. Below: The Chateau de Chinon on the Loire River, where Joan met Charles VII that same year.

heresy and sorcery by a court at Rouen, in France, that was overseen by the English and condemned to death. She was burned at the stake. In 1920, she was canonized by her Roman Catholic Church, and today many French—and others—celebrate her feast day on May 30.

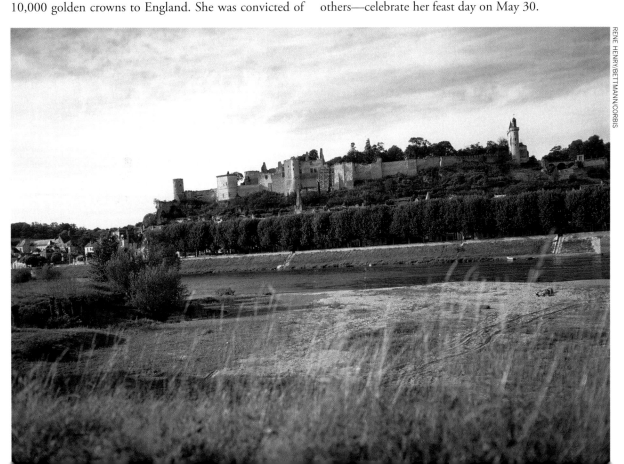

RENE HENRY/BETTMANN/CORBIS

MOHANDAS GANDHI
1869–1948

Some of the people in this book blur categories, and it was difficult to decide whether Gandhi, the great Indian leader of the 20th century, belongs among the religious and philosophical or the political figures. Our final decision was based upon this conclusion: Without the spiritual element, there is no Gandhi. The institutions that Jesus and Muhammad inspired are called religions, the one that followed the Mahatma's guidance is called a nation or state—but in this case, that seems semantics. Gandhi was seen as a transcendent man of deep thought and wisdom, therein lay his power. His political philosophies were informed by Hindu teachings blended with other intelligences that Gandhi had gleaned from such as Henry David Thoreau, Leo Tolstoy and Jesus Christ, and the man in shirt and tranquil at his spinning wheel seemed the embodiment of the philosophies. He was educated in India and London and admitted to the bar when still a young man, in 1889. Returning to India in 1915, he began working for India's independence from Britain. It should be noted that many Indians had sought sovereignty before the coming of Gandhi—consider that the Indian National Congress, which Gandhi would head several times, was founded in 1885—but most had assumed that independence would come only with bloodshed. Gandhi had different ideas. He ordered an oftentimes extraordinarily courageous war of passive resistance and nonviolent disobedience, initiating boycotts and hunger strikes (even "fasts unto death") to influence not only the British overlord but the larger world that was standing in judgment of the conflict. Over time, his methods worked. India was given freedom in 1947. Gandhi was assassinated the following January. His message and methods lived on in other movements—for instance, Martin Luther King Jr.'s crusade for civil rights in the postwar United States. The honorific *Mahatma* means "great soul," and it is one that was well earned by Mohandas Gandhi in his lifetime.

Gandhi made himself a potent, utterly consistent symbol: his Hindu faith, his uncluttered life, his vegetarianism, his spinning wheel.

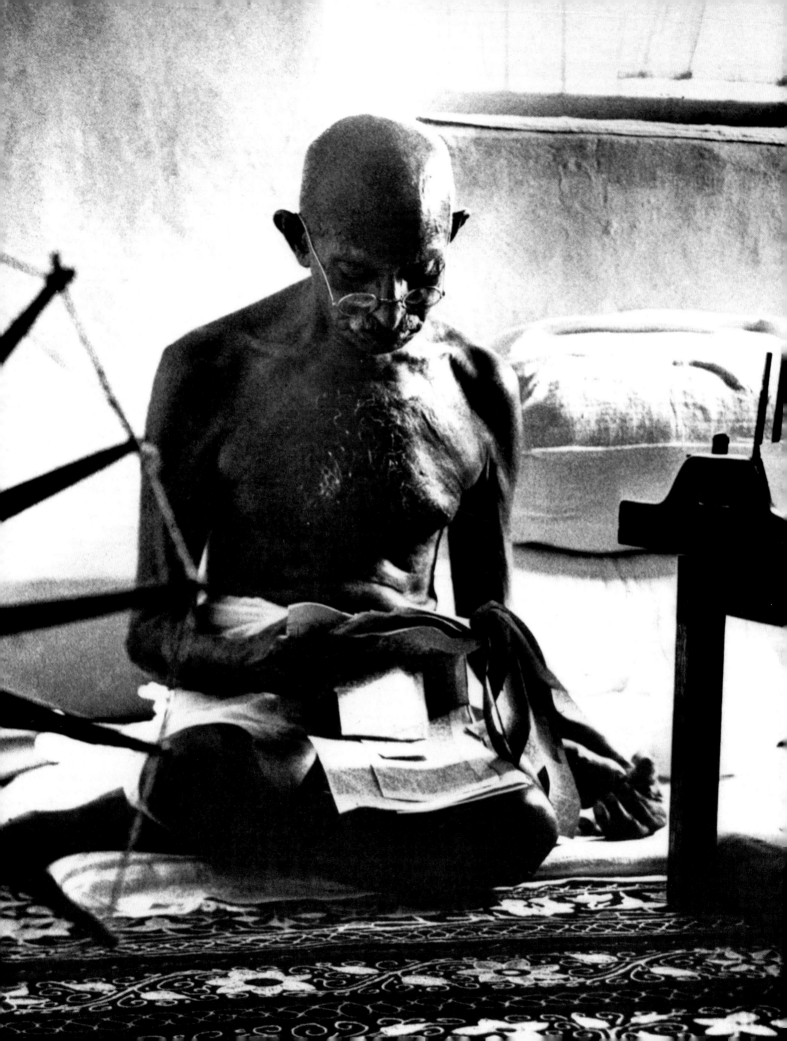

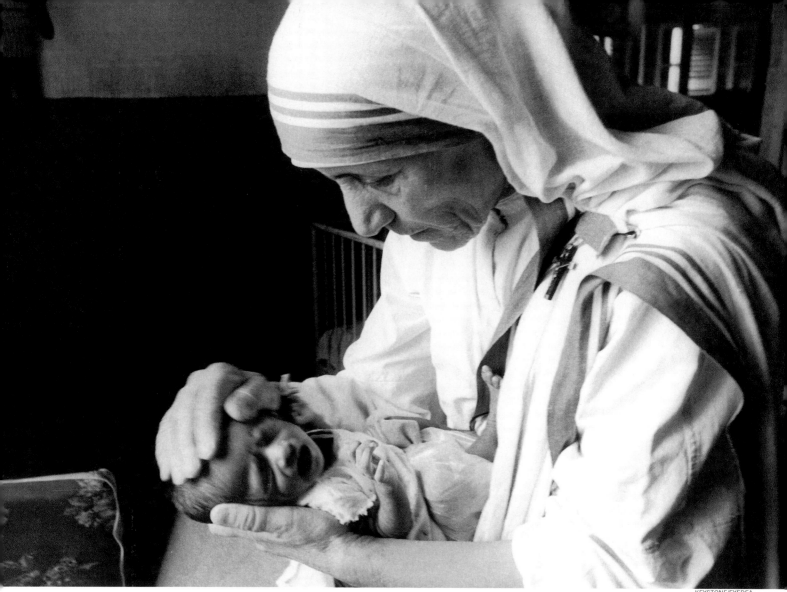

On September 6, 1971, Mother Teresa tries to calm a newborn orphan in a Calcutta clinic.

KEYSTONE/EYEDEA

MOTHER TERESA

1910–1997

There is rarely unanimous acclaim for the deeds of any famous person or celebrity, and so it is in the case of Teresa. Her church and her country have no doubts about her goodness, but critics have made various allegations: that her acts of charity were not pure but came attached to Roman Catholic indoctrination; that some of the considerable amounts of money she raised seemed unaccounted for; that the medical standards in her hospices were not what they could or should have been. With these points taken into consideration, it remains clear that note must be taken of Teresa, a woman who, by working for and among the poorest for nearly a half century, became a potent force, touched millions of lives and inspired millions more. Agnesë Gonxhe Bojaxhiu, the girl who would grow to become Teresa, was born in 1910 in what is now Macedonia and exhibited a precocious religiosity: By age 12 she had determined to devote herself to service to God, and at 18 she left home to join the Sisters of Loreto. Among other things, this order taught schoolchildren in India, and Teresa arrived in that country in 1929. Taking her vows as a nun in 1931, she chose the name Teresa after Thérèse de Lisieux, patron saint of missionaries. She was moved by the abject poverty she saw while working at a convent school in Calcutta (now called Kolkata) and founded her Missionaries of Charity there in 1950. A documentary and book on her work, *Something Beautiful for God,* brought widespread attention and acclaim, and the Missionaries of Charity was eventually able to expand into more than 100 countries; it was operating 610 missions at the time of Teresa's death, including everything from neighborhood soup kitchens to hospices for people suffering or dying from AIDS or tuberculosis. The critics had their say, but so did others: India gave her its highest civilian honor; she was awarded the Nobel Peace Prize in 1979; and not long after she died, Pope John Paul II beatified her, bestowing the title Blessed Teresa of Calcutta. To many, she seemed a saint made flesh.

The late Ruth Graham once said that her husband "wanted to please God more than any man I'd ever met." Hundreds of thousands of others who have been in the presence of Billy Graham—and he has preached to two and a half million people worldwide in his long career, reaching nearly a thousand times that many if we include radio and television broadcasts—would agree with her assessment. Graham is possessed of a powerful charisma and a tangible sincerity; no one doubts his profound belief in the message he conveys. Born into the Presbyterian faith in North Carolina, as a young man he was told by Bob Jones Sr., founder of the Christian university that bears his name, "You have a voice that pulls. God can use that voice of yours. He can use it mightily." Graham began preaching while still in college, began his radio ministry in 1944 and found his calling as an evangelist when hired to be the traveling preacher for Youth for Christ International. In the autumn of 1949 he had an enormous breakthrough with an eight-week series of revival meetings in Los Angeles; it can be claimed that in the subsequent six decades he has been what President George H.W. Bush once called him: America's pastor. Harold Bloom of Yale University, author of *The American Religion,* among other books, wrote in *Time* magazine in 2000 that "Graham has ministered to a particular American need: the public testimony of faith. He is the recognized leader of what continues to call itself American evangelical Protestantism, and his life and activities have sustained the self-respect of that vast entity. If there is an indigenous American religion—and I think there is, quite distinct from European Protestantism—then Graham remains its prime emblem." He does so in an era that includes such as Rick Warren and Pat Robertson, and he does so globally. It is possible that, along with the equally well-traveled man whom we will meet on the very next page, Billy Graham helped make the second half of the 20th century the greatest period of Christian evangelization since Saint Paul set out on foot.

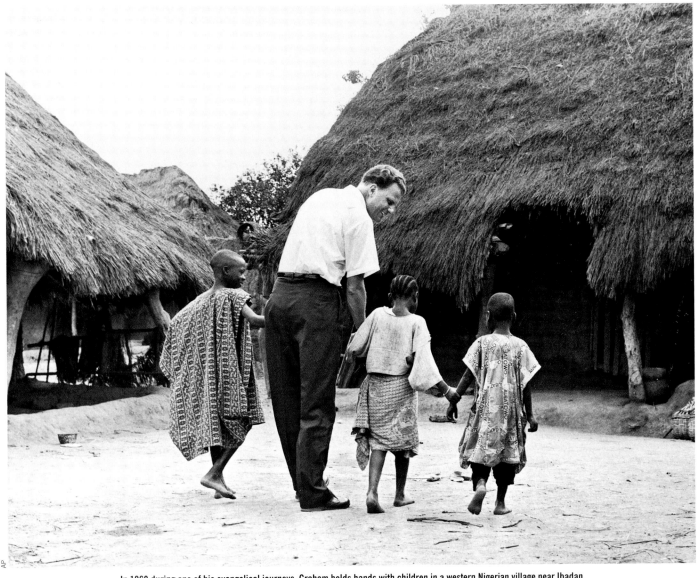

In 1960 during one of his evangelical journeys, Graham holds hands with children in a western Nigerian village near Ibadan.

POPE JOHN PAUL II
1920–2008

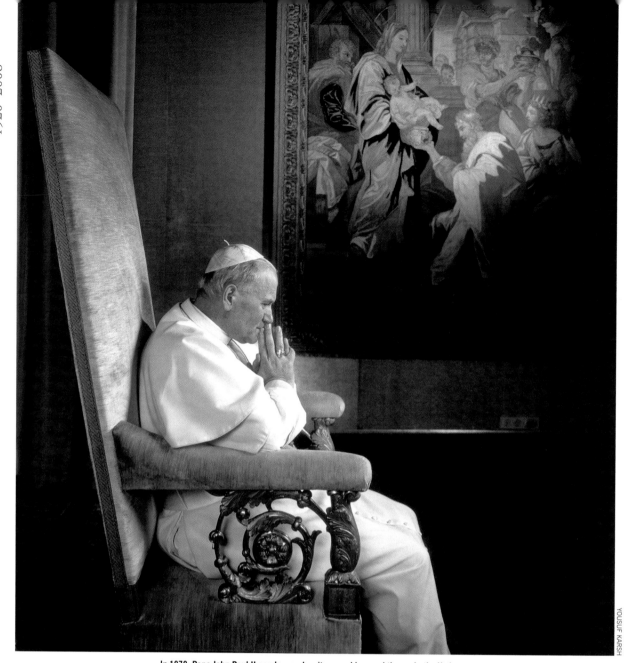

In 1979, Pope John Paul II ponders as he sits upon his papal throne in the Vatican.

Certainly there were many influential popes in the long line extending from Saint Peter to John Paul II, who ascended to Peter's throne in 1978 and embarked upon the second longest pontificate in history, but few—perhaps none—had as great an impact both on their own church and on the world at large. The Reverend Billy Graham, himself a most influential man, as we have just read, put it forthrightly in an appreciation he once wrote for LIFE: "Few individuals have had a greater impact—not just religiously but socially and morally—on the modern world." Just so: The great events of the 20th century influenced Karol Wojtyla's extraordinary life, and as Pope John Paul II, he influenced events in turn. Born in the Carpathian foothills of southern Poland, Karol was a boy who stood out: uncommonly smart, artistic, sensitive and devout. He had a bright future, but Poland back then did not. In the 1930s, Nazi tanks rolled in and terror swept the country. One of the most infamous concentra-

tion camps was built at Auschwitz, only an hour's journey from Karol's town. Jewish friends of his youth started to disappear, along with Catholic priests. Nevertheless, Wojtyla entered a clandestine seminary in Krakow to study for the priesthood. After the war he developed a reputation as an able young cleric who could get things done even as Poland suffered under a new boot, that of atheistic communism. Wojtyla rose in the Church to the rank of cardinal and then, stunningly, emerged as the first non-Italian pope in more than four centuries. As pontiff, he quickly proved an indomitable force. Working behind the scenes with other world leaders, he played a crucial role in the fall of communism. Traveling more miles than all the previous popes combined, he brought the worldwide population of Roman Catholics to more than a billion strong—he was his church's greatest evangelist since Paul of Tarsus. He was a holy man and a political one, and his presence was felt in several realms.

OSAMA BIN LADEN

BORN 1957

Not since Hitler had America's rage and hatred been so intently focused on one man. Not since World War II had the nation been so united concerning the righteousness of its aim—to take the enemy, dead or alive. For all that, on September 10, 2001, the day before the hijacked airliners crashed into buildings in New York City and Washington, D.C., and a field in rural Pennsylvania, there wasn't a citizen in 50 who could have told you much about Osama bin Laden. On September 12, everyone was asking: Who is this man? He was (and perhaps still is, if he isn't dead) a charismatic leader of a network of radical Islamist cells pledged to rid their holy land of infidels. Particularly galling to bin Laden and his al-Qaeda brethren was the presence of the U.S. military on Saudi soil during and since the Gulf War in 1990, as well as America's support of Israel, which continues to deny Palestinians a separate state. Bin Laden declared *jihad*—a holy war—against the U.S. from his Afghan redoubt and in 1998 made his intentions plain: "To kill Americans and their allies—civilians and military—is an individual duty for every Muslim who can do it." It is now clear that he was listened to, and is listened to today. His was a remarkable personal transformation, from a benign, some say feckless, scion of a prominent family into a leader for whom thousands if not millions would give their own lives to kill others. He was born in 1957 and was indulged as a child. When his father died in 1968, bin Laden inherited $80 million (his fortune as of 9/11, which represented a part of al-Qaeda's financial bedrock, was variously estimated to be between $200 and $300 million). At King Abdul Aziz University, he became enthralled with a professor, Abdullah Azzam, a Palestinian who was a leader in the Muslim Brotherhood, an organization that spearheaded a 1970s resurgence in Middle Eastern religiosity and preached the notion of pan-Islamism: a unification of the world's billion-plus Muslims. If that is bin Laden's dream today, he can never accomplish it. The vast majority of his fellows in the religion would never follow his cruel, fanatical line. But he changed the world everywhere on 9/11 and pitted a sliver of radical Islam against the West at a pitch not so feverish since the Crusades.

In 1997, four years before 9/11, bin Laden uses a map of the Middle East to indicate where U.S. troops are present—and why, in his opinion, they should not be.

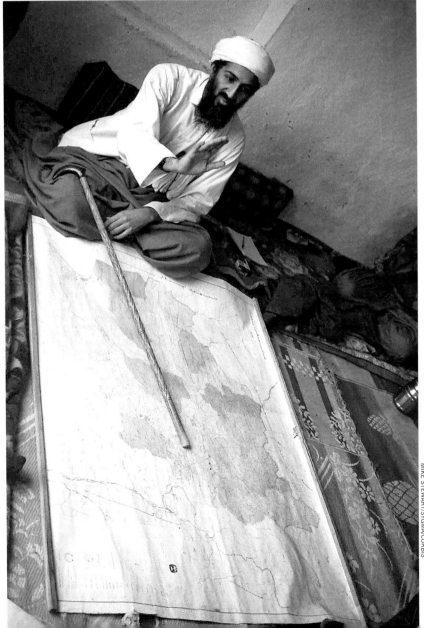

MIKE STEWART/SYGMA/CORBIS

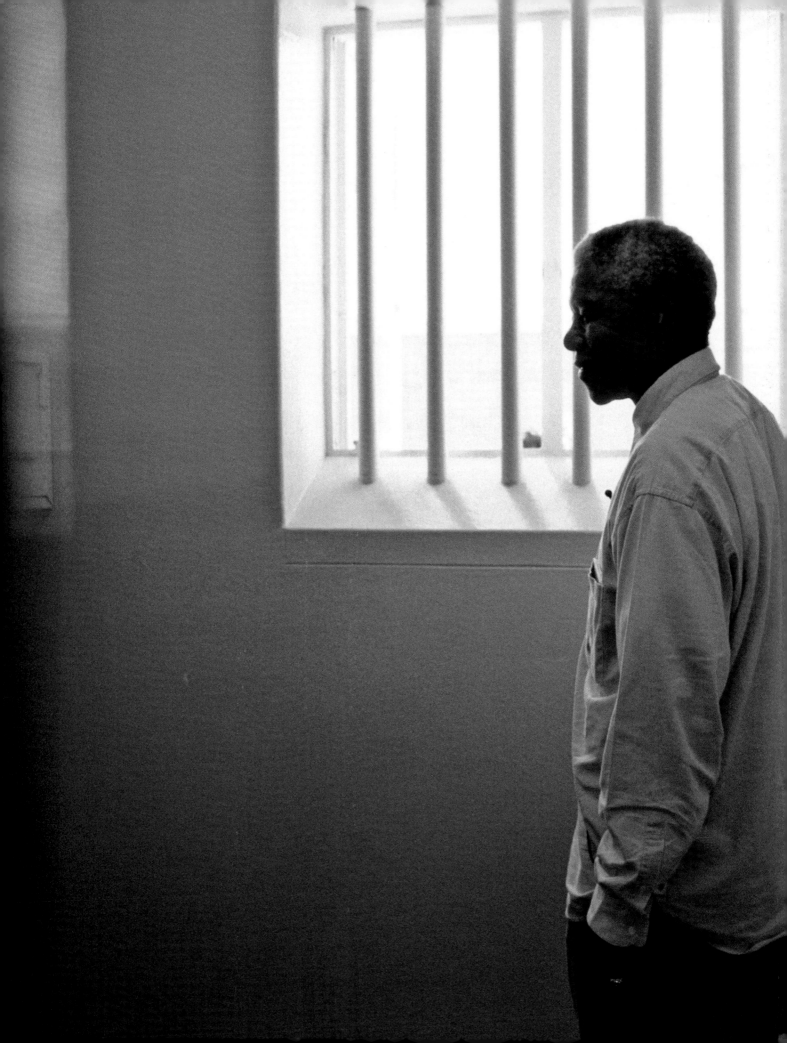

LEADERS, EVICTED & NOT

In 1994, South African presidential candidate Nelson Mandela revisits the cell in the Robben Island prison off Cape Town where he had spent more than two decades. (Please see page 45.)

KING KHUFU

CIRCA 2551–2528 B.C.

Not everyone in this book has a lasting influence in the present day, and Khufu certainly doesn't—much beyond his importance (considerable) to the Egyptian tourist board. The age of the pharaohs, minus their biblical significance (again, considerable), has as much to do with the modern state of affairs in the Middle East as the age of the dinosaurs has to do with life in contemporary Wisconsin. But taken altogether, the reign of pharaohs in the Old and New Kingdoms extended for so many centuries and impacted so many in the civilized world that attention must be paid to these powerful rulers. But which pharaoh to represent the fraternity? It is historically uncertain who was "pharaoh" when Moses said, "Let my people go." Ramses is certainly a tempting choice. But at the end of the day, no quick sketch of the pharaoh regimes offers as good a glimpse into the massive, all-encompassing power and cruelty exerted by these kings of Egypt than a quick sketch of Khufu's. And it must be quick, for we know so little. The king, also known as Cheops or Suphis, ruled for two dozen years during the Fourth Dynasty (2574–2465 B.C.) and was rumored to have been quite a tyrant. Beyond that, and the fact that he was the son of a pyramid-building king named Snerfu, not much is known about him. He clearly approved of the Old Kingdom tradition of erecting pyramid-shaped superstructures to encase royal tombs and chose the plateau of Giza, on the west bank of the Nile across from Cairo, as the site of his own. It is believed that 100,000 men worked on its construction for up to four months each year for 20 years. The word *toil* doesn't begin to tell the tale. The pyramid's 2,300,000 blocks of stone averaged 2.5 tons apiece! Each block had to be dragged by teams up ramps made of mud and brick! The pyramid, which still stands today (please see pages 4 and 5), spreads over 13 acres at its base! However else Khufu and his colleague pharaohs changed the world in their epoch can only be imagined from that starting point.

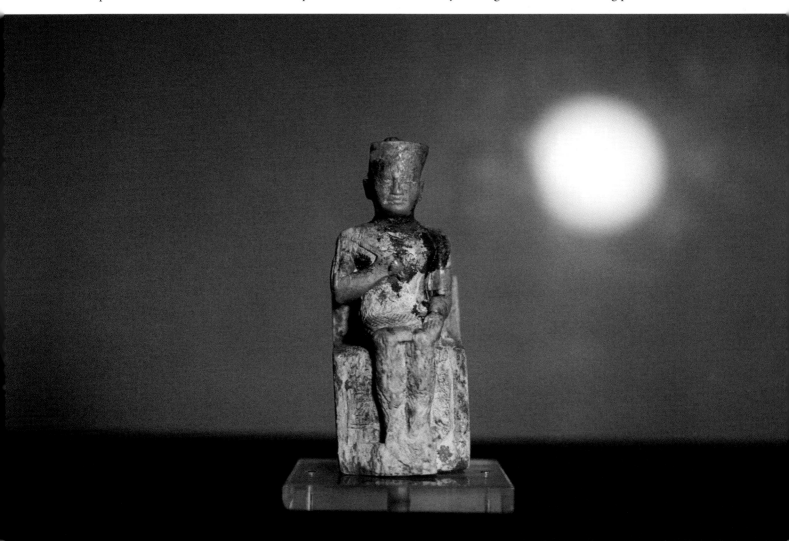

Found inside the pyramid was this statue of the pharaoh himself, which is now in the Cairo Museum.

ALEXANDER THE GREAT

Macedon's King Philip II had successfully installed his rule over Greece and had just begun his invasion of the Persian Empire, an enormous autonomy extending from the Mediterranean Sea to India, when he was assassinated in 336 B.C. His 20-year-old son, Alexander, already a veteran of the military and of Aristotle's tutoring, was thus thrust into a position of power at a young age. Not known then was that he only had another 13 years to live. What he would accomplish in that short time, in terms of world domination, is truly astonishing. Leaving behind forces to defend Greece's possessions in Europe, Alexander swept into Persia—Asia Minor, Syria, Phoenicia, Gaza, Egypt, Asia, Babylon, Iran—and, with only 35,000 men, defeated much larger armies time and again. He was, by all accounts, a brilliant, brave, inspiring general. Flush with success, he went forth beyond Persia into Afghanistan and India. Then, after 11 years undefeated in battle, he pulled back to Persia and began to reorganize his empire into a kind of utopian melding of East and West. He died a short while later of a fever, and his vast domain was subsequently split among his generals. The nation of Alexander, perhaps the greatest warrior in world history, was therefore short-lived, but the crucial linking of Grecian and Asian cultures and ideas, and the manner in which they would continue to influence and vie with each other forevermore, had been forged by one man. Alexander's ghost looms over the region and its turmoil every day.

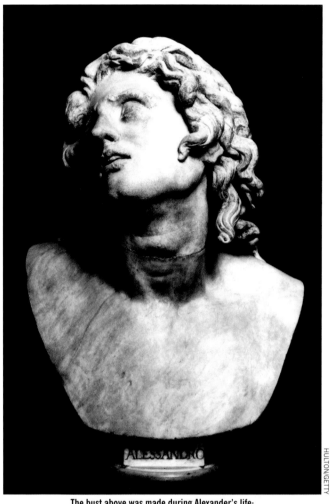

ALESSANDRO

HULTONGETTY

The bust above was made during Alexander's life; the sarcophagus below is rumored to be his.

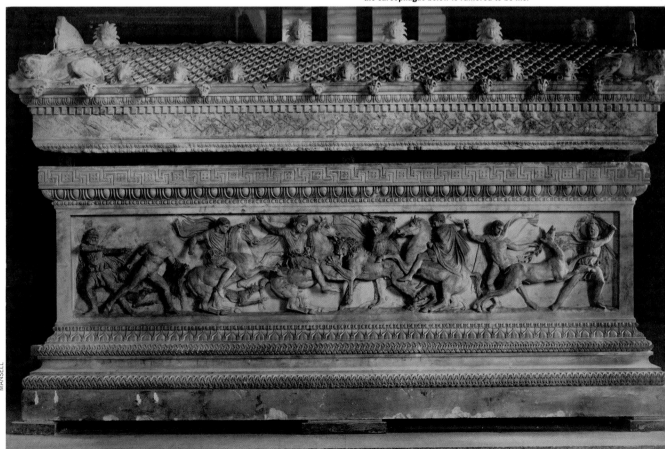

MANSELL

CLEOPATRA VII
69–30 B.C.

As with the sculpture of Alexander, this rendering of Cleopatra VII—the famous Cleopatra—was created during her lifetime.

As we pointed out in the introduction to this book, our collection does not represent *the* 100 people who changed the world but, rather, an intriguing assortment of 100 who had an impact. If we were seeking to be definitive in presenting the most influential individuals ever, it would be hard to justify omitting some religious figures not found in these pages (Martin Luther, John Calvin) or some political leaders (Josef Stalin, Oliver Cromwell). And, being honest, it would be impossible to argue for Cleopatra VII over certain Roman men who were her contemporaries, particularly the Caesars Julius and Augustus. The latter, after all, founded the Roman Empire: pretty big stuff. But Cleopatra was at the center of many intrigues, and her presence and choices had ramifications small and large; she seems, finally, an emblem of the age. This queen of Egypt was the daughter of Ptolemy XII and married first, under Egyptian tradition, her brother Ptolemy XIII, who accidentally drowned in the Nile, and then her younger brother, Ptolemy XIV. She was by accounts not a beautiful woman, but she must have had an allure. She was a lover of Julius Caesar, who fathered her son Caesarion and who supported the revolt she sponsored against her kid brother/husband in Egypt. After Caesar's death, she was comforted by Marc Antony, who fell for her, as we know. They paired in love and war, and for a time they tilted at controlling Rome. But Octavian (who would become Augustus Caesar) defeated their forces at Actium in 31 B.C. and then at Alexandria. Antony committed suicide. Cleopatra tried her wiles on Octavian, who resisted, and so she did the noble and romantic thing by having an asp bite her, thus ending her colorful life.

CONSTANTINE THE GREAT

Legend has an angel visiting Constantine in a dream and showing him the True Cross, which the emperor then used as his emblem in battle, where he prevailed.

The rise of Christianity would not have been possible minus the dedicated actions of several who came after Christ. Without the narratives of the Gospel writers Mark, Matthew, Luke and John (and others not included in the canonical New Testament); without the feverish evangelization of Saint Paul; without the devotion and example of the martyred first pope, Saint Peter—without each of these, Christianity faced a more difficult road; without any of them, it might have faced an impossible one. Now, it can be said that their work on Christ's behalf was inevitable, for the inspiration of his divinity was simply too powerful not to prevail over men. And it could be said that Constantine, too, was humbled by the example of Jesus and converted for saintly reasons. But then again, it can be speculated that Constantine, the first Christian emperor of the Roman Empire, saw the writing on the wall, and assumed that Christianity, extraordinarily resilient as it was proving to be even in the face of vicious persecution by generations of Roman authority, represented the future—a stronger, more stable future. This latter view becomes more attractive when we consider Constantine the man, who was not at all attractive in character but as ruthless as any who had preceded him on the throne; he was a fierce fighter, prevailing in a series of civil wars that had rent the empire, and at one point he had his wife and son executed for reasons unknown. He doesn't seem, on the page, a model Christian. And yet one of his earliest rulings, the Edict of Milan, changed Christianity from an illicit faith into a legal one. He never did make Christ-worship the official state religion of Rome, but with his church-building programs and his own personal conversion, he all but did so. Once unshackled, there was no stopping the Church, which swept the empire and eventually most of Europe. Constantine accomplished much else—as an example, he built the gleaming city Constantinople (today, Istanbul in Turkey)—but he is best remembered as the man who allowed his empire to embrace Jesus Christ.

LEIF ERIKSSON

CIRCA 971–CIRCA 1015

This setting in Newfoundland is believed to be where Eriksson's men made their way ashore, as depicted in the engraving.

WERNER FORMAN/TOPFOTO/THE IMAGE WORKS

The discovery of the New World by this Norseman in the first millennium went unheralded for centuries, thoroughly overshadowed by the achievements of an Italian adventurer in the employ of Spain. Even though Christopher Columbus did make it across the Atlantic to the West Indies in 1492, he never stepped foot on mainland North America. That has been proved. Nearly five centuries earlier, Eriksson had made it across the North Atlantic to what is now the Canadian province of Newfoundland, but that can only be strongly surmised because evidence of the colony he supposedly established there—a colony that did not take hold—is sketchy. And so for decades, American schoolchildren were taught that Columbus "discovered America," an absurdity anyway since there were plenty of Native Americans here already, as there had been for millennia. But if the larger question is who from the Old World first brought back information that there was something to the west worth looking at, then Leif Eriksson was probably the fellow. Whatever reports reached Scandinavia surely trickled down to the rest of the European continent, and eventually inspired further investigations by such as Columbus, Ferdinand Magellan and others. Who was Leif Eriksson? He was the son of Erik the Red, a notorious outlaw who at one point was banished from Iceland to Greenland. Eriksson traveled farther, and one theory holds that he first landed on Baffin Island and scoped that out before setting up "Vinland" on the mainland. Beguiling structures

GRANGER

have been unearthed, and in the modern day, support for Vinland has grown. While it is true that Eriksson's discoveries did not set off a flurry of new expeditions as did Columbus's, it is equally true that Europe was going to find America without either man. Even if Eriksson's voyage sparked only a flicker of interest back home, this Viking was the one who ignited it.

GENGHIS KHAN

CIRCA 1162–1227

In 2006, horsemen commemorate the 800th anniversary of the founding of the Mongol state by Genghis Khan (below).

There are some warriors and potentates absent from these pages who were, at one time or another, the most powerful individuals on the planet. The way they changed or defined the world in their day was predicated upon what that world was—the world as they knew it, anyway, however big or small—and their influence through the ages was dependent upon what became of that world. Some can be given a miss in our book because civilization has advanced well beyond their narrow scope, or because the area they controlled has since become unrecognizable, having split into new nations or been subsumed into others. If their influence lasted only a generation of two, did they really change the world? But, as with Alexander the Great, there is no denying Genghis Khan his place among our 100, both because he rose from the bottom to the absolute top, and because he proved so successful at Eurasian domination that, in showing it could be done, he inspired future tyrants to give it—and even global conquest—a try. In the late 12th century in the section of today's China known as Mongolia there were several warring tribes, and from this chaotic situation a fierce fighter named Temüjin emerged as particularly skilled not only on the battlefield but as a leader and organizer; in 1206 a conclave of Mongol warlords anointed him Genghis Khan—"the universal emperor"—and pledged fealty. The Khan went to work expanding the confederacy's reach: In 1213 he began his conquest of north China, and by 1215 he held most of the Ch'in empire; he then conquered Turkistan, Transoxania and Afghanistan and penetrated southeastern Europe. Under the leadership of his son Ogedai, the Mongols took over Russia and pushed further into Europe. In 1279, Genghis Khan's grandson Kublai Khan completed the conquest of China. By then, the Mongols controlled more land than any empire that had come before—or has come since. And here's another fun fact: Geneticists studying Y-chromosome data in the part of the world that the Mongols once overran have determined that eight percent of men there—16 million, or almost 0.5 percent of the world's male population—share a nearly identical chromosome. What does this mean? It means Genghis Khan has a truly frightening number of descendants on the planet today.

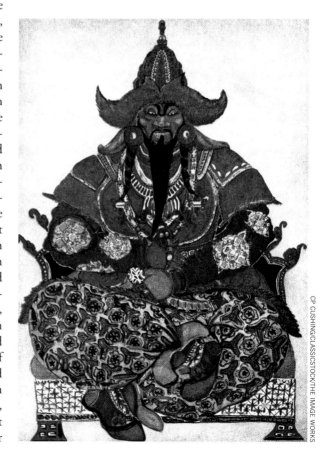

QUEEN ISABELLA I
1451–1504

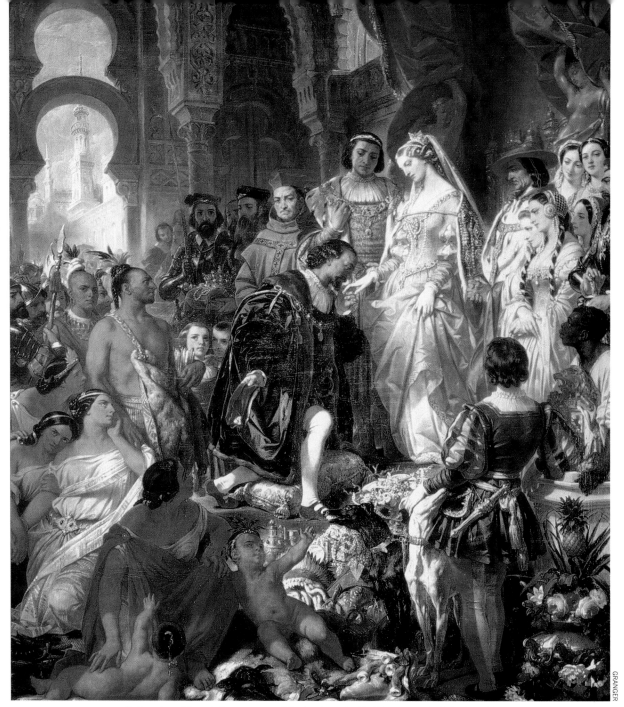

Having returned from his famous voyage, Columbus is received by his patroness, Isabella, in 1493.

This entry could be called "Isabella and Ferdinand," for the dual reign of these "Catholic Monarchs" of Spain, as the couple is called, reshaped the world, and launched enterprises that had a titanic effect in their day and that continue to influence the lives of untold millions. Just as Michael H. Hart, in his book *The 100: A Ranking of the Most Influential Persons in History*, chose Isabella over Ferdinand for inclusion, so do we, and for the same reason Hart elucidated: Although "most of her policies were decided upon after consultation with her shrewd and equally capable husband . . . it was her suggestions which were adopted in their most important decisions." These decisions led to, among other things, the reconquest of Spain from the Moors, the institution of the Spanish Inquisition, the sending forth of Christopher Columbus to the Americas (and all the unpredictable consequences thereof) and the divvying up of the world as it was then known with the Portuguese. Isabella was 18 and heir to Castile when, in 1469, she married Ferdinand II, heir to Aragon; after securing these regions in a civil war, they were overlords of most of Spain. They launched the Inquisition early in their reign, and after more than 2,000 were burned at the stake and the notion of due process was erased from the prosecutorial equation, Isabella was as all-powerful as she was feared. As for Columbus's voyage: It was underwritten by the kingdom of Castile, and so his achievement is credited to Isabella rather than Ferdinand. Of course, the makeup of South and Central America today and many parts of the United States is a result of that seminal voyage.

CATHERINE DE MÉDICIS

POPPERFOTO/GETTY

Catherine is dispassionate as she inspects the results of the Saint Bartholomew's Day Massacre, a crackdown she had ordered.

Here we will anticipate the argument. We'll throw out the words: *Scheming. Cunning. Crafty. Unscrupulous. Power hungry.* With Cleopatra in the past and Catherine the Great yet to come—and here, with Catherine de Médicis, to whom those words apply in spades—our descriptions may be read defensively. Some may (and will) say: "If they had been men, they would have been 'brave,' 'clever,' 'authoritative.' It's the same thing that goes on with Martha Stewart and Hillary Clinton." We hope not. It is hoped that we painted the megalomania of Genghis Khan and Khufu properly, and that in the pages to come we give Russia's great Catherine her due for achievements and Hitler his just condemnation as a Satan incarnate. It is hoped. Meantime: Catherine de Médicis, to whom, as said, the words *scheming, cunning, crafty, unscrupulous* and *power hungry* apply in spades. She showed these sides of her personality in defense of France and of her family, not necessarily in that order, and both survived a turbulent time because of her. As soon as she died, so did her protective intelligence, and her son Henry III was assassinated within the year. Catherine learned early that she had to fight and scrap for survival. Daughter of Lorenzo II de' Medici and Madeleine de La Tour d'Auvergne, who was related to the royal house of France, she was orphaned when only a few weeks old, then thrust into an arranged marriage at age 13 by the king of France. (Don't ask; the intrigues of this time are impossible to unravel without a detailed scorecard, and we will try to paint Catherine's portrait without the intricacies, which can be readily found elsewhere and investigated at length.) She was ignored, shunted aside and disrespected for years, but she learned how to navigate and to plot, and with her husband's ascension to the throne in 1547, she became queen of France. Henry died in 1559, and for the next 30 years Catherine showed her smarts—and, yes, her wiles—in shaping France's fate and the Western world's. She ordered assassinations when necessary; she was a Renaissance offspring of Machiavelli. Meantime, like her Russian namesake of the future, she supported the arts, boosting the Bibliothèque Royale and commissioning the Tuileries Palace. How to judge her? Like any other woman—or man.

In Tudor England, the wealthy were distinguished by their white skin (laborers became tanned), and Elizabeth used makeup made of white lead and vinegar to stress the point.

Hers was not an auspicious start, and greatness could never have been predicted. But after Elizabeth emerged from the extremely dicey situations that attended her birth and childhood, she raised her nation up, lifting England from a period of debt and religious strife to one of world-beating glory. She was the daughter of the notorious Henry VIII and Anne Boleyn, and when her mother was executed Elizabeth was declared illegitimate—not a good beginning. Parliament overturned the designation in 1544 and reestablished her at the head of the line of succession. Next, she was imprisoned in hopes of rallying discontented Protestants, but then regained her freedom by professing conformity to Catholicism (it's all very complicated, and English Catholics would rue the day they accepted the prejudiced and vacillating Elizabeth).

When she ascended to the throne, England was thoroughly downtrodden, beset by internal problems and distressed by its failures in its wars against the French. She presided over an astonishing period of growth in Britain's cultural and political influence. William Shakespeare, philospher and scientist Francis Bacon and colonist and explorer Sir Walter Raleigh are all hallmark names of the Elizabethan era; so, too, the rise of the British navy and the beginnings of British colonization. Elizabeth reestablished Anglicanism—her father's Church of England—and was tough on the Catholics. She stabilized labor unrest, instituted currency reforms and laws to aid the poor, and boosted agriculture and industry. Seeking peace in Europe, she defeated Spain and held France at bay. Vain and fickle, brave and bold, she set her nation on its path toward greatness.

CATHERINE THE GREAT

1729–1796

She knew what she wanted and she made sure that she got it, often beating long odds. Once she had power, she held it until her death, also against the odds. Meantime she made Russia larger and mightier than ever, unbalancing the scales in Europe. An instant irony is that she was hardly Russian, maybe a twig or two of Russian on the bottommost branches of her family tree. Catherine II, empress of Russia, was born Sophia Augusta Frederica in what is now Poland to a Prussian general and his ambitious wife, who from the first had designs for her daughter's Greatness. Young Sophia hardly needed coaxing. She would write years later in her memoirs that as soon as she arrived in Russia as a teenage girl she had it in mind to one day wear the crown of empress, which meant setting her sights on young Peter von Holstein-Gottorp, a czar apparent. She was feverish to learn the Russian language and announced she would convert to Eastern Orthodoxy, a decision that infuriated her father. The day after she joined the Russian Orthodox Church in 1744, receiving the name Catherine, she became engaged to Peter, and they wed one year later after the bride had turned 16. Her husband became Czar Peter III in 1762, then was deposed in a coup d'etat barely six months later while he was away and she was in residence at the Winter Palace in St. Petersburg. Catherine was a woman of many parts: She was strategic in her actions, intelligent, sociable, promiscuous, ruthless. She had known Peter's political opponents before the overthrow and did not demure when it was proposed she rule Russia. There is no evidence that she was a party to the assassination plot that took her husband's life shortly after the coup. But with Catherine, who knows? During her long, 34-year reign, she expanded Russian territory by war (often at the expense of the Ottoman Empire) and diplomacy; was the nation's greatest-ever patron of the arts, starting the Hermitage Museum with her personal collection; raised the country's profile as a sophisticated society with her cultured friends, such as Voltaire and Diderot, elsewhere on the Continent; sponsored programs to greatly improve education—and meantime put down domestic rebellion, which did occasionally raise its head, with a ruthless vengeance.

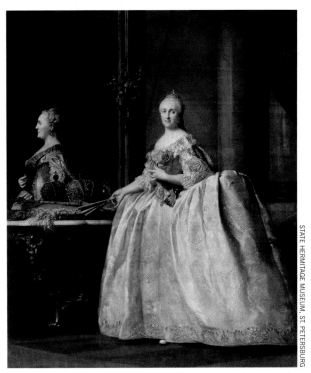

The portrait of Catherine in front of a mirror hangs today in the State Hermitage Museum in St. Petersburg (below), which she was instrumental in founding.

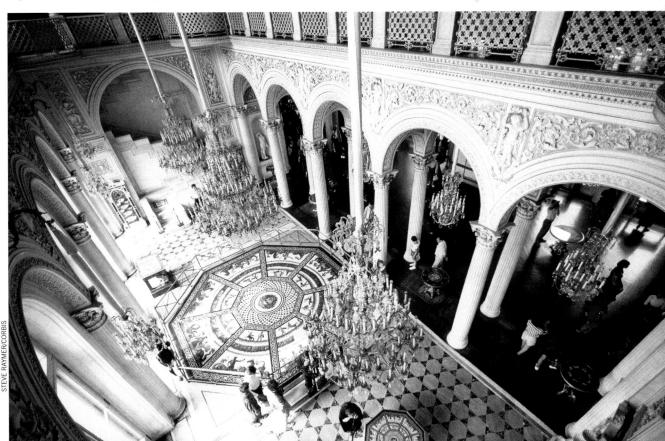

GEORGE WASHINGTON

1732–1799

He was an example of a man who could change the course of world events through the exercise of his strong moral character, not by the political manipulations of power or at the point of a gun, though he was a famous player in politics as well as war. Washington both commanded and influenced other men, and thereby wrote history. It has been said that he was the indispensable man of the American Revolution, and that is apt. Might Franklin have elucidated our principles without Jefferson, or vice versa? We can't be sure, so the answer is: perhaps. Could the colonials in Massachusetts have prevailed on the course they set for themselves without General Washington? Doubtful. Could a democracy have been born without a leader who so embodied democratic principles? Impossible. A planter's son from Virginia, Washington listed toward the military early and was a most impressive, strong soldier. "I have a constitution," he explained after his successes in the French and Indian War, "hardy enough to . . . undergo the most sever [sic] trials. [And] by the all-powerful dispensations of Providence, I have been protected . . . I had four bullets through my coat, and two horses shot out under me, yet escaped unhurt, altho' death was levelling my companions on every side of me!" It is a mistake to think of Washington as a general only and not a man of philosophy. "The crisis is arrived when we must assert our rights," he said on the eve of revolution. He led his men against the British with nobility and uncommon courage, as well as occasional brilliance. And then he demurred, refusing to seize power in the nascent nation but instead resigning his military commission. King George III of England marveled that Washington sought no recompense in terms of money or power for what he had done: "If true, then he is the greatest man in the world." He may have been; he was certainly a different kind of man. America instantly turned its eyes to its singular hero and made him, unanimously, its first President. No one else could represent—no one else embodied—what the nation hoped to become.

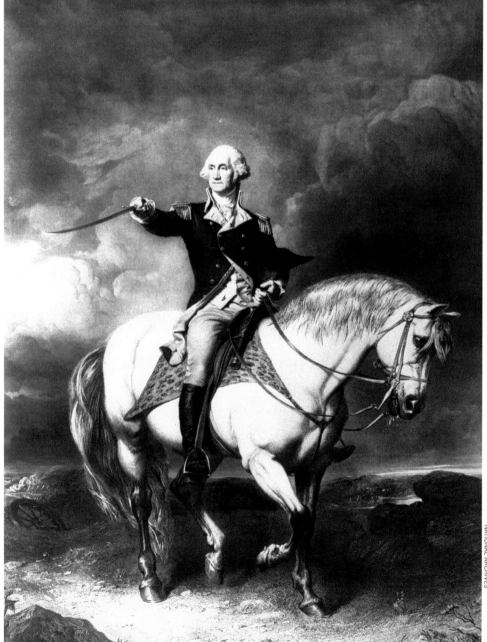

The general, a large man (six foot three and a half) who cut a fine figure on a horse, was regarded as one of the best equestrians in the land.

NAPOLEON BONAPARTE
1769–1821

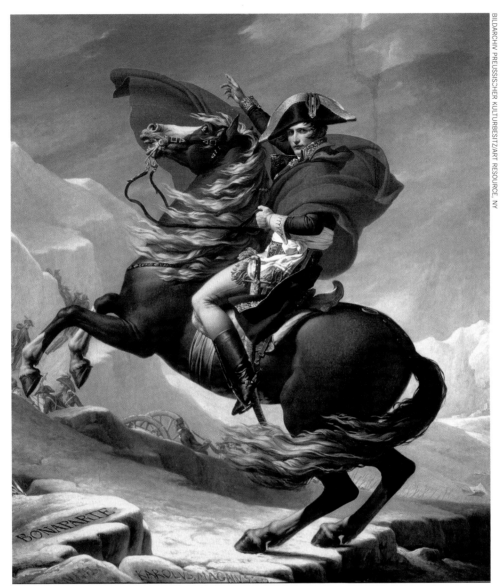

The emperor, a man of modest proportions (a shade taller than five foot six), was depicted heroically crossing the Alps by his friend, the artist Jacques-Louis David.

I in a period when warfare had become more sophisticated, making it even harder to "conquer the world," he was an Alexander the Great or a Genghis Khan many centuries after those men. Like them, his principal genius lay in his military acumen and ability to inspire his troops, but his effective governance of France once he had himself declared emperor made him wildly popular with his countrymen—for a time. Educated at military schools, his talents were on display early, and he made the rank of brigadier general before he turned 25. For the Italian campaign of 1796–1797, he was handed a starving, demoralized army, which he turned into a dynamic fighting machine. He went on a winning streak in the field not dissimilar to Alexander's, meantime consolidating his power as head of the French government. He was energetic in fighting inflation, making peace with the Catholic Church and forging a new legal code. He was elected counsel for life in 1802, proclaimed emperor in 1804 and crowned King of Italy in 1805. His allied opposition in Europe, the Third Coalition, included England, Austria, Portugal,

Russia, Sweden and Prussia, but between 1803 and 1806 he had forced all but England to bow to him and bestrode the Continent as a titan, installing siblings and in-laws as heads of state in such countries as Holland and Spain. By decade's end, however, weaknesses in his empire were becoming apparent, and enemies who had been subdued were rising again. In 1812 Napoleon's Grande Armée, 600,000 soldiers strong, attacked Russia but was forced into a retreat that ended in a rout. A new coalition of England, Russia, Prussia, Sweden, Spain, Portugal and Austria pursued Napoleon into France in 1814, and he abdicated his throne that year for the first time. He was exiled to Elba, off the coast of Italy, but returned to France with 1,100 followers on March 1, 1815, and soon was leading the country again after the people forced Louis XVIII to flee. This reign was brief and ended disastrously with the Waterloo campaign, which led to a second abdication and a second and final exile, this time to the remote South Atlantic island of St. Helena, where the legendary man died of cancer.

ABRAHAM
LINCOLN
1809–1865

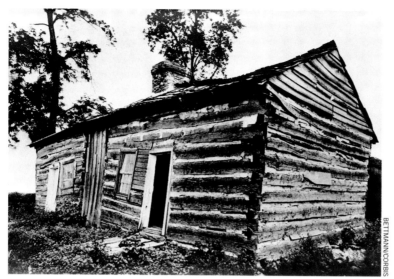

BETTMANN/CORBIS

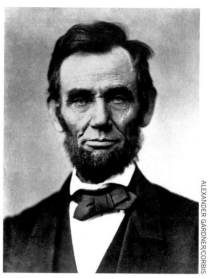

ALEXANDER GARDNER/CORBIS

George Washington had the strength of character to allow the United States to step forward as a democracy in the 1780s. Within 80 years, the fate of that nation was imperiled by civil war. What might have ultimately happened in the 20th century—a German victory in World War I? or if not that, a triumphant Hitler in World War II?—had the United States not been present and accounted for is speculative. But that the U.S. was in fact able to play a role, and a vital one, is due to its emergence from the horrible conflict of 1861 through 1865 intact. That it did emerge is attributable to many people and many facts but to one man above all: Abraham Lincoln. He was born in a log cabin—true—in Hardin County, Kentucky, and grew up on the frontier; he was largely self-taught. His family relocated eventually to Illinois, and while still a teenager he entered into the legal

profession. Lincoln was a skilled politician and was first elected to the U.S. House of Representatives in 1846. Twelve years later he ran for the Senate against Stephen A. Douglas, and debates between the two elevated both men, but particularly Lincoln. He was elected President in 1860. During the war, he was an extremely proactive commander in chief; it has been said that his complete control over all matters after the hostilities broke out practically amounted to a dictatorship. Members of his strong-willed and smart cabinet were often at odds with one another and with him; and his generals, too, chafed at his orders. During the war he was bold enough to sign the Homestead Act and issue the Emancipation Proclamation, and he delivered the lofty Gettysburg Address. Soon after the war, he was assassinated for all that he represented. But Abraham Lincoln had preserved America.

The Kentucky cabin above was once thought to have been the one in which Lincoln was born and is still today part of the Abraham Lincoln Birthplace National Historic Site. The portrait of the President dates from 1863. On November 19 of that year, the crowd engulfs Lincoln (to the left of the dominant figure in the center with the top hat) as he arrives at Gettysburg where he will deliver his address. Opposite: Conferring with the disputatious General George B. McClellan in Antietam, Maryland.

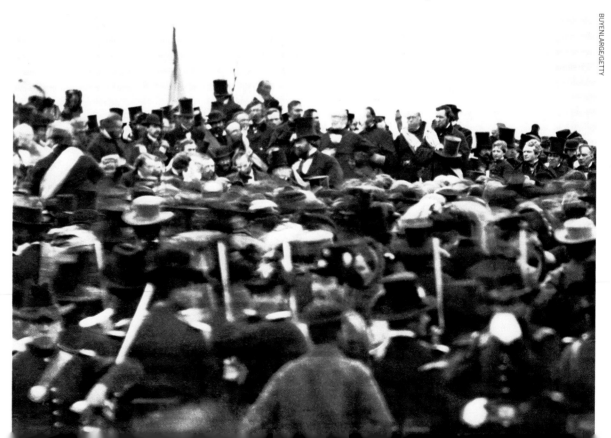

BUYENLARGE/GETTY

38

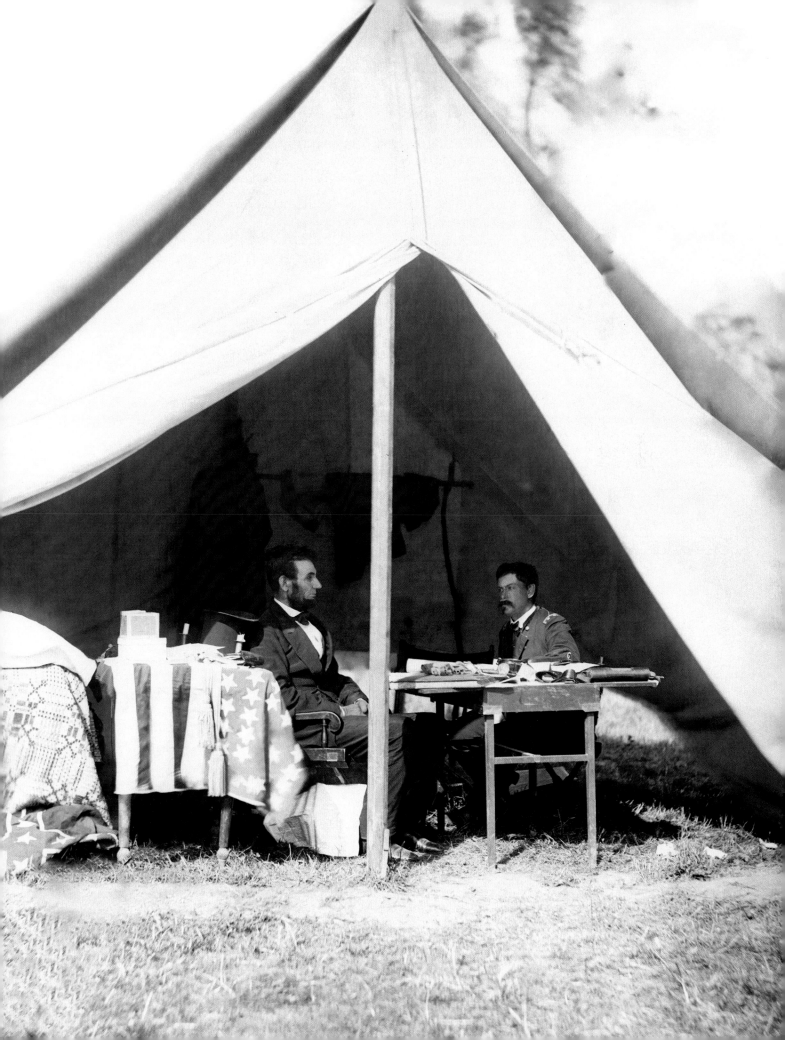

QUEEN VICTORIA
1819–1901

The Roman Empire doubtless controlled a larger percentage of the known world in its time and the Mongols ruled over more acreage, but never has one country realized so great a spread over the globe as did Great Britain during the long reign of Victoria in the 19th century. She is regarded historically as having been politically neutral in an age when England's vying parties produced extraordinarily forceful leaders (Benjamin Disraeli, William Gladstone) and having remained a stern, one-dimensional moralist in a time when her country produced cutting-edge writers and thinkers (Robert Browning; Charles Darwin; Charles Dickens; Rudyard Kipling; Alfred, Lord Tennyson; John Stuart Mill; Robert Louis Stevenson). Nevertheless, there she was on the throne in this remarkable period, helping to steer the whole earth-shattering enterprise. She became queen at the age of 18 and married her cousin Prince Albert of Saxe-Coburg and Gotha not long thereafter. She loved him deeply, and he would prove invaluable to her. Albert and Victoria had nine children before his premature death, and the marriages of those offspring would lead to British alliances with Russia, Germany, Greece, Denmark and Romania. Meantime, there were the wars—the Crimean, the Boer Wars in South Africa—and conquests in the Far East. Victoria added the title Empress of India to Queen of England. The Victorian

Age, as the period extending until and even a bit beyond the queen's death in 1901 is called, was marked by a nationalistic confidence in the country's might, fueled by the industrial revolution and a sense of righteousness, even as the British Empire sometimes behaved in a beastly fashion toward its many colonies. Victoria rubber-stamped decisions concerning the issues she needed to deal with, and if she left the messier aspects of empire-building to her ministers, she nonetheless was the face of her epoch.

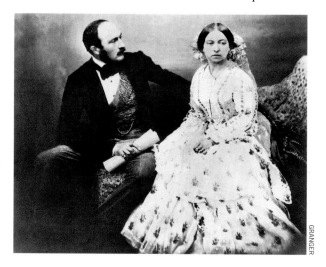

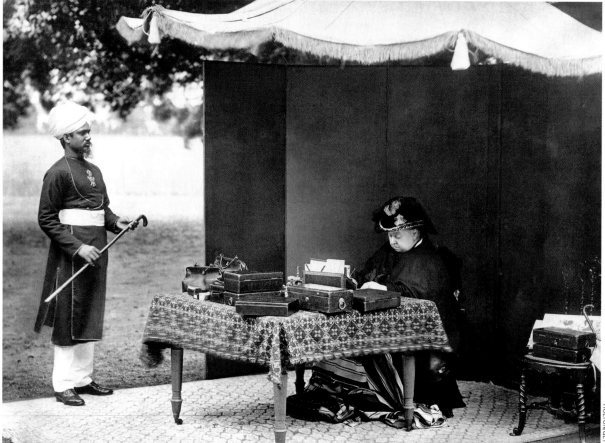

Top: Victoria and Albert are pictured in 1854. After the Prince Consort died in 1861, Victoria wore black mourning clothes the rest of her life, as evidenced in the photograph above from 1893, in which the Empress of India writes letters while her servant attends with her walking stick.

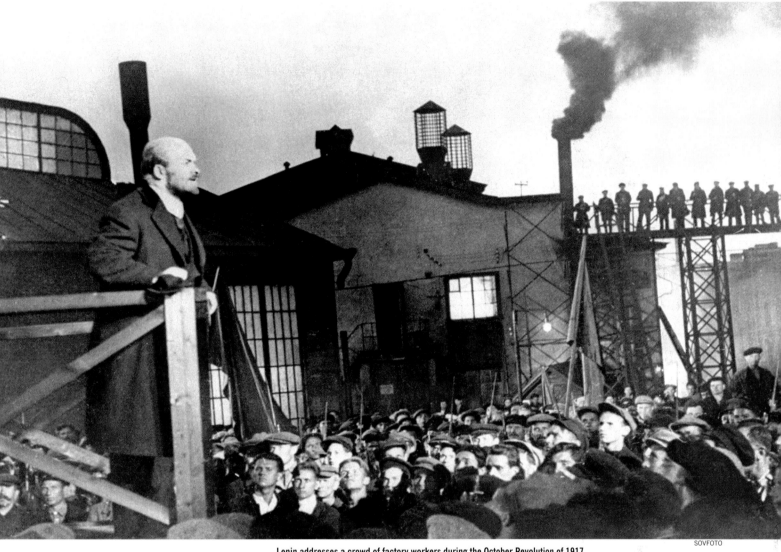

Lenin addresses a crowd of factory workers during the October Revolution of 1917.

VLADIMIR ILYICH LENIN
1870–1924

Someone needs to be credited in these pages with introducing Karl Marx's communist philosophy to the real world—in whatever shape or form or approximation Marx's ideas took—because the doctrine in its permutations became so very widespread in the 20th century and continues to exert a vast influence today. That someone is Vladimir Ilyich Ulyanov—or, rather, the man who is historically legendary under the cognomen Lenin. The son of a school official, he was smart and philosophically engaged, eventually forsaking a legal career to devote himself to the study of Marxism and, then, to revolutionary activities in czarist Russia. He was twice exiled to Siberia and left his homeland in 1900. Working from London in 1903, he effected a split in the Russian Social Democratic Labor party into the Bolshevik and Menshevik movements. He returned to Russia and from 1905 to 1907 worked with the Bolsheviks; then, during World War I, operating in Switzerland, he denounced imperialism as the end stage of capitalism and urged his followers in the proletariat to oppose what he saw as an imperialist war—propagating a worldwide battle against capitalism everywhere. The uprising came back home in the form of the Russian Revolution in 1917, and the Germans, rightly assuming that Lenin's presence in Russia would prove disruptive to that country's efforts in World War I, assisted in the revolutionary's return. Lenin was on the winning side of the civil war of 1918–1921, and when the Union of Soviet Socialist Republics was founded in 1922, this leader of the Communist party reigned as a virtual dictator. Leninism (as a practical philosophy separate from Marxism) was anti-imperialist, thoroughly atheistic, opportunistic and dedicated to the principle that a strong Communist party was needed to lead the proletariat. As for Lenin himself, he ruled unquestioned until his death, then was succeeded by the despotic Josef Stalin—as the USSR drifted ever further from the tenets laid down in Marx and Engels's *Manifesto,* which we will learn more about on page 93.

WINSTON CHURCHILL
1874–1965

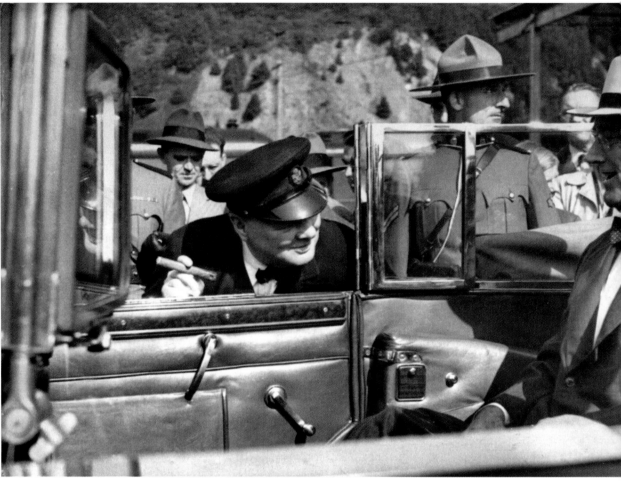

The critical alliance: Churchill has reason to smile as he has convinced Roosevelt that the Axis must be stopped.

Speaking to the British Parliament in June 1940, Prime Minister Winston Churchill said, "I have, myself, full confidence that if all do their duty, if nothing is neglected . . . we shall prove ourselves once again able to defend our island home, to ride out the storm of war, and to outlive the menace of tyranny, if necessary for years, if necessary alone." Whether he did have that full confidence or whether England could have ridden out the storm of World War II alone will never be known for certain. What is known is that no other figure on the world stage stood up so steadfastly against Hitler and so inspired the Allies to fight back, to fight on, to fight until the fighting was finished. Churchill had served in the British army as a cavalry officer in the late 1800s; captured by Boers in South Africa in 1899, he escaped and was lionized. He entered Parliament in 1901 at age 26 and served as First Lord of the Admiralty from 1911 to 1915 (until forced out after the failure of the Dardanelles campaign during World War I), then again in 1939 and '40. He was a fierce foe of fascism and, as an opponent of the appeasement of Hitler, was chosen to replace Prime Minister Neville Chamberlain seven months after Great Britain entered World War II. He became a flesh-and-blood symbol of Britain's—and freedom's—resistance to tyranny. He may have expressed to Parliament a surety that England could go it alone, but he perhaps most changed world history by accepting the communist Soviet Union as an ally and by courting U.S. President Franklin D. Roosevelt and lobbying for him to enter the fray. He addressed the U.S. Congress, and in 1941 met FDR at sea and forged the Atlantic Charter, which stressed the unity of the two nations. Initially, material support flowed Britain's way, and then on December 7, 1941, Japan, Hitler's Axis partner, attacked the American Pacific fleet at Pearl Harbor. Churchill knew what this meant, and said to himself, "So we had won after all." That would take more time, but would prove to be the case.

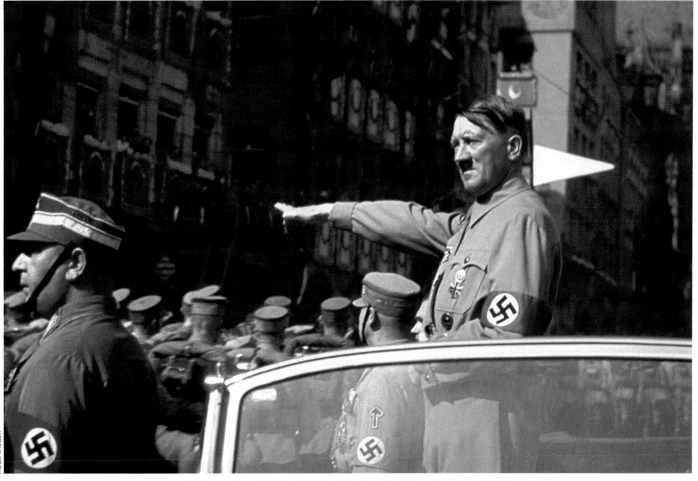

The German chancellor gives the Nazi salute as he arrives for a party congress in 1938.

ADOLF HITLER 1889–1945

He is viewed by many as the personification of evil. The personalities of some of history's previous megalomaniacal dictators—Genghis Khan, even Napoleon Bonaparte—are difficult to know with precision, but Hitler was right there, before our modern eyes, a madman hell-bent on dominating the world, subjugating or annihilating any who would oppose him. The son of a failed Austrian farmer, he was a dispruptive student. He moved to Vienna as a teen, where he was twice refused admission to art school and lived for a time in abject poverty, his resentment festering into a violent anti-Semitism. He was decorated for his service in the Bavarian army during World War I, and after the war he and his confederates formed the National Socialist German Workers Party in Munich and tried to take over Bavaria in the "beer-hall putsch" of 1923. They were quashed and Hitler spent nine months in jail, during which time he wrote *Mein Kampf* ("My Battle"), which would spread his myth and philosophy and become the Nazi bible. Exploiting German poverty, blaming all ills on Jewish capitalism and the harsh terms of the Treaty of Versailles that concluded World War I, and promising an epoch of Aryan greatness, Hitler and his Nazi Party rose quickly in the late 1920s and early '30s. In 1934, 88 percent of the populace voted to consolidate the presidency and chancellorship into one office, that of *Führer,* or "leader." Anti-Semitism became law; concentration camps were built to deal with enemies of the Third Reich. And then came conquest: Nazism rolled over Europe until only England and Russia stood between Hitler and Continental domination. Late in 1941, just before Germany's Axis partner, Japan, bombed Pearl Harbor and drew the United States into the war, Hitler personally took control of the Russian front, with disastrous results. Seeing the tide turning, a group of high Nazi officials tried unsuccessfully to assassinate him. The end to his tyranny came by his own hand when, on April 30, 1945, with the Red Army closing in, he committed suicide in his Berlin bunker.

MAO ZEDONG 1893–1976

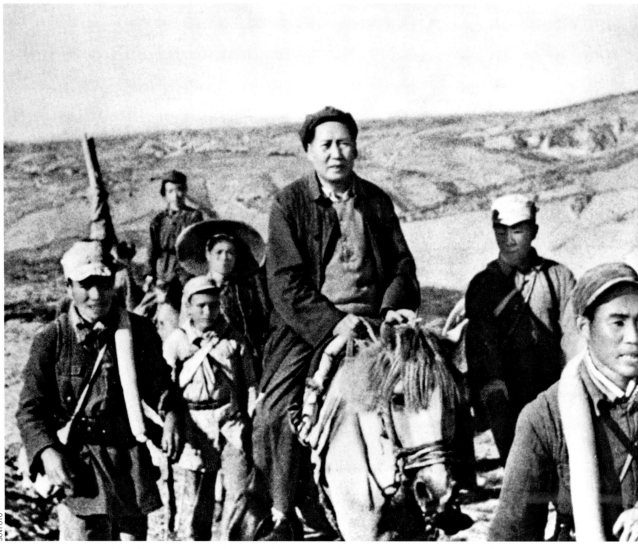

SOVFOTO

During the long Chinese civil war, Mao is seen on horseback leading his fellow communists in northern Shaanxi province.

The China that Mao came to rule when the Communists defeated the Nationalists led by Chiang Kai-shek in 1949 was an enormous country, by far the world's largest and most populous, that had suffered depredation and stagnation under the imperial rule of the Qing dynasty, in power since the 1600s. The collapse of the dynasty was followed by nearly four decades of socially debilitating civil war after the rebels who overthrew the emperor were unable to cement their hold on the nation. Mao, 18 years of age when the dynasty ended and China became a titular republic, wondered about what would be best for the country going forward. He observed what had happened with the Russian Revolution and with Lenin, and finally declared himself a Marxist. In 1921 he was one of the 53 founding fathers of the Communist party of China. It was good for these men that China's period of civil strife in the first half of the 20th century was prolonged, for they were not powerful at first and had to build their base and marshal their forces slowly, working the vast countryside. Mao, his Long March over, assumed the party's leadership in 1935 and was at its head when the Communists challenged the Nationalists beginning in 1947. His side won and, as said, inherited a long-suffering, woefully poor and underdeveloped country. Mao put in place reforms and changed the economic system from capitalist to socialist. China did modernize, if at a slower pace than Western nations in the 20th century. But as with Stalin in the USSR, his harsh dictatorial rule and his power-solidifying purges are a more famous hallmark of his reign, which claimed the lives of as many as 30 million of his compatriots. Mao changed China, but the way in which he most prominently changed the world may be an entirely surprising, late-in-life bit of diplomacy—when he and U.S. President Richard Nixon talked, dined and toasted in 1972. In allowing China to be "opened" to the West, Mao rang a bell that could not easily be unrung. His successor Deng Xiaoping, though Mao's equal in repressing dissent (see Tiananmen Square), continued pushing China back into the wider world and toward capitalism. Today, it is an economic giant and one of the very biggest players on the geopolitical stage of the 21st century.

NELSON MANDELA BORN 1918

He stands today as the father of his country as much as George Washington stands as the father of ours—he was South Africa's first true president. Rolihlahla Mandela was born in a rural, thoroughly black part of the country in 1918. He herded cattle and appeared destined for the life of meager subsistence that was usual for his people. At the missionary University of Fort Hare, however, Mandela showed a different side of himself, becoming involved in student protests aimed at the white colonial administration of the school. He apprenticed at a law firm in Johannesburg and chafed at the oppressions of apartheid—the segregated way of life in South Africa that kept the imperial whites in power and the native blacks all but slaves. He felt he had to do something, and his first choice was to join the nonviolent Youth League of the African National Congress (ANC); among his acts of passive resistance, he burned his passbook—identity papers that black South Africans were forced to carry. The government was cracking down and in 1960 massacred scores of black demonstrators at Sharpeville, and the ANC, among other groups, was outlawed. Mandela was jailed, and the details of his imprisonment on Robben Island and elsewhere, which lasted nearly unbroken from 1962 to 1990, are not as important as what he once declared when hauled before the court: "During my lifetime I have dedicated myself to the struggle of the African people. I have fought against white domination, and I have fought against black domination. I have cherished the ideals of a democratic and free society in which all persons live in harmony and with equal opportunities. It is an ideal which I hope to live for and to achieve. But, if needs be, it is an ideal for which I am prepared to die." He would not die,

of course, as over the decades widespread support grew for the world's most famous prisoner and for an end to ethically indefensible apartheid. In 1990, Mandela was released by President F.W. de Klerk; in 1991 he became leader of his old party, the ANC; in 1993 he shared the Nobel Peace Prize with de Klerk; and in 1994 he succeeded de Klerk as South Africa's first democratically elected president. Apartheid was dismantled. His may be the greatest story of individual resistance ever told.

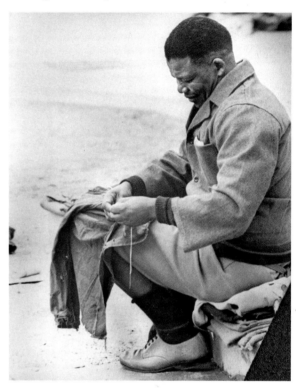

Left: In 1952, Mandela, at center, confers with his colleagues in the African National Congress. The party was eventually banned in South Africa and Mandela imprisoned. Above: In 1964 he is at work sewing prison clothes.

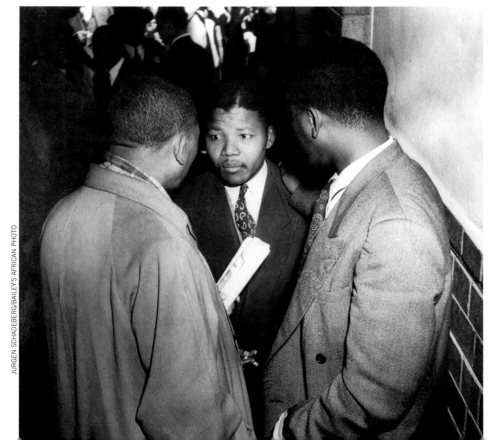

JURGEN SCHADEBERG/BAILEY'S AFRICAN PHOTO

LEADERS, ELECTED & NOT 45

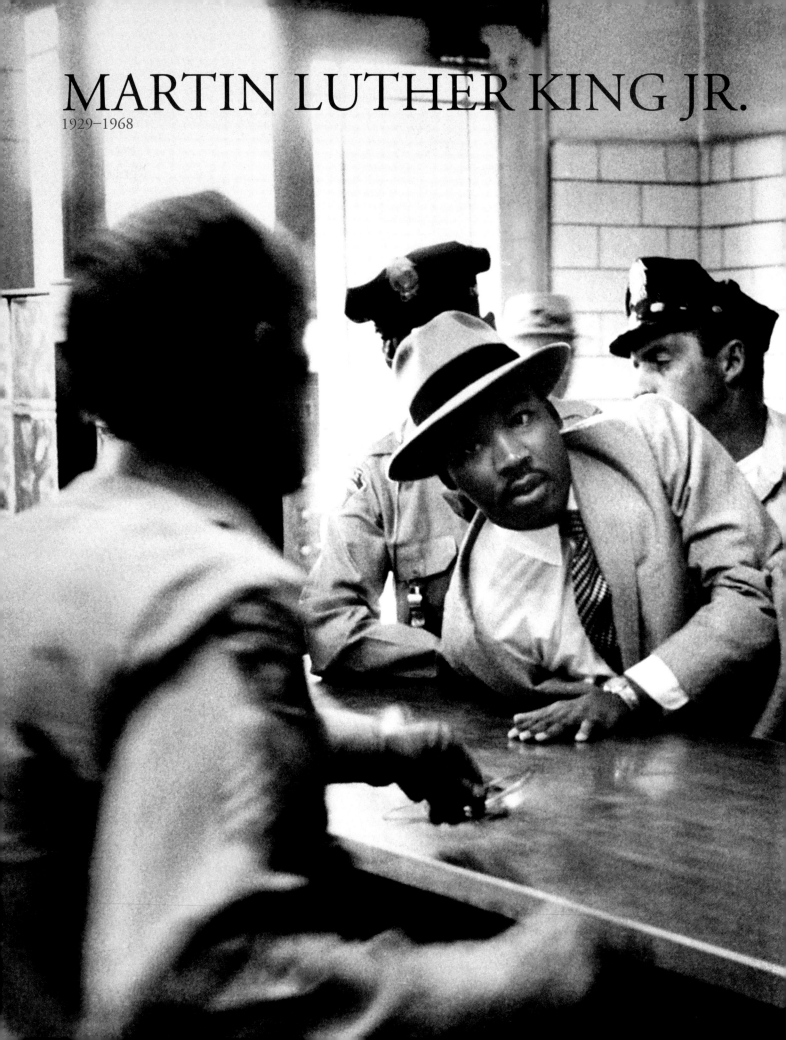

MARTIN LUTHER KING JR.
1929–1968

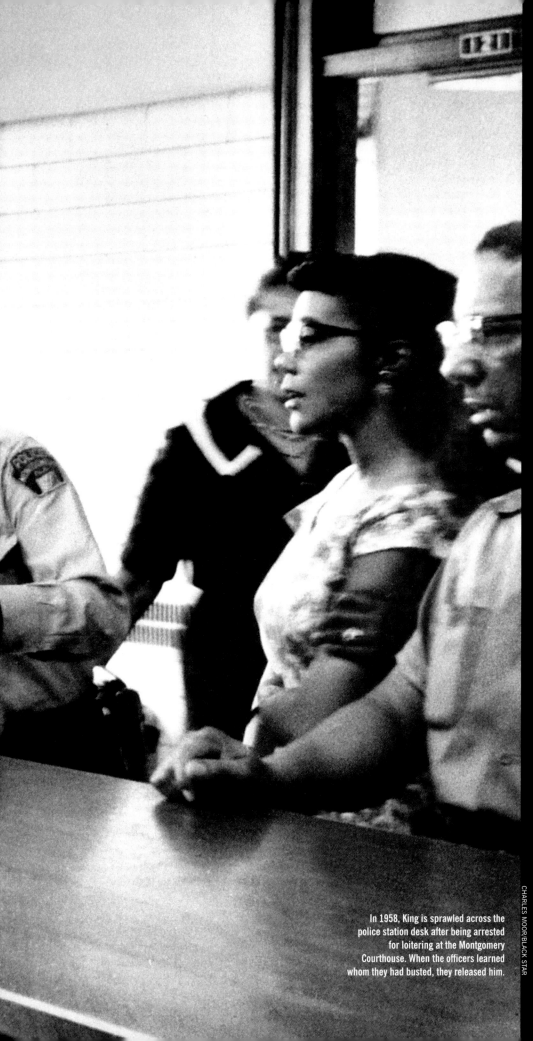

In 1958, King is sprawled across the police station desk after being arrested for loitering at the Montgomery Courthouse. When the officers learned whom they had busted, they released him.

Civil rights in the United States was an issue that had hardly been settled by Abraham Lincoln's Emancipation Proclamation or by the Supreme Court–ordered desegregation of schools in 1954. Inequality was everywhere apparent and racism rampant in many sectors of society when a young preacher from Atlanta, the latest in a family line of ministers, joined—in fact, helped launch—"the movement." In 1955 he assumed leadership of the (eventually successful) Montgomery, Alabama, bus boycott that was organized in response to the treatment of Rosa Parks, and in 1957 he founded the Southern Christian Leadership Conference, which advocated a nonviolent struggle for justice. He was one of the greatest orators in American history and could stir the masses with his biblical cadences. In march after march he led them: in Birmingham, Montgomery, Selma, Washington, D.C.—where he declared his dream "that my four little children one day live in a nation where they will not be judged by the color of their skin but by the content of their character." Because of his tactics and persona, he was not seen as "radical" like others who were fighting for equality in this era, and he was listened to by many who turned a deaf ear to the Black Panthers, certainly, and to Malcolm X. When his followers kept their dignity and poise as they were being assaulted by dogs and fire hoses, and all Americans saw this on the nightly news, public opinion turned. King, along with President Lyndon Baines Johnson, is the man most responsible for the Civil Rights Act of 1964 and the Voting Rights Act of 1965, and those acts are the ones most responsible for the stature of all minorities in the United States today. There is still prejudice and inequality, to be sure. But the Reverend Martin Luther King Jr. effected tangible change before he was assassinated in Memphis in 1968—his work not yet done, but well and truly started.

MIKHAIL
GORBACHEV

BORN 1931

President Ronald Reagan—who actually quite liked his Soviet counterpart and met with him at four separate summits, one of which produced an arms limitation treaty—demanded in Berlin on June 12, 1987, "Mr. Gorbachev, tear down this wall!" But few if any assumed that the general secretary of the Communist party of the Soviet Union would do so. That the wall was in fact torn down, beginning in late 1989, and that the Soviet Union was dismantled two years later was the work of many—among them Reagan, Britain's Prime Minister Margaret Thatcher, Pope John Paul II and, as we will learn on the following page, insurrectionists like Lech Walesa—but it was principally the work of Mikhail Gorbachev, an entirely unexpected progressive in a political culture that had been set against progressivism since the October Revolution (interestingly, Gorbachev was the first and only Soviet head of state to be born after that 1917 uprising). The son of peasants, he worked on collective farms before going to college, at which point he joined the Communist party. His political star rose quickly throughout the 1970s and by decade's end he was a member of the Politburo; after general secretaries Brezhnev, Andropov and Chernenko died in quick succession, he was elected to the top job in 1985. Citing a stagnant economy and other societal ills, he promised reform. He replaced Foreign Affairs Minister Andrei Gromyko, a 28-year veteran; he launched a war on alcoholism; he said the state would crack down on inferior manufacturing. Then came *perestroika* (in 1986) and *glasnost* (in 1988); the former encouraged creativity and self-criticism in society, the latter allowed certain liberties, including greater freedom of speech. Crucially, he abandoned the Brezhnev Doctrine and said the Eastern bloc nations could choose their own paths free of Soviet influence. *Wow.* Before you knew it, the bloc collapsed, and then so did the USSR. In 1990, Gorbachev was awarded the Nobel Peace Prize for his troubles. None other than Richard M. Nixon, a man who could well understand the pressures and temptations of high office, put it succinctly when he suggested Gorbachev as Man of the Century: "He has decided that he would risk his power in order to save his reforms, rather than risk his reforms to save his power."

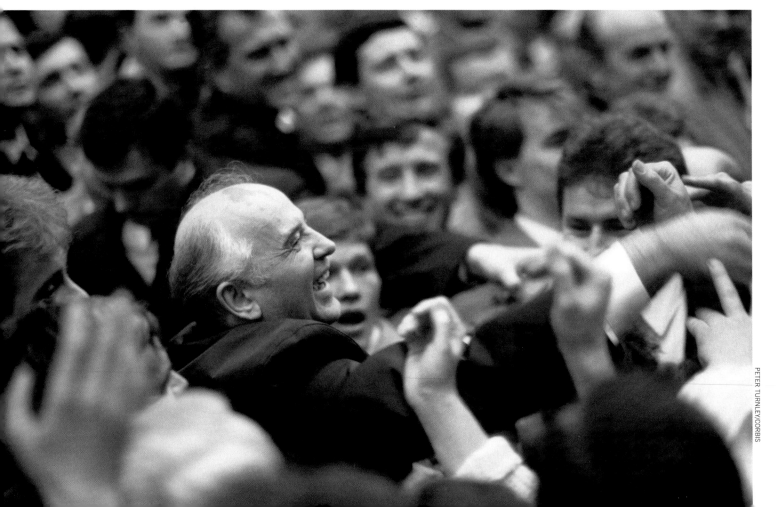

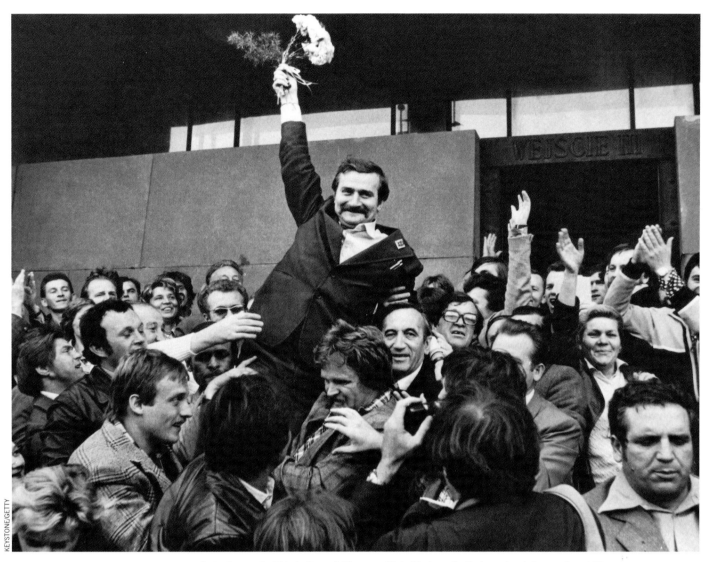

KEYSTONE/GETTY

Gorbachev was the historically crucial figure—a Mr. Inside, loosening the iron grip—but among the outsiders, none was more important in spurring the demise of the Soviet bloc than Walesa. Here, in Warsaw, in 1980.

LECH WALESA
BORN 1943

Sometimes, all that is needed is a spark. And sometimes, a spark takes human form. Such a spark was Lech Walesa. His father was a carpenter in Popowo, Poland, and the family was poor. Young Lech attended vocational school and went to work at the Lenin Shipyard in Gdansk in 1967 as an electrical technician. There were workers' protests during the period, and Walesa, appalled by the repression that was being visited upon them, fell in with opposition cells. He was canned from his job but was still in Gdansk in August 1980 when he climbed over a perimeter wall at the shipyard to join an occupation strike. Walesa was 36 years old and at the height of his energy and charisma when he was chosen to lead the protesters. He encouraged his fellows to seek more than just better wages, to fight for free trade unions. Government authorities acceded—an almost unthinkable outcome, utterly without precedent in the communist world—and suddenly there was a vigorous new union, Solidarity, with Walesa at its head. The union had 10 million members overnight. There was no question that the Polish pope,

John Paul II, was advocating for Walesa's success and communism's fall in his homeland; his first papal visit in 1979 had buoyed the nation's spirit and had, in fact, contributed to the exciting birth of Solidarity. Everything was in motion now, everything was in play, and—too late—the authorities saw it. Martial law was declared, Walesa was jailed, but 11 months later he was out and again leading Solidarity, which could not be crushed. He won the Nobel Peace Prize in 1983, which served to make him more bulletproof. His global allies Ronald Reagan, Margaret Thatcher and John Paul II were soon presented with a new Soviet leader to talk to, Mikhail Gorbachev, and they learned that they could. In 1988 there was a second occupation of the Lenin Shipyard, Walesa again present, and at the first Round Table of 1989 the Polish government agreed to semifree elections. Solidarity won. Communism crumbled in Poland, then throughout the Eastern Bloc, and finally the USSR came tumbling down. The strong little man with the mustache played a big role.

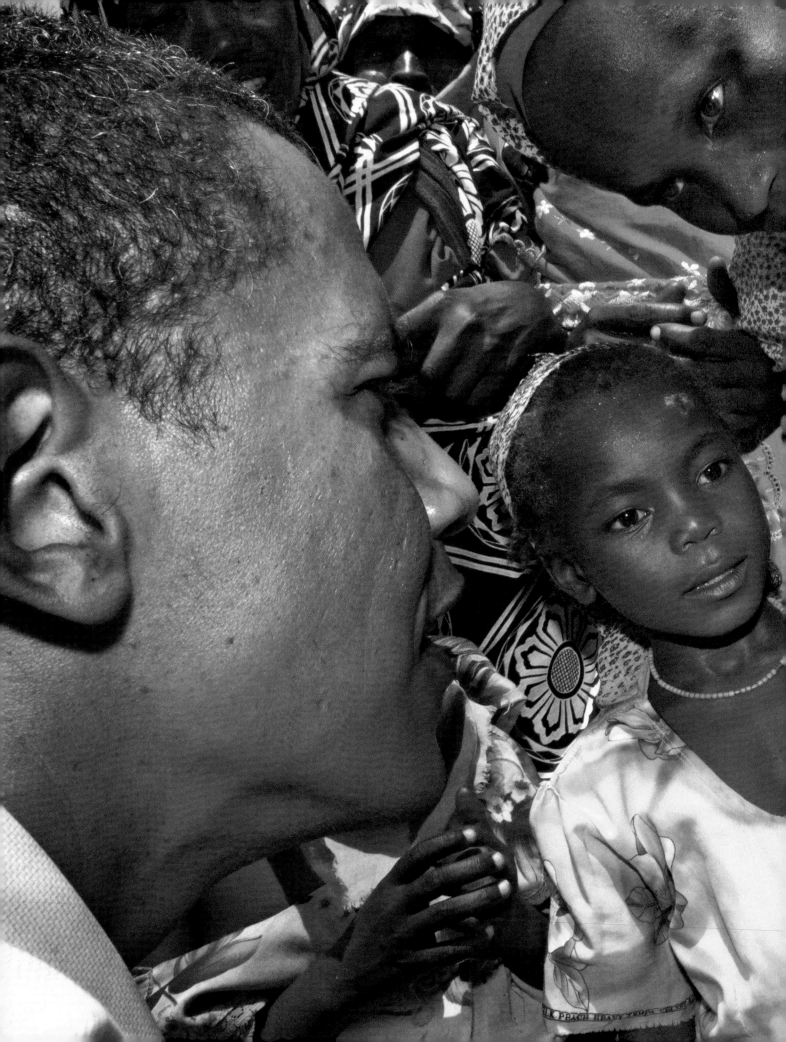

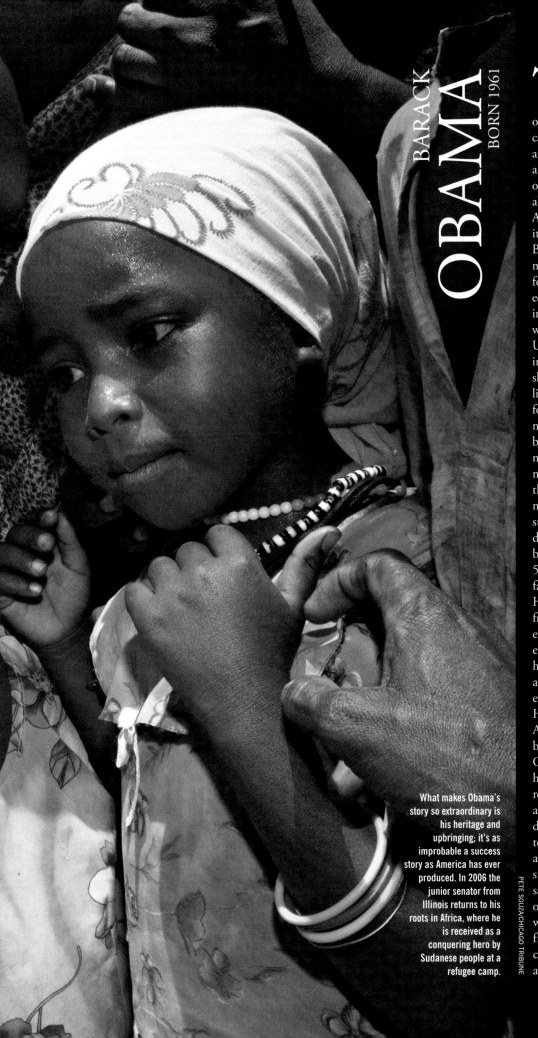

BARACK OBAMA

BORN 1961

What makes Obama's story so extraordinary is his heritage and upbringing; it's as improbable a success story as America has ever produced. In 2006 the junior senator from Illinois returns to his roots in Africa, where he is received as a conquering hero by Sudanese people at a refugee camp.

This is not about issues: It isn't about health care or the economy or the prosecution of the war in Afghanistan. Americans can disagree on any number of issues, and should; disagreement and debate are intrinsic in our founding, democratic principles. And this isn't really about "the nation's first African American President," either, although it is about that in part. It is about Barack Obama's life story, and the message it has sent. When the founders set down their notions of equality, they never could have imagined Obama—certainly not as a man who might rise to high office in the United States. Some of them, including Washington and Jefferson, were slave owners, and their promises of liberty did not extend to blacks (nor, for that matter, to women, who were not given the vote). This isn't to belittle those who formed our nation, for they were living in a much different time, and moreover they were sufficiently progressive minded to write rules under which such as Barack Obama might one day rise. He was the product of a biracial, broken home in our nation's 50th state; his father deserted the family when the boy wasn't yet one. He was raised by his mother (partly from 1967 to '71, in Indonesia) and equally, by his maternal grandparents. He has written that he might have strayed from the path when an adolescent, but he found his way and eventually was elected to lead Harvard's *Law Review*, the first black American to hold that office. Yes, he became a community organizer in Chicago—and why this item on his résumé is derided by his critics remains a mystery. He was ambitious and audacious, and the audacity he displayed in running for President led to a history-making election. There are many other African American stories that might have led to the same conclusion yet would not, in our estimation, have "changed the world." But this one did. It reaffirmed for millions that, in this country and maybe elsewhere, too, anything is possible.

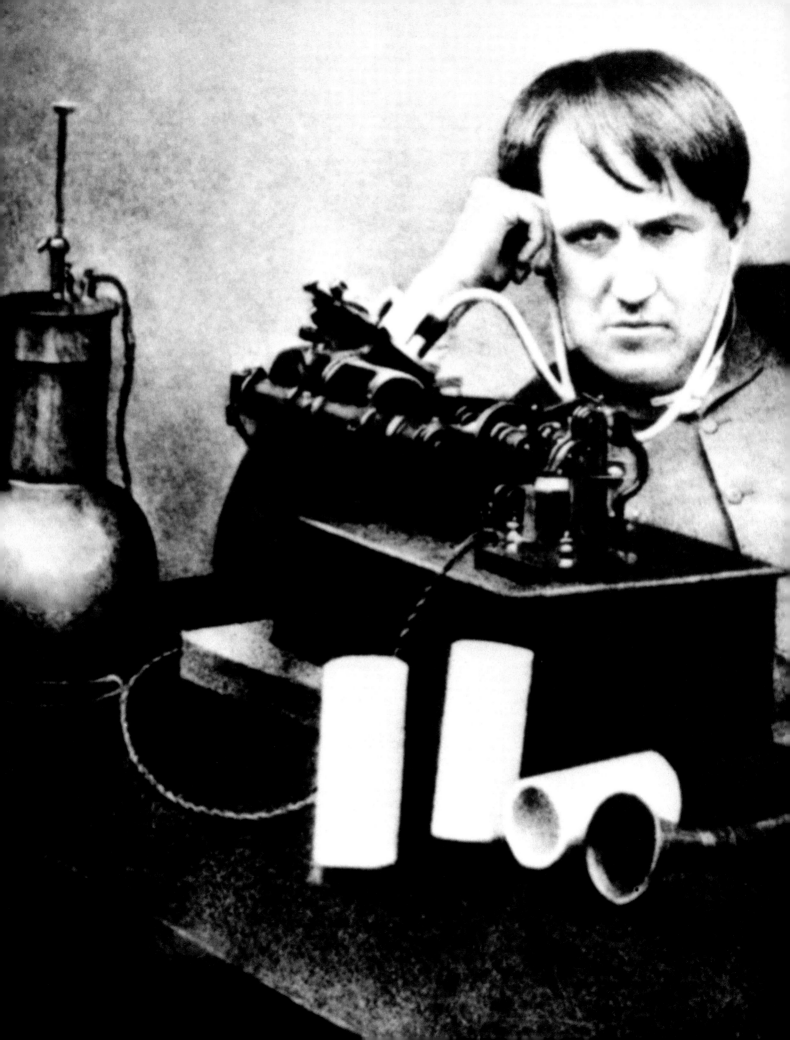

SCIENTISTS, INVENTORS & INNOVATORS

Thomas Edison, the most prolific and most
practical of inventors, poses with his
phonograph in 1888. (Please see page 66.)

JOHANN GUTENBERG

CIRCA 1398–1468

At left is a page from Gutenberg's famous *42-line Bible*, printed in Mainz sometime between 1453 and 1456. Below: The printer inspects a sheet while his backer, Fust, consults with an apprentice.

GRANGER (2)

This entry celebrates the German printer, but it celebrates many other craftsmen, too. It celebrates the man who refined paper in China more than a dozen centuries earlier, Cai Lun. It celebrates the thousands of Asian artisans who used this invention in block printing, a method of reproducing a written work with woodcuts and ink. It celebrates Bi Sheng, who invented movable type in the 11th century (though its utility never took hold in China for various reasons having to do with materials and methods of production). And it perhaps celebrates Laurens Janszoon Coster or Panfilo Castaldi, two other Europeans who are sometimes credited as having beaten Johann Gutenberg to the crucial innovation with which he is associated: printing multiple copies of a text from movable metal type. What these three men and others clearly saw by the mid 15th century was that printing's potential power lay in mass production—block printing was even less practical than handwriting, since it was time consuming to cut the blocks and, due to the frangible nature of wood, the blocks could be used for only a limited number of copies of a

book. Gutenberg is a suitably elusive individual to be seen as the inventor of something that in fact had so many fathers: He was probably born in Mainz; took his mother's surname as was then customary when a woman had no other kinsmen to carry on her name; became a printer in his native city; lived for a time in Strasbourg, where he may have made his great breakthroughs in either 1437 or 1438; and was apparently a lousy businessman, for he eventually lost his press and types to Johann Fust in settlement of a debt. What is clear is that Gutenberg realized that a printing system composed of movable type that you could set and fix, a press that could churn out multiple copies, and suitable ink and suitable papers would be an entirely different animal than a handwriting or block-printing operation. His books, including the so-called *Mazarin* or *Gutenberg Bible,* proved the point, and soon literature—philosophy, poetry, propaganda—was proliferating in Europe, which began to progress socially at a speed unrealized by other sectors of the globe. Movable type was soon a tool of industry, of learning, of governing. Gutenberg gets the credit.

LEONARDO
DA VINCI
1452–1519

Geniuses among our 100 people who changed the world have emerged from disparate backgrounds that range from abject poverty to nobility; as a more modern genius, Chuck Berry, once observed, "It goes to show you never can tell." Leonardo da Vinci, the towering Italian artist, scientist, architect, musician and visionary nonpareil—an exemplar of Renaissance genius—was the illegitimate son of a Florentine notary and a peasant girl. As would be the case not long after with Michelangelo, he showed early talent and had the good fortune to be apprenticed as an artist in Florence—in Leonardo's case, to the sculptor and

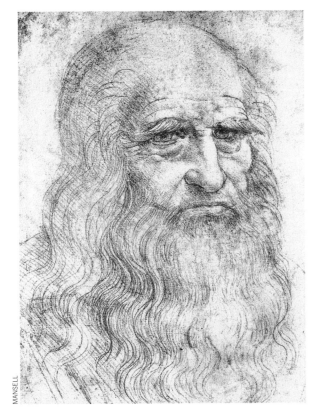

MANSELL

painter Andrea del Verrocchio. (It has been said that Verrocchio modeled his *David* on the handsome young Leonardo.) Leonardo gained his first and most durable renown as an artist; the unfinished *Adoration of the Magi,* painted before he was 30, proved him already a master. In 1482 he went to Milan as a court artist but couldn't restrict himself to the canvas. He began writing his famous notebooks, which dealt with hydraulics, mechanics, mathematics, anatomy, geology, botany—almost anything. He could bury a masterpiece anywhere: His sketch *Vitruvian Man,* made circa 1487 in pen and ink on paper, is, along with his later masterworks *The Last Supper* and *Mona Lisa,* one of the three or four or five most often reproduced works of art in the history of the world; it's on the Italian Euro, for instance, as well as on a million T-shirts. While it is true that the "inventions" Leonardo made notes on—a helicopter, a tank, a calculator, a submarine—were never made and, in fact, couldn't have been built as designed, he inspired others to think about these things and, in the way the writer Jules Verne would centuries later, he pushed the game along. Barely more than 20 of his paintings survive, but this is unsurprising because there weren't all that many to begin with—maybe 30 in total. His was a most restless mind, and he was given to procrastination, always dropping this project for the next one. Clearly, that was the handicap of his particular genius, and its glory.

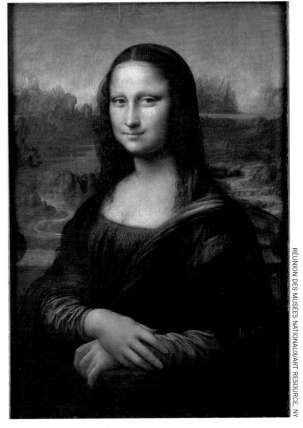

RÉUNION DES MUSÉES NATIONAUX/ART RESOURCE, NY

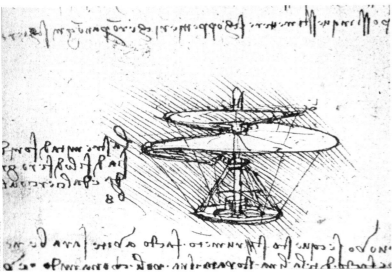

ART RESOURCE, NY

Illustrative of Leonardo's multifold genius is the fact that all works on this page are by him: The self-portrait at top, the sketch for a flying machine, above left, and the breathtaking *Mona Lisa.*

COPERNICUS

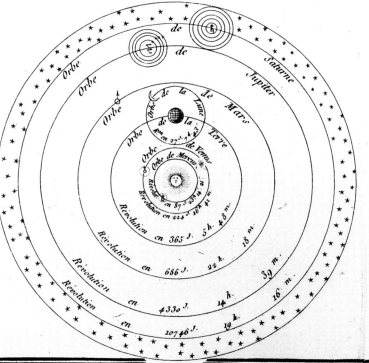

SYSTEME DE COPERNIC

On this page we see the result of Copernicus's observations (indicating that he considered planetary orbits perfectly round as opposed to elliptical) and the canon himself, depicted as a man straddling science and Church.

Copernic, aussi instruit que sage, replace le Soleil immobile au centre du monde, comme un flambeau qui l'éclaire et le vivifie; il lui donne un mouvement de rotation sur lui même. Dans son système, le mouvement diurne de tout le ciel s'explique avec une extrême facilité; il suffit en effet que l'habitant de la terre tourne autour de l'axe, d'occident en orient, pour que tous les astres lui paroissent rouler d'orient en occident et qu'il rapporte au Soleil le mouvement qui n'est réel que pour la terre. Mais tandis que la terre tourne sur elle même en 24 heures, elle décrit une orbite autour du Soleil, dans l'espace d'une année. Par ce mouvement propre, que l'illusion attribue au soleil, cet astre semble s'avancer chaque jour d'environ un degré vers l'orient, pendant qu'il est emporté chaque jour avec tout le ciel et d'un mouvement commun vers l'occident. La trace de ce mouvement annuel est l'écliptique; au bout de 365 jours, une étoile observée se reconnoit à la même heure, au même lieu, où elle s'étoit montrée l'année précédente, à pareil jour.

Perhaps no one else so changed the world as we would come to know it as Nicolaus Copernicus, and he did so in his spare time without inventing anything or conquering anyone. The gist is, before Copernicus, we pretty much saw ourselves as the center of the universe—literally—and all of science, philosophy and indeed religion extended from that starting point. After Copernicus—and after further thinking that built upon his work by, to name a couple of the most prominent, Galileo Galilei and the mathematician, astronomer and astrologer Johannes Kepler—we knew differently. The Polish Copernicus was, as an astronomer, quite a bit more than a hobbyist but was not a professional; a student of economics, law and medicine, he actually received his doctorate in canon law and spent his career as a canon at the cathedral in Frombork, which is very interesting since no one was more insistent that the sun keep revolving around the earth than the Church. People before him had speculated that things might be otherwise, that the earth and other planets might actually be orbiting around the sun in

a solar system, but Copernicus, who had become an astronomy addict during his college days, investigated more deeply. For more than 20 years he probed the planets and the stars, applying mathematics to his observations, becoming more and more convinced. He was a man of high reputation and so was allowed, at age 60, to have his theories presented in a series of lectures in Rome. (The Church did not crush the canon, though Galileo would later be punished for similar sins, as we will read on the opposite page.) The Copernican universe had the sun at its center with, in order, Mercury, Venus, Earth, Mars, Jupiter, Saturn and then the stars rotating around it. Furthermore, Earth spun on an axis, and that moon up there in the sky was revolving around us. Copernicus got the orbits wrong (he liked circular) and other details, but there it was: the plain, fantastic, heretical truth. His opus *On the Revolution of the Celestial Spheres,* probably the greatest moonlighting achievement ever, was published just before he died in 1543. What was contained in its pages hardly died with him, as mankind began to reconsider all.

GALILEO GALILEI 1564–1642

He too, like Copernicus, forced us to reassess our views of reality. If Galileo Galilei's specific achievements and discoveries do not seem, in considerable hindsight, to have been quite so crucial as stepping stones to the advances of modern science as, say, Sir Isaac Newton's (whom we will learn of very shortly), his manner of approaching the natural order and questioning what might be the truth of the matter was revolutionary. Revolutionary in the extreme, and because that was the case, it cost Galileo dearly. He was, it can be argued, the ultimate Renaissance man, more so even than the renowned philosopher-painter-tinkerer Leonardo da Vinci. Galileo was a brilliant astronomer, mathematician and physicist, and an accomplished artist. Born in Pisa, Italy, in 1564, he became a university professor in that city despite having not completed his own course of study.

Later, working at the University of Padua, he elucidated his crucial insights in the field of physics: that the Aristotelian belief that heavy objects fall more rapidly in a vacuum than lighter ones was incorrect; that there is in fact a uniform rate of acceleration; that an object in motion would tend, unaffected by outside forces such as friction, to stay in motion. As an astronomer, he became notorious. He devised a telescope, the world's first used for astronomy, and began experimenting, which led to his support of the Copernican hypothesis: that the earth and other planets in the solar system revolved around the sun. This put Galileo, a devout Catholic, in direct opposition to Church teachings, and he was placed under house arrest and forced to publicly recant his conclusions. He did so—which did not mean, and still does not, that they were not true.

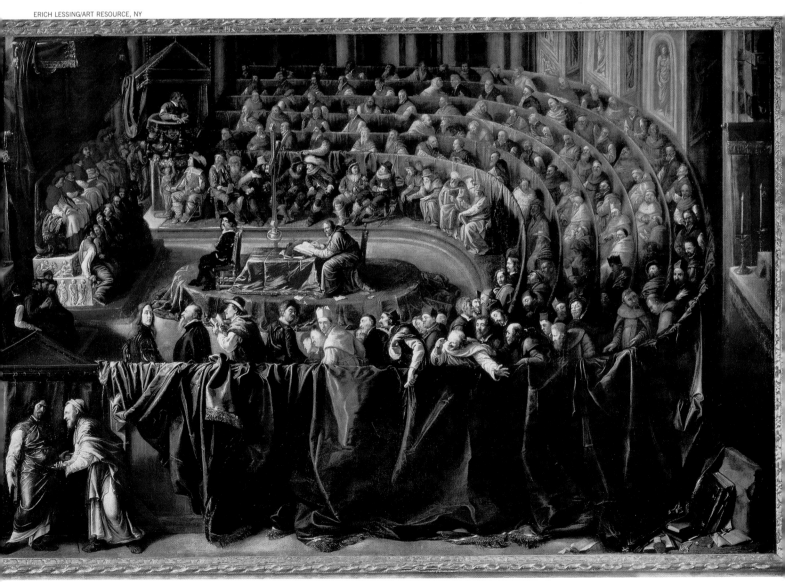

In this 17th century painting by an anonymous artist, Galileo faces his inquisitors in 1633.

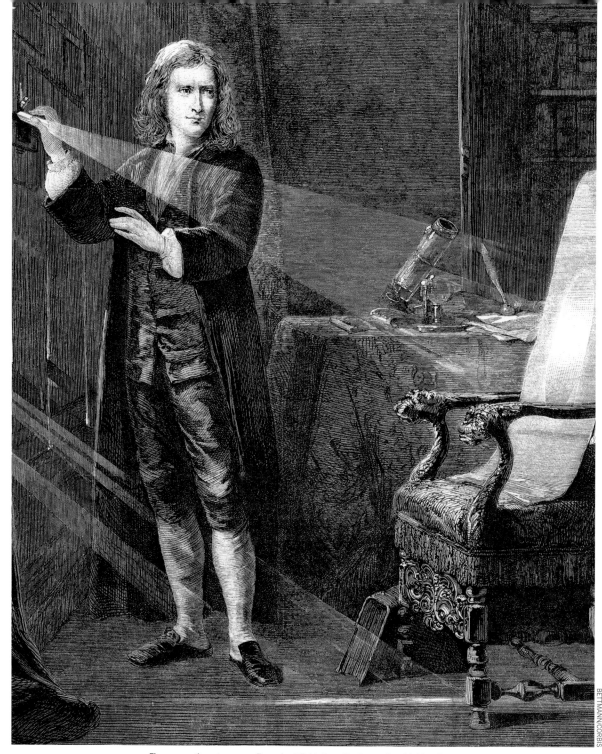

ISAAC NEWTON 1642–1727

The men on these two pages figured out light. Here, Newton works with his prism.

I n the late 17th century, this English scientist developed original theories that would be the basis for much if not all that followed; it is hard to overestimate the importance of Newtonian insights and formulations in fields from optics to mechanics to mathematics to physics to philosophy. Experimenting with light, Isaac Newton employed a prism to break white light into the colors of the spectrum, then to recombine into white. This experiment would lead to spectroscopy. Observing an apple fall from a tree at the same time that the moon was visible in the sky, Newton had an epiphany that led to him elucidating the principle of gravity. His laws of motion (that every object moves in a straight line unless impacted by a force, that the acceleration of an object is dependent on its mass and the forces acting upon it, and that every action has an equal and opposite reaction) were crucial to man's understanding of the physical universe. Like Benjamin Franklin later, Newton was an inventor and technician as well as a theorist: He devised a reflecting telescope. He came up with calculus. His *Mathematical Principles of Natural Philosophy,* first published in 1687 and now known as the *Principia,* is perhaps the most important book of natural science ever written. Newton was born the same year Galileo died, but when you consider how breathtaking his discoveries were, you must conclude that, while all of us stand on others' shoulders, he was uniquely brilliant. All scientists who have followed owe an incalculable debt to Newton.

And here, Niépce (below) is represented by his image of a pigeon house and a barn roof, forged in 1827.

NICÉPHORE
NIÉPCE
1765–1833

As early as 1793, this Frenchman and his brother Claude imagined a photographic process, and over the next several years, Nicéphore Niépce experimented with various light-sensitive substances and cameras. In 1824 he produced a view from his window on a metal plate covered with asphalt. That and most other pictures fashioned by Niépce in the 1820s no longer exist, but the fuzzy image of a pigeon house and a barn roof taken in the summer of 1827, and seen above, is a good example of his art. To make what he called a "heliograph," or sun drawing, Niépce employed an exposure time of more than eight hours. Photography, if not yet practical, had been invented. Another dabbler of renown in this period was the British philosopher and scientist William Henry Fox Talbot who, in 1833, while on holiday in Italy, wondered if images his camera obscura threw against paper could be made to imprint themselves. His experiments led to the first paper negatives and greatly reduced the exposure time required to make a picture. Then there was the Parisian stage designer Louis Daguerre, who learned of Niépce's heliography and promptly importuned Niépce to share his ideas. The men partnered in 1829, but Niépce died in 1833. By 1837, Daguerre had developed a process by which an image could be frozen with exposures of mere minutes rather than hours. The daguerreotype led to a boom in photography; in an 1840 magazine account, Edgar Allan Poe said it "must undoubtedly be regarded as the most important, and perhaps the most extraordinary, triumph of modern science."

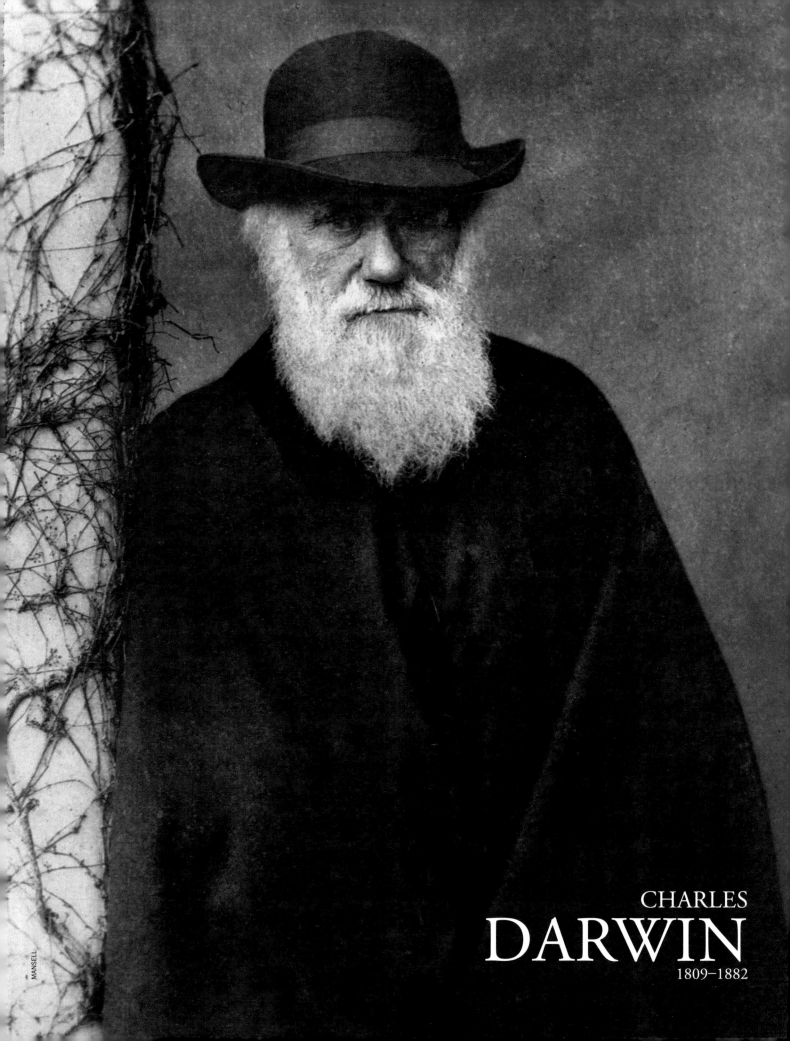

MANSELL

CHARLES
DARWIN
1809–1882

Opposite: Darwin in 1881, the year before he died. Right: Marine iguanas perched on new lava flow on Fernandina Island in the Galápagos, where Darwin formed such earth-shaking theories as the "Tree of Life," which he sketched in his notebook (below) in 1836.

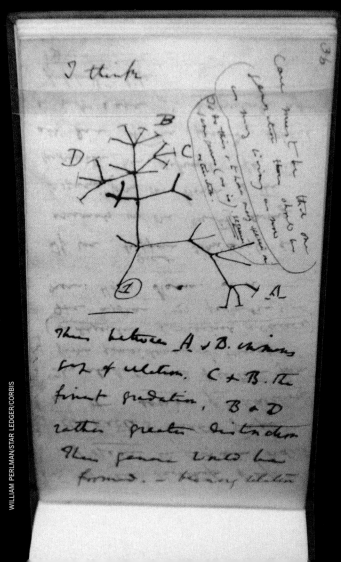

For 200 years beginning in the mid 18th century, the Darwins were Britain's first family of science. Erasmus, born in 1731, was a physician and sometime poet (*The Botanic Garden*) and one of the first, along with the French naturalist Jean-Baptiste Lamarck, to propose the evolutionary theory, even if neither man could explain precisely how it worked. Sir George Howard Darwin, born in 1845, was a renowned mathematician and astronomer, and his brother Francis, born in 1848, was an accomplished botanist. Sir George's son, Sir Charles Galton Darwin, born in 1887, was a physicist who served as director of the National Physical Laboratory from 1938 to 1949. But it is to the work of Charles Robert Darwin, grandson of Erasmus, father of Francis and George and grandfather of C.G., that the term Darwinism applies. This refers to the monumentally important theory of evolution Darwin propounded, based upon his explorations, observations and investigations as official naturalist on the H.M.S. *Beagle,* a ship of scientific inquiry that, between 1831 and 1836, sailed around the world, stopping here and there at exotic locales, including the extraordinarily populated Galápagos Islands in the Pacific. By the early 1840s, Darwin had conceptualized his great theory, which included the crucial element of natural selection, but he spent a long time carefully marshaling his evidence as he suspected his conclusions would cause a furor (which they did, in 1859, when *On the Origin of Species by Means of Natural Selection, the Preservation of Favored Races in the Struggle for Life* was finally published). Meantime, it should be noted, another British naturalist, Alfred Russel Wallace, arrived at similar conclusions to Darwin's while working in the East Indies, but it was Darwin's tome that changed the worldview. Advances in biology and anthropology after Darwin were manifold; and philosophical, religious and ethical debates in light of his findings continue today. Where does mankind fit with the Darwinian concept of "survival of the fittest"? And where does God

FLORENCE
NIGHTINGALE
1820–1910

This was a woman to whom much was given and not much expected (beyond marrying well), but who gave the world much in return. Named after the Tuscan city of her birth, she was raised amid stupendous luxury at her family's estate in England, Embley Park. There on February 7, 1837, as she was nearing her 17th birthday, Florence, a Christian Universalist, heard a voice: "God spoke to me and called me to his service." This was not the last time she experienced a divine inspiration, and over the next few years she, with God's help, sorted out what service she might contribute. When Florence Nightingale told her parents that she intended to become a nurse, her mother in particular had a fit, not at all understanding that Florence's career choice was in part a reaction to the day-to-day indolence she saw practiced at Embley Park by Mrs. Nightingale and Florence's older sister, Parthenope. In 1844, Florence began visiting hospitals and studying methods of training; she enrolled in a program in Kaiserswerth in Prussia. She worked briefly for a Sisters of Mercy hospital outside Paris, then became the unpaid administrator of the Institution for the Care of Sick Gentlewomen in London. It was during the Crimean War that her fame was cemented. After reports came back to England about the horrible conditions being faced by wounded and sick soldiers, Nightingale volunteered to go to Turkey, and inspired others to join her; on October 21, 1854, she led a group of 38 women nurses she had trained to the war zone. From then until 1856 she headed the nursing efforts in British military hospitals in the Crimean towns of Scutari and Balaklava, and although death rates dropped in this period, how much of that might be attributable to Nightingale's lobbying for better nutrition and supplies is contested. What is certain is that she was an inspiration to her colleagues and patients; and after an account of her work in *The Times* of London depicted the "ministering angel" tirelessly "making her solitary rounds" all through the night, she was given the nickname "The Lady with the Lamp." Back home after the war, she founded the Nightingale School and Home for training nurses at St. Thomas' Hospital in London. She wrote the rules and elevated her profession—indeed, she made it into a respected career choice—and is considered the founder of modern nursing.

The revered Nightingale is at the center of the nursing staff at St. Thomas' Hospital in London, circa 1886.

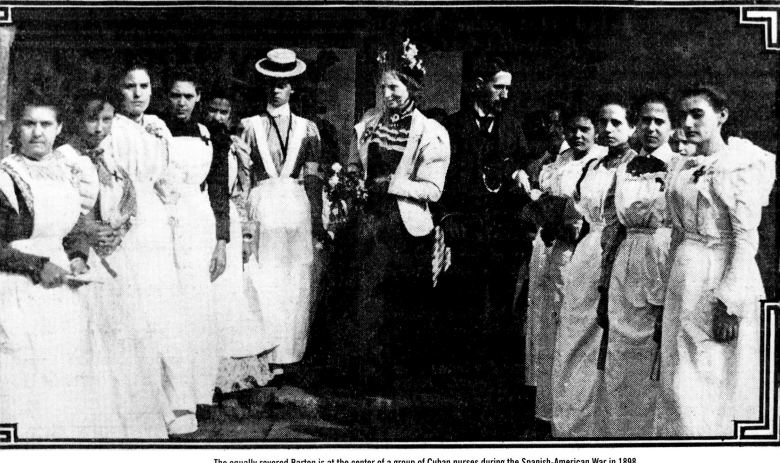

The equally revered Barton is at the center of a group of Cuban nurses during the Spanish-American War in 1898.

CLARA BARTON 1821–1912

When the earthquake destroyed the Haitian capital of Port-au-Prince in January 2010, when Hurricane Katrina stormed ashore in Louisiana in 2005, when the tsunami swamped Southeast Asia and claimed nearly a quarter million lives in 2004, Clara Barton went to work. She was born in Oxford, Massachusetts, the youngest of five children, one of whom forced Barton's hand regarding nursing: Her brother David fell from a rafter in the barn, and 11-year-old Clara began two years of ministering to his needs, organizing his medicines, applying the "loathsome crawling leeches." When her father, a horse breeder, was dying, he gave his shy daughter strong words of instruction that she took to heart the rest of her life: "As a patriot, he had me serve my country with all I had, even with my life if need be; as the daughter of an accepted Mason, he had me seek and comfort the afflicted everywhere, and as a Christian he charged me to honor God and love mankind." She would fulfill her father's charge gloriously. First came public service as a teacher in Massachusetts, and then in New Jersey, where, recognizing the need for a free school, she established one in the face of vehement opposition. That grit was eminently on display again during the Civil War. By then she was working in Washington, D.C., for the government, and it was just a short step to help in the war effort. She worked to get needed supplies to the wounded, then obtained clearance, again over some objection, to go to the front. She built up a store of her own provisions and pitched in wherever she could, working for the Union but eventually nursing soldiers on both sides of the conflict. Her bravery at the Siege of Richmond was noteworthy, but her actions at Antietam, the bloodiest battle of the war, were the stuff of legend. She was everywhere, running to her wagon for medicines and bandages, assisting surgeons working in the field, seeing a soldier shot and killed as she knelt to give him a drink of water. Said Dr. James Dunn, who was present, "In my feeble estimation, General McClellan, with all his laurels, sinks into insignificance beside the true heroine of the age, the angel of the battlefield." After the last shot was fired at Antietam, Barton collapsed with what developed into typhoid fever. She recovered in Washington and returned to the fray. When the war ended, Barton, inspired by the works of the International Committee of the Red Cross, used her fame and influence to establish the American Red Cross, which quite quickly began working on a global scale (Barton led Red Cross efforts in Armenia in 1896, aiding victims of the Hamidian Massacres carried out by the Turks) and in disaster relief that had nothing to do with war (her last fieldwork, at age 78, was in the aftermath of the Galveston, Texas, hurricane of 1900). Clara Barton did her father proud.

LOUIS PASTEUR 1822–1895

In his laboratory in France, Pasteur performs an experiment.

HULTON-DEUTSCH/CORBIS

Before this French chemist made his crucial breakthroughs while experimenting with bacteria, there was a general belief in the concept of spontaneous generation—that life could and sometimes did systematically emerge from inanimate matter, sources other than living seeds, eggs or the combination of the two. This myth had been on the books for more than two thousand years, ever since the wiser-than-wise Aristotle synthesized various theories into a single treatise. After Louis Pasteur, germ theory and cell theory held sway, and because they did, massive progress could be made in preventing and curing diseases. Pasteur discovered that many illnesses and infections have their roots in microorganisms. Once this was proved, sterilization came into play and physicians began to treat their equipment before treating a patient. Pasteur

also developed a cure for rabies. He devised ways to control silk-worm disease and chicken cholera. He came up with a vaccination technique against anthrax. In 1887 in Paris, he founded the Pasteur Institute, which included a cutting-edge research center for work on virulent and contagious diseases. (He's buried beneath the institute today.) As might be guessed, he invented the crucial process that bears his name, *pasteurization,* in which liquids are heated to destroy microorganisms—such as bacteria—that could be carrying disease, and to limit fermentation as well. When used with a product as commonly consumed as milk, pasteurization becomes a health benefit of incalculable proportions. Indeed, it can be said—and has been said—that Pasteur was the most important scientist the field of medicine has ever known.

WILHELM KONRAD RÖNTGEN
1845–1923

Röntgen (above, in a photographic self-portrait) found that his rays could pass through matter, and in December of 1895 made what is today the oldest surviving X-ray image of a part of the human body: his wife's hand (note the wedding ring).

To know something like the back of your hand is a timeless concept, one that was taken yet further in 1895 by Wilhelm Röntgen, a physics professor in Austria who was working on a series of experiments with vacuum tubes, through which he was passing electrical charges. He noticed at one point that a bit of barium platinocyanide emitted a fluorescent glow. Röntgen speculated that a new kind of ray might be possible; he continued to experiment and began to take notes. He became consumed by his work, and he essentially lived in his laboratory for days on end. In mathematics, X is a term often applied to an unknown entity or figure, and Röntgen began referring to his discovery as *X-rays*. Within weeks of concluding that he had indeed found something, he laid a photographic plate behind the hand of his wife, Anna Berthe, and made the first X-ray photo (right). When he showed her the result, she said, "I have seen my death." With the publication of Röntgen's paper "On a New Kind of Rays" on December 28, 1895, hitherto unknown possibilities opened up for the medical field and others. Before Röntgen's revelation, physicians were unable to look inside a person's body without making an incision. Now, they could peer deeply like an astronomer with a telescope looking at the stars. Röntgen, the Father of Diagnostic Radiology, was the recipient of the first Nobel Prize for Physics in 1901. The citation recognized "the extraordinary services he has rendered by the discovery of the remarkable rays subsequently named after him." Indeed, in many places they are still called Röntgen Rays, but the professor himself, a modest man of science, always demurred. He never took out patents on his discovery so that the rays could be widely used, and he urged others to call them what he did: X-rays.

SSPL/THE IMAGE WORKS

TOPHAM/THE IMAGE WORKS

SCIENTISTS, INVENTORS & INNOVATORS 65

SCIENTISTS, INVENTORS & INNOVATORS 65

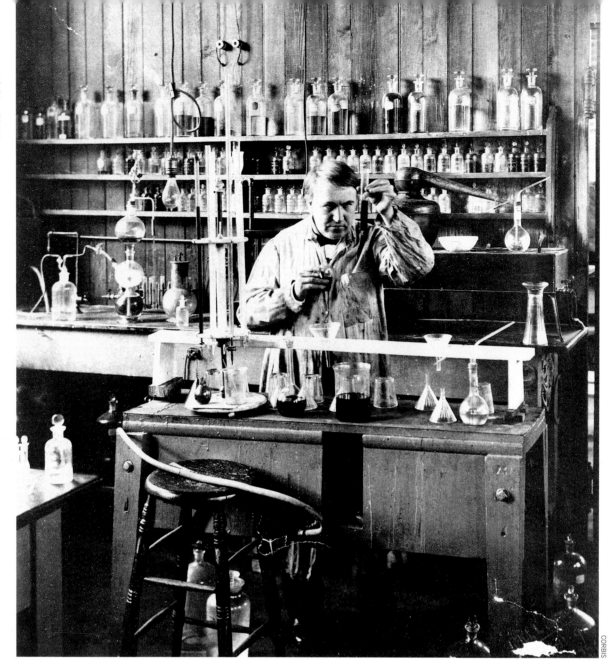

CORBIS

In his New Jersey workplace, seen here, Edison kept a cot where he took catnaps to fuel his indefatigable lust for discovery.

The man who eventually registered more than a thousand U.S. patents (and hundreds abroad) during his long career didn't just invent something for the sake of it; his inventions were useful to both the master of industry and the man on the street alike. Working constantly—he considered sleep a waste of time and was reputed to require only about four hours per night—he produced a steady stream of innovation. His earliest contraptions included a transmitter and receiver for automatic telegraphing and an improved stock-ticker system. In 1878 he patented the phonograph. A year later, most famously, he produced the first commercially practical incandescent lamp, and then, always eager to boost the utility of his products, quickly developed the first central electric-light power plant in the world. Thomas Edison laid important foundations with other initiatives and ideas that were not, strictly speaking, inventions. He established a sophisticated research facility in Menlo Park, New Jersey, for himself and his team, and this beehive of productivity became a model for industrial research laboratories elsewhere. He established a distribution unit to carry electricity into places of business and individual houses, not only juicing sales of his lightbulbs but encouraging American industry to plug in. In one experiment, he discovered that an electric current could flow through a near vacuum between two wires that weren't touching; this would lead eventually to the vacuum tube and, along with his distribution network, would jump-start the electronics industry. He conceptualized the Kinetoscope, an early motion picture exhibition device; he synchronized moving images and sound, presaging by decades feature film "talkies"; he produced a superior storage battery; he built an experimental electric railroad. Edison changed the way the world saw and heard things, and the way it made things go.

ALEXANDER GRAHAM BELL 1847–1922

A native of Scotland, Alexander Graham Bell moved to Boston in his mid twenties and in his laboratory there worked on voice transmission, something he was interested in not least because his mother was deaf and his father had been a teacher of the deaf. (His eventual wife, Mabel, would also be deaf.) Well before he secured his "master patent" for his phone, considerable energy was being poured into experiments for just such a device by a number of inventors, including Thomas Edison, who engaged Bell in quite a sprint to the finish line. Bell won this race, though of course Edison won plenty of others, and on March 10, 1876, when Bell uttered, "Mr. Watson, come here, I want to see you," the way humanity communicated was forever altered. (Another man in the race with Edison and Bell was one Elisha Gray, who is now lost in the mists of history because, although he filed a patent claim on the same day as Bell, he did so just a bit later.) By the end of 1877, there were 3,000 phones in the U.S.; this was still a luxury device. By mid 1878,

10,000 phones were in use, principally in New England, and the first manual switching board, which allowed numerous phones to be connected through a shared exchange, began operating in New Haven, Connecticut. Bell Telephone became a mighty monopoly in urban centers, and by the turn of the century there were 800,000 Bell phones in service in the U.S. as well as 600,000 independent instruments. Clearly, a boom was on, and there was no stopping a phenomenon that would become a part of life's essence worldwide. Government leaders needed their phones, as did town gossips and teenage girls with essential information to convey. With the recent explosion of computer and digital technology, this formerly straightforward device has changed by leaps and bounds on an almost annual basis. First there were cell phones replacing landlines, and then camera phones and music-playing phones and BlackBerries and iPhones. Millions of phones sold each year are now "smart"—some of them seem smarter than we are. Bell boggles.

MANSELL

Bell's work with the deaf preceded his telephonic discoveries and continued after them. Here, he is in the top row, far right, with students at the Boston School for Mutes.

SIGMUND FREUD 1856–1939

LEON DANIEL

Whether or not the good doctor's dogs were allowed to get up on the famous couch (below) is unanswered by these pictures.

No editors of a book such as ours could ever say that we are correct in our assessments of all of our subjects' achievements. We can testify truthfully that we enjoy Beethoven's music and have stood in awe of Michelangelo's sculpture—and we can quote critics and thinkers more expert than ourselves—but we would never argue that Beethoven was *better* or *more talented* than Bach. We do feel, however, that Beethoven did more to change the world; here, we're judging impact. When it comes to Freud, the ferociously controversial father of psychoanalysis, we must freely admit that we have no idea if he was right. The scientific consensus indicates that some of his ideas, as elucidated in *The Interpretation of Dreams* and other works, were either valid or sufficiently provocative to bear further study. The human id, ego and superego; our capacity to throw up defense mechanisms; repression, sublimation and all of that sex stuff: Freud put a lot of plates on the table. In doing so, he stimulated thought, debate and, throughout the 20th century and still today, action. Certainly there can be no doubt that many people have been helped (and perhaps some hurt) by psychoanalysis. In the larger picture, Freudian theory (or reactions to it) has no doubt informed criminal investigation, wartime strategy, the interviewing of job and government

EDMUND ENGELMAN

candidates, even football playmaking in the years since he posited it. We are always seeking the answer to what makes us and the other guy tick; what can be healed and what exploited. Freud, during his long career as a writer and practitioner in Vienna, was concerned with the healing—that, too, is one thing we can say with certainty.

HENRY FORD
1863–1947

If this entry were about the automobile, then the man being celebrated would be Karl Benz or Gottlieb Daimler, two Germans who are most usually credited with inventing the gas-powered car in the late 19th century. But it's not about the automobile; it's about the growth of American industry and mass production. The son of an Irish immigrant farmer in Greenfield Township, Michigan, outside Detroit, Henry Ford was working as an engineer in the city when automobiles first started popping up in America. They were ultra-luxury items, well out of the reach of most working class families. Ford intuited that there was a vast audience for this attractive and useful vehicle if costs could be brought down. The notion that an operation utilizing mass production techniques could churn out more product at a lower cost, and do so faster, was hardly invented by Ford; think back to Gutenberg and his printing press, or consider Eli Whitney, whose cotton gin revolutionized American farming in the 19th century. But the world had never seen anything comparable to the industrial complex Ford was about to create. In Ford Motor Company plants, cars weren't built, they were assembled. Workers stayed at their stations as the automobiles-to-be came to them on an assembly line. Each worker added the interchangeable part he or she had been trained to add (unskilled labor could be hired by Ford since many of the tasks were so straightforward), then said "so long" as the car rolled on to its next stop and, eventually, out of the factory. Statistics tell the tale: Beginning in 1908, some 15 million Model T's were sold, and the car became ever more attractive as Ford refined his operation and continually dropped the sticker price, from $825 originally to $360 by 1916 to an eventual $290 in 1926. Ford, of course, became rich beyond belief, but he not only shared the wealth—he paid his workers well and spurred the rise of Detroit's lower class—he freely shared his production techniques, and soon other American industries were being modernized with assembly lines. Productivity in the U.S. zoomed, and the country was on the way to becoming prosperous, even mighty—a world power.

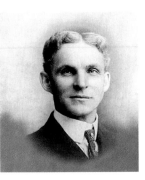

Ford (pictured in 1893) employed women as well as men on his assembly lines, as the photograph below of one of his earliest, outdoor operations indicates.

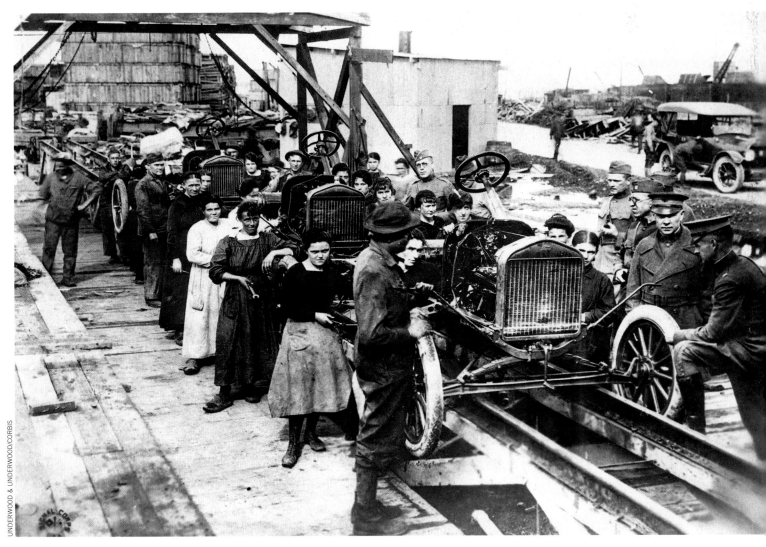

UNDERWOOD & UNDERWOOD/CORBIS

MARIE CURIE

1867–1934

She stands here representing three people—herself and the two men, her husband, Pierre Curie, and Antoine Henri Becquerel, with whom she shared the 1903 Nobel Prize in Physics—and she also stands alone. Marie Curie did not in fact discover radioactivity (Becquerel did), but she performed pioneering work with it, making her own breakthroughs, and, as important, she was a successful female scientist—recognized as such—in a day when successful female scientists were scarce to non-existent. Soon we will see, with the sadder case of Rosalind Franklin (page 77), that women faced a glass ceiling in science (and academia) for a long time. (It can be argued, they still do today.) There was this ceiling in science and, without doubt, in many other endeavors. Such intrepid and talented achievers as Curie were incalculably important to the rise of women in the 20th century. To boot, she did vital research that benefited humankind. The value of understanding radioactivity, being able to harness and control it—whether in medicine or in any of a number of other fields—cannot be overstressed. Curie's personal accomplishments included the discovery of the chemical element polonium (she named it after her native country, Poland) and then the discovery and isolation of radium itself. In 1911 she won a second Nobel Prize (she's still one of only two people, with Linus Pauling, to be twice laureled), this one in chemistry. She died in 1934 of aplastic anemia; she was probably a victim of her work, the illness caused by overexposure to radioactivity. Her legacy extended from there, however, and not only in the eternal benefits of her own science. It turned out she had been a great mother. While one of her daughters became a successful musician, the other followed in her parents' footsteps and, along with her own husband, discovered artificial radioactivity, for which they shared a Nobel in 1935. Five Nobel Prizes in science to one family, and Marie the matriarch: That's acknowledgment.

She became famous as *Madame* Curie, which was misleading; as a scientist, she could stand on her own. Below: In the lab circa 1905.

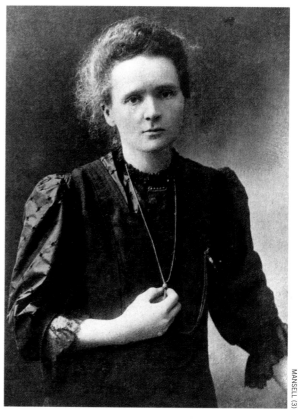

MANSELL (3)

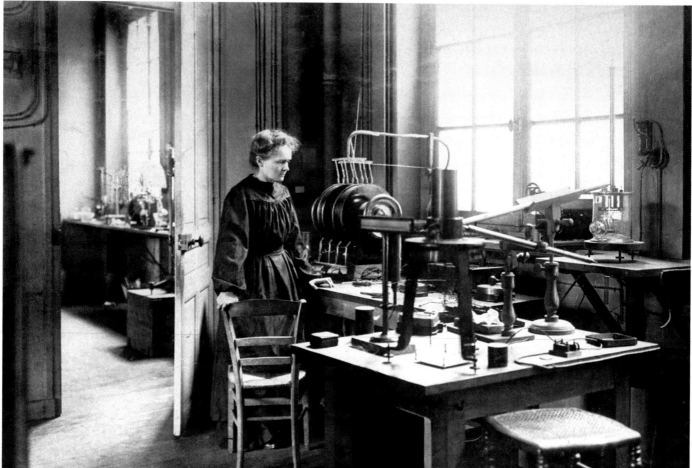

GUGLIELMO MARCONI
1874–1937

The dapper Marconi is seen in the abandoned hospital at Signal Hill, Newfoundland, where,
in December 1901, he received the first wireless transmission from across the Atlantic.

Earlier in the 19th century than the appearance on the scene of Thomas Edison, Alexander Graham Bell or Guglielmo Marconi, the eminent British scientists Michael Faraday and James Clerk Maxwell, among other theoreticians, made crucial contributions to the dream of electricity—and so helped to change the world. We in no way seek to demean the accomplishments of these Brits, but we are taken by the notion that Edison, Bell and Marconi came up with inventions that changed things overnight, and very dramatically. While Edison is known for his many gadgets and gizmos, both Bell and Marconi are principally associated with one big idea: for Bell, the telephone; for Marconi, radio. Born into well-to-do circumstances near Bologna, Italy, in 1874, Marconi became entranced at age 20 by the potential of electromagnetic waves: Could these be harnessed to carry messages through the air at lightning speed? Might we be able to move beyond the present-day telegraph, which is connected sender-to-receiver by

wires? He began experimenting, and in short order was transmitting long-wave signals. He obtained his first patent on a wireless device in 1896 and began making money transmitting Marconigrams, using the same Morse code system as telegraph operations. Marconi oversaw the first transatlantic radio message in 1901. Of course, now information could be sent ship-to-shore and ship-to-ship as well, and in 1904 the Marconi International Marine Communication Company, imagining the most consequential employment of its technology, announced that the Morse Code transmission CQD would represent a general distress call on its installations. This saved lives when the RMS *Republic* sank off the Massachusetts coast in 1909 and was employed again three years later when the RMS *Titanic* hit an iceberg. Marconi shared the 1909 Nobel Prize in Physics for his work on radio, which of course led in a straight line to the invention of television. Marconi single-handedly made the world a much smaller place.

ALBERT EINSTEIN
1879–1955

This photograph of Professor Einstein was taken at his home circa 1925.
By then he had already formulated most of the theories that would so impact the future.

GENERAL PHOTOGRAPHIC AGENCY/GETTY

That he was one of the preeminent intellects in recorded history goes almost without saying; if a person is called "an Einstein" today, he or she is said to be among the most brilliant of the brilliant (or, if in second grade, tops in the class). That Einstein's discoveries and philosophies were at the very heart of the 20th century's largest issues is also a given: This is what led *Time* magazine to name him Person of the Century as that hundred-year span—which had included Roosevelt and Churchill, Gandhi and King—drew to its close. That any of this could have been predicted for a theoretical physicist who would stick to the chalkboard his whole life is impossible. Einstein did not in fact develop the atomic bomb and thus defeat Japan, nor did he himself order the universe. But in the practical estimations of modern man, he might as well have. He was born in Germany, and his genius was on display early. He postulated photons in 1905, and explained the photoelectric effect; he set forth his special theory of relativity in that same "miracle year." In 1911 he asserted the equivalence of gravity and inertia; within a half decade he completed the mathematical formulation of his general theory of relativity. Einstein was awarded the 1921 Nobel Prize in Physics. Such a mind as his would have been of immeasurable use to Nazi Germany, but this was not to be. A Jew, Einstein left his homeland in 1932 for Princeton, New Jersey, and in 1940 became an American citizen—a year after he, persuaded by physicists Leó Slizárd and Edward Teller, petitioned President Franklin D. Roosevelt to beat Germany to the atomic bomb (a petition that produced no immediate effect but was a factor leading, eventually, to the Manhattan Project). In his last years, Einstein, whose breakthroughs in mathematics and physics had made so much possible, became an ever more "militant" pacifist. He had seen what was possible, and he was appalled.

MARGARET MEAD 1901–1978

This is a rare case: an anthropologist who became a pop-culture figure, and whose work greatly influenced some of the large social movements of the 20th century. Margaret Mead was raised in Doylestown, Pennsylvania, by her father, a business school professor, and her mother, a sociologist. While attending Columbia University in New York City, she studied under Franz Boas, the so-called Father of American Anthropology, and began a lifelong friendship with Ruth Benedict, who would gain her own renown in the field. Masters degree in hand, Mead announced she intended to do fieldwork in Polynesia. Boas thought such a venture too dangerous for a woman, but Benedict said go for it, and Mead did. Her research led to what remains arguably the best known (and most controversial) of her many books, *Coming of Age in Samoa,* an assessment of the social progress of 68 young women between nine and 20 years old, and a comparison of that progress to the fraught adolescence of so many American girls. Boas approved of the book and contributed the foreword but knew the work would have a rocky reception. It did, not least because of Mead's observation that these contented Samoans were in no hurry to marry but enjoyed casual sex before settling down, and were psychologically none the worse for it. The book became a best-seller and Mead a celebrity. In other books and in her column in *Redbook* magazine, she wrote of such things as a thriving society in Papua New Guinea where woman were dominant and of the naturalness of human bisexuality. Needless to say, her work turned some heads, changed some minds and was an underpinning of not only the sexual revolution but the women's movement. Some contemporary critics have attacked her work, saying for instance that males are dominant throughout all of Melanesia. One even charged that the Samoan girls who made Mead famous had duped her concerning their social habits. But most of the anthropological community stands by Mead today, and she remains something of a sainted figure in her field of science.

Einstein remains unrivaled for coiffeur, but Mead, in the native Samoan garb that she wore during her investigations, is forever science's Queen of Headwear.

ALAN TURING
1912–1954

This was a great man—a true hero—who was victimized in his lifetime and celebrated only much later. A brilliant English mathematician and pioneering computer technician, he is best known today as a World War II code breaker working in the legendary Government Code and Cypher School at Bletchley Park. First, though: his legacy in computers. He developed the Turing machine, which dealt with algorithms and computing, and it is simplest to let *Time* magazine explain its significance, as it did in 1999 when it named Turing one of the 100 Most Important People of the 20th Century: "The fact remains that everyone who taps at a keyboard, opening a spreadsheet or a word-processing program, is working on an incarnation of a Turing machine." Turing's razor-sharp mind was put to work at Bletchley Park, where he came up with ways to crack German ciphers and, along with Gordon Welchman, developed "the bombe," a machine that yielded the settings of the enemy's Enigma message-protection program. Now, beginning in 1940, the British could listen in, and quickly the naval conflict in the Atlantic, which had looked to be England's undoing, shifted. After the war, there was no release of information about what had happened behind the walls of Bletchley Park, and so no celebration of the heroes therein. Turing went quietly on his way—at first. He was a homosexual, which was an illegal status in England at the time, and . . . Well, the end of his tragic tale is told most aptly in an apology issued in September 2009 by British Prime Minister Gordon Brown: "It is no exaggeration to say that, without his outstanding contribution, the history of World War II could well have been very different. He truly was one of the few individuals we can point to whose unique contribution helped to turn the tide of war. The debt of gratitude he is owed makes it all the more horrifying, therefore, that he was treated so inhumanely. In 1952 he was convicted of 'gross indecency'—in effect, tried for being gay. His sentence—and he was faced with this miserable choice or prison—was chemical castration by a series of injections of female hormones. He took his own life two years later." Turing's mother, for one, never accepted that last assumption: that Turing's death was a suicide, caused by a bite of a poisoned apple. But no one has ever come up with any evidence of foul play.

Turing, standing, confers with colleagues in 1952. He is at this point an entirely anonymous war hero who is soon to be prosecuted—and persecuted.

NORMAN BORLAUG
1914–2009

BETTMANN/CORBIS

In 1970, Borlaug, a newly minted Nobel laureate, is all smiles in wheat fields that he fostered outside Toluca de Lerdo, Mexico.

There are other historically important people presented in these pages whose influence upon the world was for the worse, and who caused the loss of a multitude, even millions, of lives. But there are few who can claim to have saved millions—indeed, hundreds of millions. The American agronomist Norman Borlaug would never have made that claim himself because he was a resolutely self-effacing man who instinctively deflected credit for his pioneering work. But others have made it for him, over and over again. He is one of only six people in history to win the Nobel Peace Prize as well as his own nation's two highest civilian honors, the Presidential Medal of Freedom and the Congressional Gold Medal. That he did this while never really emerging as any kind of public figure is testament to the work itself and its far-reaching impact; it is possible and even probable that no individual had a greater humanitarian impact in the 20th century than Borlaug. What was that work, precisely? Beginning in Mexico after receiving a Ph.D. in plant pathology and genetics from the University of Minnesota in 1942, Borlaug began researching and developing high-yield, disease-resistant wheat varieties. It was clear to him that such strands could help in the famine-plagued third world, and his breeding techniques were spread throughout Latin America and Asia (he was also awarded, at one point, India's second highest civilian honor, the Padma Vibhushan). When the vast difference in crop production became clear—by 1963, Mexico was, in fact, *exporting* wheat—Borlaug was dubbed the Father of the Green Revolution, which he considered "a miserable term." He was similarly reticent one day in 1970 when, while working in a wheat field near Mexico City at age 56, he was approached by his wife, Margaret, bearing the news that he had been given the Nobel Peace Prize. "Someone's pulling your leg," he said to her. Assured that there was no leg-pulling involved, he went back to work, telling Margaret they would celebrate later.

JONAS SALK 1914–1995

In recent years fears regarding the global spread of the SARS virus (which killed no one in the U.S.) and swine flu have given Americans the smallest taste of the fear that can grip a country facing an outbreak of a deadly viral disease. In the postwar years, America was in full panic mode, as the virus in question was not only killing thousands and leaving many more paralyzed, but was principally attacking our helpless children. The disease was polio, most famous in the U.S. for having been the affliction suffered by the late, revered President Franklin D. Roosevelt. FDR himself had spurred an effort to find a vaccine that could prevent polio through his National Foundation for Infantile Paralysis, established in 1938, but by the early 1950s there had been no success. In 1952, at the height of the epidemic, nearly 58,000 were hit by polio, of whom 3,145 died and 21,269 were left permanently stricken. As William L. O'Neill, historian and author of *American High: The Years of Confidence, 1945–1960,* put it, the reaction on the street "was to a plague. Citizens of urban areas were to be terrified every summer when this frightful visitor returned." By the mid

1950s, $67 million annually was being thrown into the fight against polio in the U.S., and among the army of medical researchers working around the clock was the young virologist Jonas Salk, who in 1948 had begun his project at the University of Pittsburg with funding from the Infantile Paralysis organization. While many were experimenting with the live virus, Salk used the dead virus and by 1953 felt he had found the answer. "I will be personally responsible for the vaccine," he announced in New York City that November, saying further that he, his wife and three sons had been among the first to be inoculated. Having gained the public's trust, Salk rolled out his field test in 1954: 20,000 medical workers, 64,000 school personnel, 220,000 other volunteers—and more than 1,800,000 school kids as the subjects. By the spring of 1955 the vaccine was declared "safe and effective," and Salk was hailed as a hero. As did Röntgen with his X-rays, Salk refused to patent his discovery so that it could be widely and quickly distributed. By 1957, 100,000,000 doses had been distributed in the U.S., and the global fight against polio, which would be won, was fully engaged.

AL FENN

Dr. Salk, having already taken care of his own family's inoculation as a show of confidence, personally ministers to an American schoolboy.

ROSALIND FRANKLIN
1920–1958

Franklin at the microscope: Her images of DNA crystals were of the very highest quality and recognized a number of elements in the structure of DNA.

Another heated race: Scientists everywhere were feverish in May 1952 to be the first to discover the cellular basis of heredity. At King's College in England, Rosalind Franklin, a biophysicist and X-ray crystallographer, exposed crystalline strands to 100 hours of radiation in a series of X-rays. Her colleague Maurice Wilkins privately showed her work to molecular biologists James Watson and Francis Crick, who used one X-ray, Exposure 51, to decode the double helix of DNA—the blueprint for all living things, which would unleash multitudinous advances in biological science and medicine. Said Watson later: "The instant I saw the picture, my mouth fell open and my pulse began to race." Crick, too, has acknowledged that Franklin's data was used in helping to formulate his and Watson's breakthrough 1953 theory on the structure of DNA. But what of the woman who had made the picture? Why is she not remembered alongside the storied male scientists? There are various points of view on this. It was alleged that she did not fully understand the implications of her own data; Watson himself wrote ill of her in his book *The Double Helix*. There is also the notion that the male-centric world of King's College in the 1950s simply wouldn't allow her to be part of the varsity team, as Crick implied years later: "I'm afraid we always used to adopt, let's say, a patronizing attitude towards her." Whether or not she was a victim of sexism, she never alleged it in her lifetime—her too short lifetime. In 1958, Franklin died in relative obscurity of ovarian cancer, a condition likely caused, as Marie Curie's fatal disease perhaps had been, by the radiation she had been exposed to in her work. The three men, including Wilkins, shared a 1962 Nobel Prize and lifelong fame as the ones who had cracked the DNA code. The rules of the Nobel do not allow for posthumous honors, and so the name Rosalind Franklin is nowhere in the citation. But her story is a fascinating footnote to one of the great milestones in the history of science.

In this book, many holy grails are seized. The telephone, manned flight, an understanding of gravity, the summit of Mount Everest, a polio vaccine: These were all holy grails for one group of questers or another. For surgeons, particularly in the years after the first successful kidney transplant had been performed in the

MARAIS GILL/SIPA

United States in 1954, the grail was a human-to-human heart transplant. At Groote Schuur Hospital in Cape Town, South Africa, Dr. Christiaan Barnard was on the trail. As it happens, he had been the first to transplant a human kidney in his country in 1967, and he was in the meantime experimenting tirelessly with animal heart transplants, including more than 50 involving dogs. By late '67 he felt he was ready and had a willing patient, Louis Washkansky, who at 54 was suffering from advanced heart disease and diabetes. On December 2, a young woman was killed in a car accident in Cape Town, and Barnard received her father's permission to transplant her heart. The operation, performed on December 3, was an ordeal: 30 doctors, nurses and assistants in the theater, nine hours of work. Eventually Barnard stepped back from the table and said, "It works." It did work, although pneumonia would claim Washkansky's life only 18 days later. In the early days of the procedure, problems surrounding the body's rejection of the transplanted organs were great, and drugs to combat this situation were not what they are today, but still there were soon more successes—by Barnard and others, including by surgeons in the United States. Barnard's first black recipient, whose operation was a landmark event in South Africa in 1969, lived for 12 and a half years after the operation, and one of Barnard's patients who received a heart in 1971 survived more than 23 years. In the present day, more than 3,500 heart transplants are performed globally each year, and the average survival span of the patients is 15 years. As for Barnard: A handsome, vivacious man, he became internationally renowned overnight and didn't mind the spotlight at all. But he continued as a surgeon and wrote several books, some of the profits from which he used to set up the Chris Barnard Fund for heart disease research.

Above: In 1975, Barnard performs heart surgery on a young girl in South Africa. By then, many of his calmest moments were in the operating theater, as he was a world-famous figure. Right: Arriving at the National Heart Hospital in London in 1968.

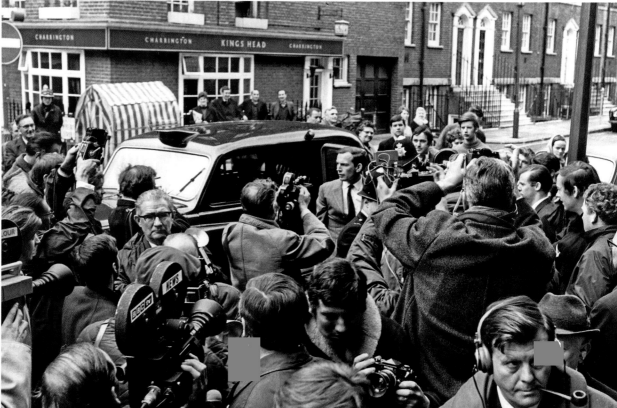

POPPERFOTO/GETTY

GEORGE LANGE

From the first, everything about Apple and its CEO—who, like Barnard, became a mainstream celebrity through his work in an industry not known for producing them—reflected a California cutting-edge cool. Here, he is barefoot and at ease in his Palo Alto home in 1991, schmoozing with fellow computer-industry titan Gates.

STEVE JOBS BORN 1955

This was a difficult call: Who, in the computer age, truly changed the world? Someone did, that's for sure. More than one person did, certainly. But who can stand in for the whole? We've already nodded, on page 74, to Alan Turing and his revolutionary machine. How about Jack Kilby or Robert Noyce, the men who independently invented the integrated circuit, the so-called microchip? Bill Hewlett or Dave Packard or both? Bill Gates? But can it be about software, or . . . Finally we focused tightly on Apple's two Steves, Wozniak and Jobs, and our internal debate continued. Which of these men told Americans (and others) that everyone should have a personal computer with the introduction of the Apples I and II in the 1970s, leading to the breakthrough that was the first Mac in 1984? Was it the techno-geek Wozniak, who had more to do with the invention itself, or his partner in the California garage, Jobs, who knew what product was required by the masses and how to sell it? Jobs did

not carry the debate based solely upon the computers themselves, but because, with his charisma and intuition and certainty that style mattered just as much as mechanics did, he spun it all forward. He was always there, sometimes being shunted aside, sometimes returning in prodigal fashion to haul his old company back to center stage. So often he was right. Today, people talk to one another via the Internet through their laptops, and many households have no landline telephone at all, with each member possessing a personal cell that is a necessary appendage—particularly necessary if it is an iPhone, which connects its user constantly to the wider world. Texting has replaced an actual conversation for many, and there is little doubt that many of us already read in a new, electronic way. Patron saint to some, pitchman supreme to others, Steve Jobs has been at the vanguard of this revolution: a visionary à la Edison and a promoter à la Barnum. Just what any revolution needs.

A master's hand: In 1959 the Russian composer Igor Stravinsky works on a score at the piano in his West Hollywood home. (Please see page 105.)

Perhaps it is inevitable that the cultural icon in our book who lived longest ago is also the most elusive of all; it is certainly fitting. Did Homer in fact exist? Were the epic poems that are commonly ascribed to him really the work of one man? These questions have been debated by literary historians since anyone first became concerned with literary history, and to this day there is no concrete proof of Homer's existence. So please consider this entry to be not so much about a man but about two books of extraordinary poetry, the *Iliad* and the *Odyssey,* whose influence on the world was and still is profound; even if we can choose to ignore the flesh-and-blood Homer, we cannot ignore these narratives and their impact. As to the man: Various legends maintain that he was a blind storyteller, a singer-poet, something of an itinerant minstrel who took his verses from town to town. It is believed Homer's works, including lesser ones sometimes ascribed to him, were delivered orally—whether by him, or handed down from Greek to Greek—before they were written down. By the 6th century B.C., the *Iliad* and the *Odyssey* were considered the apex of Greece's national literature and something of a tutorial on what it meant to be Greek, though it remains unclear when they were first transcribed in the canonical versions we know today. The two-poem series, running to a length of nearly 28,000 verses, recounts heroic episodes from Greek history, and involves myth and events that are not so mythical. For instance, excavations in the late 19th century proved that there is a historical basis for the Trojan War, which is recounted in the *Iliad.* Homer's work, as said, informed Greek culture: why it mattered to be brave and noble and adventurous and righteous. It influenced the Roman poet Virgil and became an underpinning of that world as well. Plato and Aristotle learned what they learned in a land steeped in Homeric tradition. In short, all of Western civilization has as part of its foundation this man called Homer and his ethos. Whoever he was.

HOMER

CIRCA 600–1000 B.C.

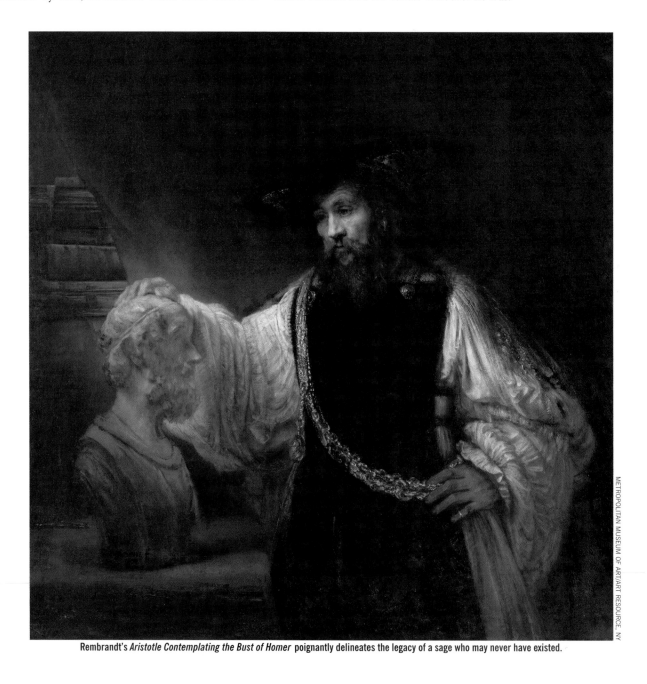

Rembrandt's *Aristotle Contemplating the Bust of Homer* poignantly delineates the legacy of a sage who may never have existed.

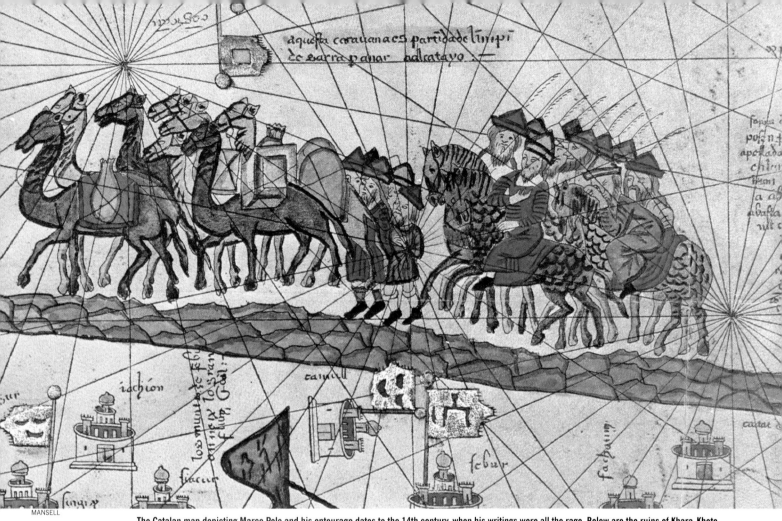

The Catalan map depicting Marco Polo and his entourage dates to the 14th century, when his writings were all the rage. Below are the ruins of Khara-Khoto in the Mongol autonomous region of China. The fortified town was once occupied by Genghis Khan and served as a stopover for Polo. Or so said Polo.

MARCO POLO
CIRCA 1254–1324

It is doubtful that many of the thousands of kids who play the game "Marco Polo" in the summer swimming pools of America have much of an idea who the antic contest is named for. Or if they do harbor a notion, it might be something about "a guy in China." Well, that would be right, though the fellow was not Chinese but Venetian. Marco Polo was the son of a successful merchant who, along with his brother, was possessed of an extraordinarily peripatetic nature; Marco would eventually inherit his father's trade, his success and certainly his wanderlust. The Polo brothers Niccolò (Marco's dad) and Maffeo (his uncle) left Venice for the East in 1260 when the boy was only six. They would not return until he was 15. While the men were away, traveling as far as today's Beijing, where they were cordially greeted by the Mongol ruler Kublai Khan (who sent them home with letters of goodwill for Pope Clement IV), Marco's mother died. When the boy was 17, he was happy to be invited to join his father and Maffeo on yet another journey to Mongolia. The intrepid Polos skirted a war zone and passed through Armenia, Persia and Afghanistan, then climbed the Pamirs and took to the Silk Road headed for China. To cut to the chase, which we necessarily must do when recounting the formidable journeys of the Polos, they traveled north to skirt more trouble and then south, aiming again for the city that is today Beijing (and

was then the capital of the Mongol empire), covering 5,600 miles in all before delivering to the Great Khan valuable gifts from the new pope, Gregory X. The Polos stayed 17 years in the Khan's court, Marco gaining high posts in the administration and being sent out on special missions throughout China and to countries such as Burma and India. Then it was back home with the vast wealth they had compiled, finally arriving in Venice in the winter of 1295 after 24 years away. Did this really happen? It is claimed that it did in *The Travels of Marco Polo,* dictated by the man himself, which was copied many times (no two copies agreeing on all facts and adventures) and was widely read throughout Europe. The book, whether journalism or fiction (or some of both), inspired others, including Columbus, to seek the East. Marco Polo made the world a place to investigate further.

MICHELANGELO

BUONARROTI
1475-1564

When assessing how artists in any field might change the world, we can sometimes find the specific example: Beethoven, as we will learn, made highly original music that bridged the classic and romantic periods; Stravinsky and Picasso changed the rules of the game for composers and painters, respectively, in the early 20th century. With the Italian artist Michelangelo, we can cite his integration of sculpture and architecture (he was a master painter and a fine poet as well). But how can we measure the extent to which any of these people may have changed the world by inspiring others through their creations—by adding richness to the human condition? We cannot. The emotions stirred over time in a billion human souls by Michelangelo's *Pietà* or the ceiling of the Sistine Chapel at St. Peter's Basilica are unquantifiable, and whether these emotions perhaps led to acts of devotion or charity or bravery or whatever else—well, this can only be supposed. Who was the man behind the art? Michelangelo di Lodovico Buonarroti Simoni was born in the Tuscan town of Caprese in 1475, and by age 13 was an apprentice painter in Florence. When assessing his own talents, which were evident at an early age, he considered himself first and foremost a sculptor; in his twenties he completed both his giant *David* in Florence and his *Pietà* in Rome. He obviously received many commissions from the Church, and his art is represented throughout the Vatican; in 1546 he became chief architect of St. Peter's, a post he held until his death. He poured himself into his work during his 88 years, and his vocation worked on him in turn. A second *Pietà* that Michelangelo labored on tirelessly in Florence in his old age shows signs of his increasing spirituality: in fact the face of Nicodemus, who is supporting the dead Christ in the statue, is said to be a self-portrait.

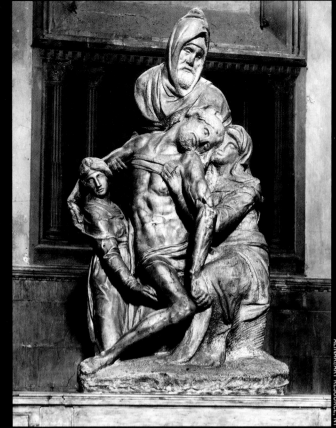

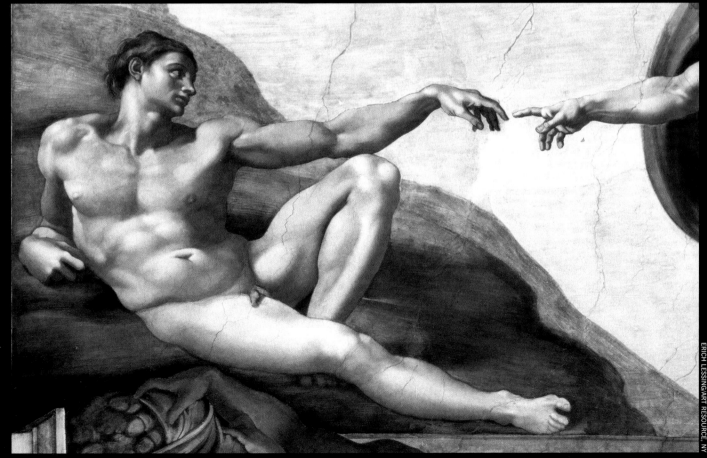

In two of these three works, we have self-portraits: Michelangelo is seen in the sketch (opposite) and, as Nicodemus (top), rising above the martyred Christ in the sculpture. Above: The creation of Adam, from the frescoes on the ceiling of the Sistine Chapel.

We do not care, in these pages, who Shakespeare really was: the young dramatist from Stratford-upon-Avon who found popularity in London; the nobleman Edward de Vere, writing under Shakespeare's name; Sir Francis Bacon; or one of the several other candidates—Elizabeth I!—who have been proposed or supposed. That is to say: We *do* care—it is certainly a fun game to play—but in assessing whether a person changed the world or not, what we are concerned with here is that Shakespeare did so, whoever he or she was. As the identity controversy indicates, hard facts about Shakespeare's life are difficult to pin down. To consider the man from Stratford who bore the name: William Shakespeare was fairly well educated, may have been a schoolmaster in his town, married Anne Hathaway in 1582, may have fathered as many as three children, and by 1588 had moved to London to work in the

theater, possibly first as an apprentice. One year later, his first play, perhaps either *The Comedy of Errors* or the first part of *Henry VI,* was staged. He continued to produce astonishing theatricals—comedies, tragedies, chronicles—and poetry steadily until his retirement to his native town in 1610. He would be remembered today for any part of the whole work; had he written only *A Midsummer Night's Dream* or *All's Well That Ends Well* or *Hamlet* or *Macbeth* or *Henry V* or *Julius Caesar,* or the poem *Venus and Adonis* or the many sonnets, he would be remembered. The language is rich and witty and beautiful beyond measure. He perfected the blank-verse line and proved a genius at plot development as well. All who competed with him at the time and all who have followed him since have been affected by his canon. Any who have aspired to wrest from Shakespeare the title of the greatest writer who ever lived have failed.

WILLIAM SHAKESPEARE
1564–1616

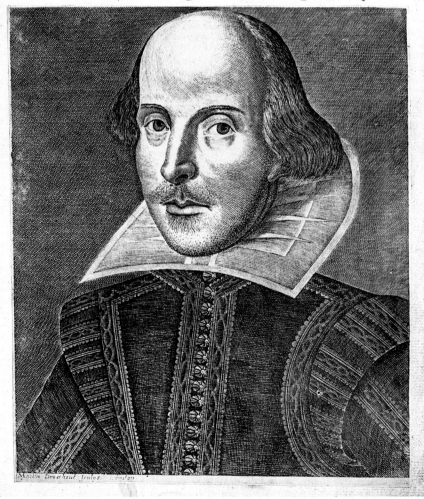

MR. WILLIAM

SHAKESPEARES

COMEDIES,
HISTORIES, &
TRAGEDIES.

Published according to the True Originall Copies.

Martin Droeshout sculps: London

Which artistic portrait of Shakespeare is the most accurate is endlessly debated, but this picture comes with authority: It is the Martin Droeshout rendering that graced the frontispiece of the first complete and official folio of the bard's canon.

LADY MARY PIERREPONT WORTLEY MONTAGU

1689–1762

Lady Montagu, seen in a contemporary etching, was neither a scientist nor a doctor but used her high station to advance both science and medicine.

Among the 100 people in these pages, there are more than a few to whom the term "quite a character" might be applied. More than most of them, Lady Mary Wortley Montagu (née Pierrepont) was most certainly one. And her important contribution to history could never, ever have been predicted from her upbringing. She is listed here among the cultural icons, for instance, because that is what she was, but her lasting impact is in medical science. She was born to great wealth in the London aristocracy but was largely self-educated prowling the family libraries, as her parents saw little value in formal schooling for a girl. Mary didn't see eye to eye with her mother and father when marriage was the subject, either. After the senior Pierreponts had selected a suitable husband and drawn up a marriage contract, their daughter rebelled and eloped with Edward Wortley Montagu. (Later, in 1726, Lady Mary, who was something of a protofeminist, would publish *On the Mischief of Giving Fortunes With Women in Marriage.*) It is often written that Mary was one of the most "colorful" women of her epoch in England. She certainly was spirited, witty, bright and beautiful (even after her features had been marred by smallpox

during a 1715 outbreak that killed her brother), and she and her husband were favorites at court. In 1717, Lord Montagu was appointed ambassador to Istanbul, and Lady Mary chose not to remain at home, as would have been customary, but to accompany him on his adventure. She was an inquisitive tourist, and her *Turkish Embassy Letters* is a wonderful account of their travels. Among the many things she learned was of the Turks' practice of inoculating healthy children against smallpox. This wasn't being done in the West, where the medical establishment opposed the procedure, but the subject had obvious resonance for Mary. She had her son and daughter inoculated and back in England started lobbying among her friends in the aristocracy that they, too, should protect their children. When London suffered another severe outbreak of smallpox in 1721, her aristocratic friends began to follow her example, and Lady Mary took her campaign wider, despite the controversy. She broadened public support for the practice, and eventually inoculation did trickle down from the upper classes, then spread around the world. In 1979 the U.N. World Health Organization declared that smallpox had been thoroughly eradicated.

ADAM SMITH
1723–1790

The little man had large ideas that were hugely influential. Below: The title page of the first edition of his seminal work, which was published in London in 1776.

I t is hard to say what impacts the day-to-day of the world most profoundly, but safe to say that economic conditions can never be denied. A nation is prosperous or not. The people within it are prosperous or not, fairly treated or not. Their lives, liberty and ability to pursue happiness are in large part determined by the economic situation they find themselves in. Understanding the way economies do, can or should work is a crucial part of effective governance. No one has been more important to the formation of modern economic theory than the Scotsman Adam Smith, a university professor of moral philosophy and logic, who published in 1776 his seminal work *An Inquiry Into the Nature and Causes of the Wealth of Nations*. The book was immediately influential, and today, with more than two centuries of subsequent economic evidence to draw on, it can be concluded that the book remains important and that, for the most part, it was right on the money. Smith argued for the significance of labor when assessing the wealth of nations, and criticized government regulations that stifled industry. He liked, to use an au courant word, *stimulus;* he was in favor of low import taxes; he opposed mercantilism; he encouraged free trade but admitted that certain restrictions on trade might be necessary. If these arguments seem ripped from yesterday's newspaper, this only proves Smith's enduring relevance. Moreover, because he put forth his tenets—not all of which were original but when taken as a whole were revelatory—in the very year that the United States declared independence from Great Britain, Smith was, from afar, a major player in the development of our democracy's economic behavior and overall attitude toward markets.

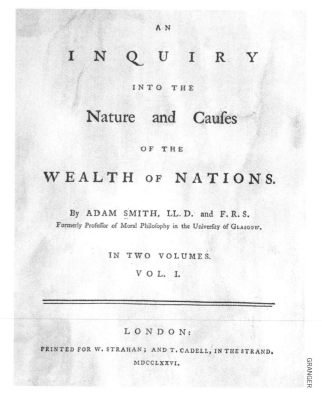

A N

INQUIRY

INTO THE

Nature and Caufes

OF THE

WEALTH OF NATIONS.

By ADAM SMITH, LL. D. and F. R. S.
Formerly Profeffor of Moral Philofophy in the Univerfity of GLASGOW.

IN TWO VOLUMES.
VOL. I.

LONDON:
PRINTED FOR W. STRAHAN; AND T. CADELL, IN THE STRAND.
MDCCLXXVI.

MARY WOLLSTONECRAFT
1759–1797

No, we have not chosen to anoint the woman who wrote *Frankenstein.* That would be Mary Wollstonecraft *Shelley,* Mary Wollstonecraft's daughter, whose troubled birth in 1797 in fact led to the septicemia that claimed her mother at a young age. If there is any silver lining to that sad end, it is that Wollstonecraft, a prolific writer and highly original thinker, had already contributed much and left a legacy that would eventually lead to her being called alternately "the first feminist" and the "mother of feminism." This reputation rests on the vigorously independent life Wollstonecraft led and on one work in particular among her several: *A Vindication of the Rights of Women,* published in 1792. Just the title of the book would have been striking in its day: clear, aggressive, strong—and, *goodness,* about women having rights. Wollstonecraft's central argument was not that women were in all ways men's equals but that they were in no way inferior. If they were different, that didn't make them lesser, and if society saw them as lesser it was only due to a lack of educational opportunities for women and a lack of fairness in society. Wollstonecraft developed her ideas while traveling among a London intelligentsia dominated by such men as Thomas Paine, Samuel Coleridge, William Wordsworth, William Blake and the philosopher William Godwin, who was her lover. When Wollstonecraft became pregnant with the child who would eventually become Mary Wollstonecraft Shelley, Godwin and Wollstonecraft, both of whom were opposed to the institution of marriage, wed. After his wife's death, Godwin published his *Memoirs* of her, which proved to be all too candid for their time, as they detailed Wollstonecraft's troubled earlier love life and suicide attempts. Critics of her feminist thinking used Godwin's account to sully Wollstonecraft's reputation, arguing that all this *nouveau* thought came from a woman who couldn't control her own life. Their attacks worked for a time, and Wollstonecraft's influence receded. But her words remained on the page and were found again, and a direct line can be drawn from Mary Wollstonecraft to Susan B. Anthony, Elizabeth Cady Stanton, Virginia Woolf and Betty Friedan.

By 1909, when Wollstonecraft's visage was used to promote a women's rights program in London, the writer's reputation had been largely restored and the significance of her legacy was being widely acknowledged.

International Woman Suffrage Alliance.
Quinquennial Congress.

PROGRAMME
April 27th, 1909

WOMEN'S

TRADES AND

PROFESSIONS

MARY WOLLSTONECRAFT.
Born April 27th, 1759.

PROCESSION to ALBERT HALL
GREAT MEETING
in favour of
WOMEN'S SUFFRAGE

LUDWIG VAN
BEETHOVEN
1770–1827

"They are not for you, but for a later age." So, reputedly, said Beethoven to a critic, regarding his increasingly complex compositions. He, more than Bach or Mozart or Haydn, redefined what music might be, what were the parameters of a symphony and of an orchestra. He is seen as both the last of the classic and the first of the romantic composers, and he did much to build the bridge; his influence on future composers such as Brahms, Schubert, Mahler and Strauss was tremendous. In his commitment to remain unswayed by current styles and to create art that he felt was correct, he became an everlasting inspiration for creative people in all fields. And there is this, which seems, ultimately, a miracle: Several of his greatest masterworks— the Ninth Symphony, the *Missa Solemnis,* the last five string quartets—were composed after he could no longer hear. Beethoven was born in Bonn, Germany, though like Mozart and Haydn just before him, he would find his fame in music's capital city, Vienna. He was a brilliant pianist; one of his innovations was to install the piano in a place of primacy within the orchestra, and many of his 32 piano sonatas, as well as his five piano concertos and 10 sonatas for piano and violin, are considered works of almost unfathomable genius, plumbed for new depths by each successive generation of keyboard masters. Before he was 30, he was going deaf. He considered taking his own life, and that he did not act on the impulse is the world's eternal gain. Even as his handicap progressed, his works grew in wondrous ways. For the most part, the audience followed him as he expanded the size of the orchestra and the length of the symphony in order to convey the music that was playing in his head. Beethoven spent nearly a full decade of his 57-year life unable to hear any of that sublime music: an irony, a tragedy and—again—a miracle.

In this tiny room in the attic of Number 20 Bonngasse, Beethoven was born, probably on either December 16 or 17 in 1770 (the date is uncertain, but it is known that he was baptized here on the 17th; because of high infant mortality rates during that era, christenings were organized very quickly). Today the room is part of the Beethoven-Haus Museum.

ALFRED EISENSTAEDT

MESERVE-KUNHARDT COLLECTION

Barnum poses with one of his *big* stars, 29-inch-tall Commodore Nutt. The poster below heralds a 1902 European tour.

B ruce Springsteen, Madonna and U2 owe him a debt, as do all the various extravaganzas lighting up the Vegas Strip nightly, particularly those of Cirque du Soleil. P.T. Barnum didn't invent the idea of the entertainment spectacle and he most certainly didn't invent the circus, which dates to the chariot races and trained-animal acts of ancient Rome. But the 19th century showman boosted the idea that bigger was perforce better, and that, at least in the field of entertainment and, more broadly, in our culture, America was now a player. By 1825, the American circus, expanding upon traditions well established in Europe and Asia, had begun to find its own character. Joshuah Purdy Brown had added the big top when he housed his transportable road show in an immense tent. Another memorable character of the pre–Civil War era was the clown Dan Rice, who made "Hey, Rube!" a popular phrase throughout the land. Barnum first gained fame in 1842 with his American Museum in New York City, which he promoted with extravagant advertising shouting of such attractions as the Bearded Lady of Geneva and the midget General Tom Thumb. His management of a successful U.S. tour by the Swedish singer Jenny Lind put Barnum on the national stage. He partnered with William Cameron Coup in launching the traveling enterprise P.T. Barnum's Museum, Menagerie & Circus, which attached a sideshow of freakish human oddities to the usual animal and acrobatic acts. Coup and Barnum's operation also introduced the idea of the "circus train," which transported the ever-growing extravaganza from city to city. Visitors from Europe took word of this American mode of entertainment back home, but Barnum's global influence was realized posthumously: After his death in 1891, his business, which had merged with James Anthony Bailey's, grew larger still. From 1898 to 1902, The Barnum & Bailey Greatest Show on Earth toured Europe, astonishing audiences with its size, variety of acts and sheer spectacle. All competitive circuses now had to grow, and a measure of the rising status of these attractions can be seen in Vladimir Lenin's 1919 declaration that the circus be regarded as the people's art form in the Soviet Union, supported by the state just as ballet and opera were. Even Barnum, a huckster of monumental aspiration, might have been (to use a word he liked) *amazed*.

CHARLES DICKENS
1812–1870

ADOC-PHOTOS/ART RESOURCE, NY

Dickens is seen in 1865, and below is the 1846 edition of his galvanizing novel *Oliver Twist.* Some of the author's works, including this one, were illustrated by the illustrious George Cruikshank.

LEBRECHT/THE IMAGE WORKS

The characters are indelible: David Copperfield, Mr. Creakle, Miss Havisham, Little Nell and Little Dorrit, Oliver Twist, the Artful Dodger, Fagin, Pip, Tiny Tim, Scrooge. The plots are ingenious, even if the intrigues sometimes drift toward the extreme and tax the reader's credulity. Dickens was a writer who, in book after book, had his audience at hello, to use the contemporary phrase, and never let it go. But reading Dickens today and reading him in the mid 19th century are two different experiences. Dickens wanted to entertain, certainly, but he also intended to inform and to provoke. While his expositions of the society in which he lived might in the 21st century make us momentarily sad or even disturbed, we are sad or disturbed for the plight of a fictitious protagonist, a player in an invented tale. In his time, however, Dickens meant to move his readership to the point of social activism. He wanted Oliver to be real, the boy next door. This calling came naturally to him as he had seen early in life, despite a generally happy boyhood, the belly of the beast. His father, a clerk, was sent to debtor's prison when Charles was 12. He worked in a factory to pay his boarding expenses with a surrogate family, and at the factory he was exposed to horrid conditions—"literally overrun with rats"—that were especially horrid for the many child laborers. He took mental notes. Once he began to write, he quite quickly became famous and a man of means, and was given to philanthropy, helping, for instance, to found a home for fallen women. But many people are charitable, and while their good auspices benefit some, they might not change the world. Dickens did this—with his novels. Every one of his books comments on social ills, and some were so fierce in their condemnation of the Victorian-era caste system that they led to real change. The London slum where *Oliver Twist* was based, Jacob's Island, was attended to after that novel of want and criminality was published and then republished with a new preface by the author explicitly calling for action. *Bleak House* led to reforms of the British legal system. And how many readers then and since have supported efforts for the poor or lame after reading *A Christmas Carol*? Charles Dickens was an ambitious man of letters who liked to sell his stories, but he was also a constant crusader.

KARL MARX 1818–1883

To some it may seem surprising that Marx was a man of the 19th century, since his influence, great as it has been, was such a factor in the progress of our 20th century world. Be that as it may, the fact remains that *The Communist Manifesto,* which includes the basic formulation of Marxism as conceived by this German social philosopher and his collaborator and friend Friedrich Engels, was first published (and first turned heads) in 1848. Marx's *Das Kapital* appeared in three volumes between 1867 and 1894, and so all of his political and social thought was made public well before Lenin, Stalin, Mao, Castro and others began to impact the world, often for the worse, in his name. Most modern forms of communism and socialism are drawn from Marx's arguments for societal change. He proposed, in his ideas of economic or materialistic determinism and scientific (not utopian) socialism, that in a capitalist state, the bourgeoisie would get richer and the proletariat poorer over time, and that "the history of all hitherto existing society is the history of class struggles." He predicted that the eventual outcome of the struggles would be the rise of the working class to a position of power, the centralization within a state of production and industry, and that revolution was an acceptable means to hasten this inevitable outcome. Such a vision, whether correct or incorrect, has proved useful to many a political leader in preaching to downtrodden masses, and visionaries and despots alike have attracted support by invoking Marxist principles. How many have been killed or otherwise persecuted in bastardized misrepresentations of communism is, more than a century and a half after the *Manifesto* was penned, incalculable.

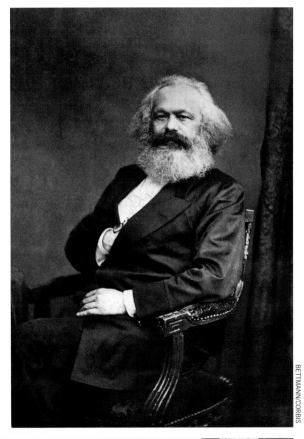

BETTMANN/CORBIS

In eulogizing his friend and colleague upon his burial in London's Highgate Cemetery (right), Engels said of Marx (above): "He died beloved, revered and mourned by millions of revolutionary fellow workers—from the mines of Siberia to California, in all parts of Europe and America—and I make bold to say that, though he may have had many opponents, he had hardly one personal enemy. His name will endure through the ages, and so will his work."

HANS WILD

JULES VERNE 1828–1905

Any number of prominent scientists in the 19th and 20th centuries testified that they had been inspired to pursue their studies and chosen fields by the writings of Jules Verne. Yes, those works were all fictions. But the domino effect that the Frenchman Verne caused by persuasively putting into the minds of men the idea that they not only should but *could* go to the moon, or to the bottom of the ocean, or around the world in a balloon is a remarkable thing to track. Konstantin Tsiolkovsky, the Russian theoretician who is regarded as the father of Soviet astronautics, once wrote: "I do not remember how it got into my head to make first calculations related to rocket. It seems to me the first seeds were planted by the famous *fantaseour*, J. Verne." Tsiolkovsky's American counterpart as a rocket pioneer, Robert Goddard, said much the same thing on regular occasion, as did the German rocket scientist Wernher von Braun, who led the team that developed the Nazis' V-2 ballistic missile during World War II and then helped the United States put a man in space during the postwar period. As might be expected, the famous oceanographer Jacques Cousteau, who invented the aqualung (with Emile Gagnan) and helped develop early submersibles, was also in thrall to the novels of his fellow Frenchman. Verne's real-world influence is certainly due to how realistic his science fiction seemed. In *From the Earth to the Moon*, three astronauts are launched from Florida, reach the lunar surface and are recovered on their return after splashing down in the ocean—and if that sounds like an account of what eventually happened with *Apollo 11* precisely 104 years after Verne's novel was published, well, so be it. Verne described weightlessness in space and thermal vents on the ocean floor well before they were discovered. Certainly Leonardo da Vinci had dreamt up helicopters before him, but Verne predicted not only flying machines but deep-sea diving submarines, movie projectors and even jukeboxes. His book *Paris in the 20th Century*, which was written in 1863 and set in a technologically wondrous 1960, contains descriptions of electricity, air-conditioning machines, gas-powered cars, high-speed trains, calculators, TVs, elevators, fax machines, criminals "executed by electric charge" and a global "telegraphic" communications web that sounds like the Internet. Verne wrote novels that were road maps.

An illustration from the 1865 book *From the Earth to the Moon* depicts a space capsule being recovered from the sea after returning from its lunar voyage, presaging precisely an event that would happen just over a century later. Right: The author in an 1875 portrait.

LEO TOLSTOY
1828–1910

MANSELL

Late in life, the count grew ever closer to the people, and sometimes went forth in peasant garb, mingling with the poor and aiding them with his considerable riches.

He thought Shakespeare was very much overrated, but then: No one's right about everything. Born into an aristocratic family in the 19th century, he was destined to parse life in imperial Russia much as Dickens (whom he *did* admire) parsed Victorian England. But Leo Tolstoy went overtly further than his titanic fictions. He is rightly remembered for *War and Peace* and *Anna Karenina,* but in his learning and teaching he became a proselytizer for Jesus Christ as a philosopher king. He saw great wisdom in the Sermon on the Mount and became a pacifist and an activist for nonviolent protest, as expressed in *The Kingdom of God Is Within You.* He carried on a mentoring correspondence with Gandhi, who called him "the greatest apostle of nonviolence that the present age has produced," and in the United States, later, he had a profound influence on Martin Luther King Jr. Tolstoy was a vegetarian, a supporter of the Esperanto movement, a wealthy man who contributed the money from his inheritance to neighboring peasants. All of this is overshadowed, as it must be, in the common conception of Tolstoy. *War and Peace* is justly considered one of the greatest novels of all time, and by commenting on Russia's social and political situation in the 19th century, he commented universally. But after *Anna Karenina,* even Tolstoy's fiction—*The Death of Ivan Ilyich* and *Resurrection*—was informed by his radical (in Russia) pacifist Christian philosophy and this led to his excommunication from the Russian Orthodox Church. Readers worldwide know that Tolstoy was immense, one of the few true titans of the novel. What they don't know is what he meant to people throughout the world who had never heard of him—people who perhaps could not even read—because disciples of his philosophical and religious works put his thoughts into practice.

MOTHER JONES

1837–1930

Many of the stories in this book could never have been predicted, but this is one of the wildest: The daughter of a tenant farmer from County Cork, Ireland, immigrates to the United States, emerges from personal tragedies that would have felled a lesser person and goes on to become a formidable crusader and labor organizer in a period when women were still arguing for the right to vote. You look at the pictures, peer into the sweet face of Mary Harris "Mother" Jones, and you ask: Really? Yes, really. She claimed to have been born in 1830, perhaps to add years to the matriarchal image that was useful in her work, but historians put the year at 1837. She was evidently smart; by the time she was 20 and living in Michigan with her family, she had qualified to be a teacher. She married George Jones, a laborer and member of the Iron Molders Union, and they quickly built a family in Memphis: four children born between 1863 and 1867. In that later year, yellow fever swept through Tennessee and all of the Joneses died except Mary. Grief-stricken, she relocated to Chicago to find a way forward. She became a dressmaker, but lost her shop and home in the Great Fire of 1871. Now what? She found solace in her Catholicism and, recalling her husband, found a purpose, joining the Knights of Labor, which would evolve into the Industrial Workers of the World (the so-called Wobblies, a massive union). Mother Jones was charismatic and soon powerful, helping to organize strikes of mine workers nationwide. In 1902, on trial in West Virginia for having ignored an injunction against assembling striking miners, she remained stoic as the district attorney looked at her and told the court, "There sits the most dangerous woman in America. She crooks her finger—twenty thousand contented men lay down." Those men weren't contented, and neither were the parents of children being exploited in mills and mines. In 1903 Jones led a youth march from Pennsylvania to the front door of President Theodore Roosevelt's house in New York, forwarding the crusade that led to child labor laws. A decade on, after organizing coal miners in Colorado, she was granted an audience with Standard Oil's John D. Rockefeller Jr., who then traveled west, inspected conditions there and ordered reforms. Mother Jones gave a distinctly different face to labor grievances, and her association with the unions bettered conditions for workers in the U.S., establishing a model for the world,

Sometimes politicians were happy to greet Mother Jones, and sometimes they were not so happy. Above: She calls at the White House in 1924 to tell President Calvin Coolidge that he will have her support in his November reelection bid. Right: In Denver in 1913, Jones leads a procession to present Colorado governor Elias M. Ammons with a formal complaint protesting his order to send in troops to deal with a labor strike.

RICHARD WARREN SEARS

1863–1914

The dapper Sears poses with his fat catalog, which became an American staple as ubiquitous as the phone book. Below: His company's most modern sloganeering could be employed today, without changing a word, by Amazon or eBay.

There were department stores before him, and the mail-order business. There are other legends in the field, from R.H. Macy to L.L. Bean to Sears's partner Alvah C. Roebuck. But no one so clearly tapped into the ideas of mass and marketing before—no one is such an obvious progenitor of the WalMarts and Targets and B.J.'s and Costcos and Lands' Ends and even Amazons and eBays of today—as Richard Warren Sears. The son of a blacksmith in Stewartville, Minnesota, he saw the family crippled when his father lost all of his money in a failed stock-farm venture. He needed to chip in at a young age and learned telegraphy, eventually rising to station agent in North Redwood. He decided to moonlight and in 1886 entered into an enterprise that is legend in American retailing. At the time, wholesalers were engaging in the questionable practice of shipping products to retailers who hadn't ordered them, and then offering to discount the goods to below the cost of sending them back. The retailers usually bought and then tried to sell the items. But a Minnesota merchant balked at a consignment of pocket watches. Sears made a deal with the wholesaler to peddle the watches and keep any profit he made above $12. He proceeded to sell the lot for $14 per watch. Within a half year of doing such deals, he had made $5,000 and hung out his shingle in Minneapolis as the R.W. Sears Watch Company. Sears was a Shakespeare at promotional copy, and the flyers and ads he sent out to prospective buyers were genius. He gained the trust of the rural population. In 1887, he hired watch repairman Roebuck to handle any returns, thus establishing a reputation for quality. (Roebuck sold his share of the company to Sears in 1895 for $25,000.) The company grew, added product and outreach, and built a catalog 500 pages thick that was sent to some 300,000 homes every year. Sears didn't know much about watches and in fact wasn't much of a businessman

(he retired in 1908, well before he was 50, sold his portion of Sears stock in 1913, and died at the age of 52 the following year), but he sure could sell. He could sell like nobody's business.

Shop the MODERN Way

from your easy chair

That's the modern way to shop. In the ease and comfort of your home—alone, or with your family, you may select the merchandise you want from our catalog—"The Thrift Book of a Nation"—away from the fuss and confusion of crowded stores.

Removed from the urgent influence of insistent salespeople, quietly and without interference, "The Thrift Book of a Nation" tells its story of quality, value and saving. You are the

judge—to make your own comparisons and weigh your own values. You can take the whole family shopping with you—at the fireside or on the front porch.

Our new Fall and Winter Catalog of over 1100 pages, portraying 48,000 articles—every one at a real bargain price—is ready for those who would like to shop this new, modern way. We have reserved a copy for you. Just fill in and mail the coupon today.

SEARS, ROEBUCK and CO.

SEARS, ROEBUCK AND CO.
Chicago, Philadelphia, Boston, Minneapolis, Kansas City, Atlanta, Memphis, Dallas, Los Angeles, Seattle
(Mail Coupon to Store Nearest You)

Send me your Latest General Catalog.

Name
Postoffice _____ State
Rural Route _____ Box No.
(Please give both Route and Box Number if on a Rural Route)
Street Address

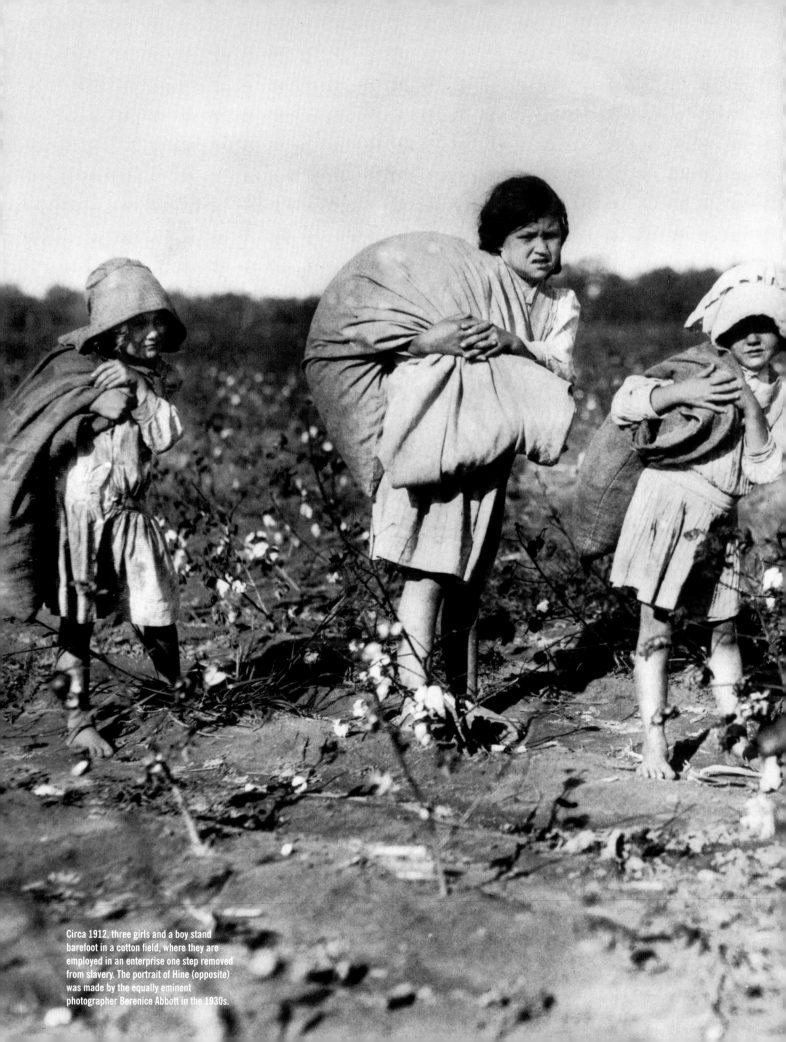

Circa 1912, three girls and a boy stand barefoot in a cotton field, where they are employed in an enterprise one step removed from slavery. The portrait of Hine (opposite) was made by the equally eminent photographer Berenice Abbott in the 1930s.

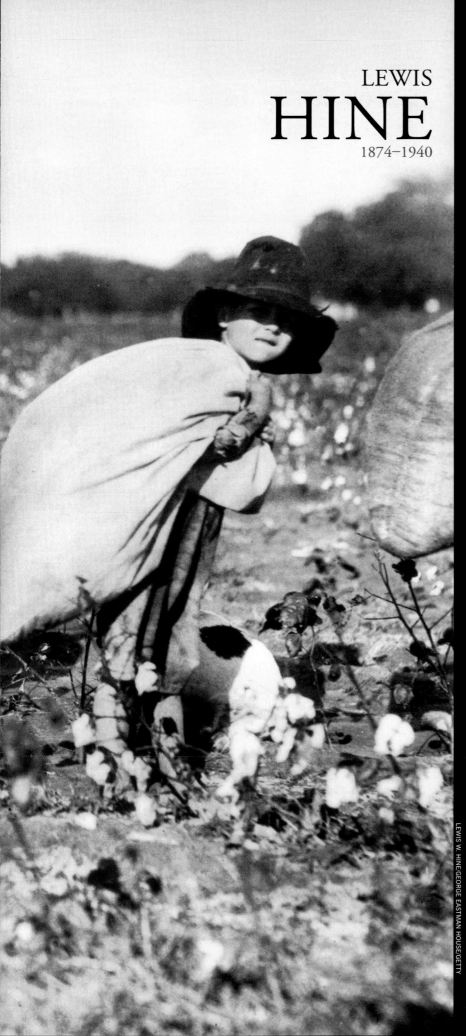

LEWIS HINE
1874–1940

Muckraking journalists and novelists have often changed the world. In the 19th century, Nellie Bly's *Ten Days in a Mad-House* shone a light on the treatment of mental patients, and Jacob Riis drew cries for urban reform with his book on the slums, *How the Other Half Lives.* In the 20th century, such as Samuel Hopkins Adams, Lincoln Steffens, Upton Sinclair, Ida M. Tarbell, I.F. Stone, Bob Woodward, Carl Bernstein and Seymour Hersh carried on the tradition and effected change. Elsewhere in our times: In 1979 Chinese muckraker Liu Binyan made Beijing respond with his reporting on bureaucratic corruption; and in 2006, Russian journalist Anna Politkovskaya, who had written critically of the Kremlin, was shot dead in a case that remains unsolved. Since we are LIFE and are concerned above all with photojournalism, we choose Lewis Hine to stand in for the noble calling that is muckraking. Born in Oshkosh, Wisconsin, he studied sociology in Chicago and New York City, then landed a teaching job at the city's Ethical Culture School. He taught his students, among other things, what an effective educational tool a camera can be and led field trips to Ellis Island to take pictures. He made photographs of conditions in tenements and sweatshops, and in 1908 published them in *Charities and the Commons,* hoping to "exert the force to right wrongs." Hine found his great issue when he was employed as staff investigator and photographer by the National Child Labor Committee, which was pushing for federal laws to protect America's exploited young. There had been earlier work in this realm—socialist writer John Spargo's 1906 exposition of the terrible conditions for child laborers, *The Bitter Cry of the Children,* and the images of photographers in the employ of Irish crusader Thomas John Barnardo—but Hine approached the subject clear-eyed, and it made all the difference. Hine never exaggerated the plight of the children, as Barnardo's shooters sometimes did, but for eight years showed the truth in his photography for the committee. "Perhaps you are weary of child labor pictures," he said. "Well, so are the rest of us." When Congress passed the Keating-Owen Act in 1916, Owen R. Lovejoy, of the Child Labor Committee, wrote: "The work Hine did for this reform was more responsible than all other efforts in bringing the need to public attention."

Many of our choices in this book might be controversial to you, our readers, but as far as individuals being controversial in their day, few were more so than the American birth control advocate Margaret Higgins, better known by her first husband's surname, Sanger. She lived to see many of her battles won in the courts and in the laboratory, but the truth is that the furor that raged over her core issues still rages today—and perhaps always will. Sanger was influenced by her own life experience: Born into an Irish Catholic working class family in Corning, New York, she witnessed her mother die of tuberculosis and cervical cancer after 18 pregnancies and 11 live births. Her father was a socialist and an early advocate of women's suffrage, and from him Margaret inherited her political pluck. She worked as a midwife in New York City slums and was appalled that the women she ministered to had none of the information or options for controlling their own destinies that were available to the rich—condoms, spermicides and such. She began to write articles in a series entitled *What Every Girl Should Know* and in 1914 launched *The Woman Rebel,* a feminist monthly that advocated "birth control," a term

she coined. She was indicted for inciting violence and promoting obscenity, a case that was eventually dismissed. She opened birth control clinics that dispensed pamphlets and products, initiated sex counseling and founded the American Birth Control League, which would become, in 1942, Planned Parenthood. Crucially, in 1951, she recruited the American biologist Gregory Goodwin Pincus to work with others to develop an oral contraceptive; she was more than 80 years old when, a decade later, she saw the first marketing of "the pill." That product has obviously brought a lot of change to an overpopulated world, not to mention how much it altered the lives of women, who could now control their own fertility. It also had what some would call a liberating effect on sexual mores. Even those who see these changes as positive are relieved that other parts of the Sanger doctrine have not been adopted by society. She was a racist in her assessment of human development and would have used her birth control methods in a program of negative eugenics: "Apply a stern and rigid policy of sterilization to that grade of population whose progeny is already tainted." Margaret Sanger—the mother of all controversial figures.

MARGARET SANGER 1879–1966

Banned in Boston, and elsewhere: In advance of an appearance before activists and other iconoclasts in the Massachusetts capital, Sanger, whose New York City clinic has recently been raided, is symbolically gagged by fellow traveler Edythe S. Tichell—indicating that Sanger has been warned against preaching on birth control.

BETTMANN/CORBIS

HELEN KELLER
1880–1968

This photograph, too, was taken in Massachusetts, in the Cape Cod town of Brewster in 1888. It shows young Helen when she was only eight years old, holding hands with her teacher, Sullivan, who gave her a doll when she arrived to work. This is the crucial period, as Sullivan is barely a year into her lifelong mission. The photo was recently discovered in a collection donated to the New England Historic Genealogical Society in Boston.

The title of the play and movie *The Miracle Worker* referred to Annie Sullivan, an undeniably brilliant teacher, herself having damaged eyesight, who worked with and helped Helen Adams Keller for a half century. But that title inadvertently tends to diminish Keller, an altogether phenomenal woman who was very much a player in her several breakthroughs and her rise to societal significance. Whether any other disadvantaged—or handicapped, as some term it—person has ever become such a figure of admiration and inspiration is debatable; Helen Keller was the fountainhead for much of American (and then global) progressivism for the disabled. Moreover, she contributed to several other causes with her keen intellect—which, unbound, was unaffected by her physical condition. Keller was born on a plantation in Alabama and at 19 months fell ill with what may have been meningitis; she was tragically rendered deaf and blind. Her mother searched for help, and her hunt led eventually to none other than Alexander Graham Bell,

who was working with the deaf, and through him to the Perkins Institution and Massachusetts School for the Blind in Boston. Sullivan was a former student there and was asked, at age 20, to work with Keller. Helen had already developed methods of communicating with her family, but the way these two *found* each other—drew each other out—was truly remarkable. At the Perkins Institution and other schools, Helen progressed, and when she graduated from Radcliffe College in 1904 at age 24, she became the first deaf and blind person to ever receive a bachelor of arts degree. She was hardly done with her achievements. In fact, she was only beginning. Her newfound voice revealed an inspired thinker, and as a writer Keller became an important force in the suffrage and pacifist movements. She and Sullivan traveled the world—to some 40 countries—and Keller opened people's eyes with each visit. At every vote in Congress today on legislation aiding the disabled, at every local school board decision on special needs, Helen Keller is present.

PABLO PICASSO
1881–1973

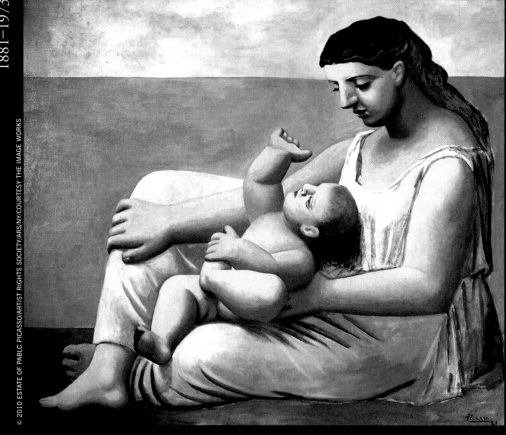

The painting at left is *Mother and Child* from 1921 and the one below is *Les Demoiselles d'Avignon* from 1907. The photograph opposite is a famous one made for LIFE by Gjon Mili. It shows Picasso sketching with a penlight at the Madoura Pottery workshop in Vallauris, France, in 1949.

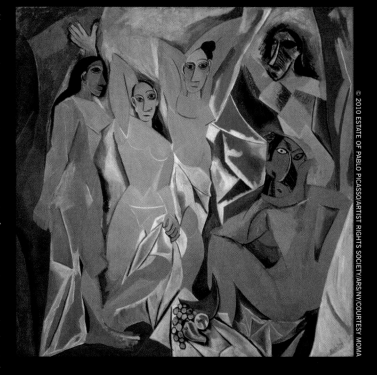

H e changed art, certainly, but something else was afoot early in the 20th century. Along with our next two entries, James Joyce and Igor Stravinsky, each born one year after Pablo Picasso, plus Stravinsky's colleague, ballet master Václav Nijinsky, as well as another dancer, Isadora Duncan, and the writers Virginia Woolf and Franz Kafka and Jean Cocteau and the poets Ezra Pound and T.S. Eliot, and others, Picasso helped effect cultural and, indeed, societal shift. These artists were at the vanguard of modernism, and much of the rule-breaking that would inform the 20th century—in all realms—can be traced to them (which is why more than one or two will be listed here). Also, Picasso made art matter to the masses, particularly in electric, media-savvy countries like the United States. As the estimable art critic Robert Hughes wrote in explaining Picasso as one of *Time* magazine's history makers: "To say that Pablo Picasso dominated Western art in the 20th century is, by now, the merest common-place. Before his 50th birthday, the little Spaniard from Málaga had become the very prototype of the modern artist as a public fig-ure. No painter before him had a mass audience in his own lifetime. The total public for Titian in the 16th century or Velázquez in the 17th century was probably no more than a few thousand people . . . Picasso's audience—meaning people who had heard of him and seen his work, at least in reproduction—was in the tens, possibly hundreds of millions. He and his art were the subjects of unending analysis, gossip, dislike, adoration and rumor . . . No painter or sculptor, not even the sainted Michelangelo, had been as famous as this in his own lifetime. And it is quite possible that none ever will be again." But what made Picasso matter, beyond his celebrity,

pushing of the envelope." Interestingly, since his experiments would influence so many, Picasso claimed to be not at all concerned with changing things or with legacy: "All I have ever made was for the present and in the hope it will always remain in the present. When I have found something to express, I have done it without

JAMES JOYCE
1882–1941

"One of the things I could never get accustomed to in my youth was the difference I found between life and literature." This was the testimony of James Joyce, and it explains pretty much everything about his writing. His lifelong mission was to correct the disconnect. To do so, he had to find a different way: a way of looking inward, and letting the heart and soul speak. None of this came easy. He was plagued by financial difficulties and took clerical and teaching jobs to support his family (the love of his life and muse, Nora Barnacle, and their two children), while managing to write books that are today considered masterpieces but at the time either didn't sell well or were banned. The Irishman reflected best upon his homeland only when in self-imposed exile: Pula, Trieste, Zurich, Rome, Paris. He explained all of this, in his fashion, in *A Portrait of the Artist as a Young Man,* a clear-eyed look at himself in the fictive persona of Stephen Dedalus, a vaguely tormented but likable striver who decides, finally, that he must leave Dublin to pursue his art, in which he hopes to accomplish nothing less than the creation of the "conscience of my race." High aims, and it is left to the critics—and to you— as to whether or not Joyce achieved it in *Dubliners, Portrait* and the extraordinary, avant-garde *Ulysses* and *Finnegans Wake.* What can be said with objective certainty is that those works cumulatively—in particular, *Ulysses*—opened doors. He began his masterpiece in 1914 and it appeared in serial form for a number of years; even before it was finally published in whole in 1922, on the author's 40th birthday, critics were comparing the author's breakthrough to those of Albert Einstein and Sigmund Freud. *Ulysses* has no relation to what came before in literature: It has no plot, no dashing hero, no ending. Its words often flow as a stream of consciousness. At times it is difficult to read. It is a challenge, and readers and writers for the remainder of the century (and beyond) have met it as such.

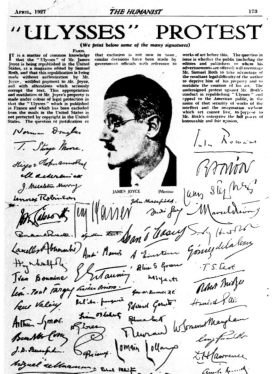

Literally, a portrait of the artist as a young man: Joyce, age 22, in 1904, intent on forging in the smithy of his soul the uncreated conscience of his race. His most famous attempt to do so was *Ulysses,* which spurred protests and counterprotests. Note that the signatories on the above protest in support of Joyce include such luminaries as A. Einstein, T.S. Eliot, D.H. Lawrence and Sean O'Casey.

IGOR STRAVINSKY 1882–1971

GJON MILI

Stravinsky composes and poses. At left, in 1957, in the wee small hours, writing his music in a Vienna nightclub. Below: Circa 1910, with the Russian dancer Vaslav Nijinsky. It is an endless debate as to whether it was Stravinsky's music or Nijinsky's choreography for *The Rite of Spring* that more infuriated the opening night audience.

KEYSTONE/EYEDEA

No critical evaluations of a composer's brilliance will be put forth here, rather we are concerned with a composer's impact and influence: Did he or she reach and move the audience, meantime pushing the music forward? With the Russian-born Stravinsky, who became a United States citizen in 1945, the answer is an unqualified yes. It is generally conceded that he is one of the most significant composers in the classical repertory, and *Time* magazine named him one of the 100 Most Influential People of the 20th Century. His work caused a riot, for goodness' sake. Between 1910 and 1913, he wrote three ballets for impresario Sergei Diaghilev's legendary Ballet Russes, and these—*The Firebird, Petrushka* and *The Rite of Spring*—secured his fame and also his notoriety. As for the *Rite* and the riot: While some critics put the blame for the ruckus on the music, others say it was a combination of Vaslav Nijinsky's radical choreography and the disturbing rhythms and dissonant harmonies of the innovative composition that unsettled the Parisian audience. One thing beyond question is that Stravinsky's work changed the way composers thought about the structure of a musical piece. It's worth noting too that, while such as Schoenberg, experimenting with atonality, spoke to the cognoscenti, Stravinsky, despite the initial dust-up over the *Rite*, reached the masses. In the 1920s Stravinsky produced neoclassical works that nodded to such past masters as Tchaikovsky—*Le Baiser de la fée* and the opera-oratorio *Oedipus Rex* among them. As late as 1951, at nearly 70 years of age, he was still writing important, innovative music: that year, the opera *The Rake's Progress*. By then, he had changed the game. He once stated, famously, that "music is, by its very nature, essentially powerless to express anything at all." But his work defied his words.

COCO CHANEL 1883–1971

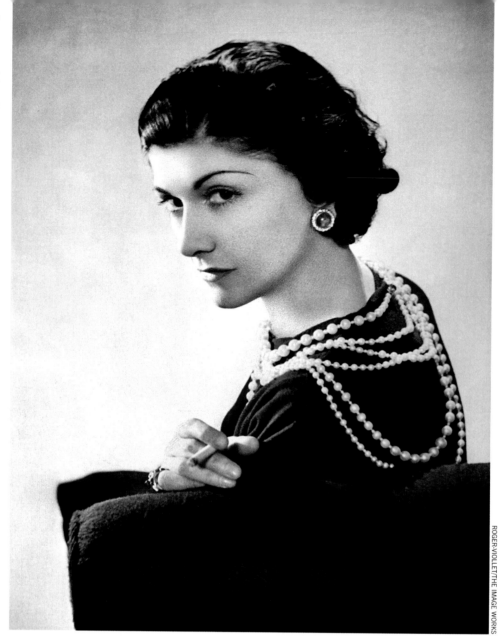

In 1936 the couturier poses in Paris. Not long after would begin her controversial World War II years.

Picasso, Joyce, Stravinsky, Chanel: all born at the same time. Certainly they fed off one another, though Coco Chanel might have been the last to admit it. She was egocentric to a degree that perhaps would have daunted even Picasso. For instance, she had affairs with many men but never married. When asked why she didn't wed one of her more prominent lovers, the Duke of Westminster, she answered characteristically: "There have been several Duchesses of Westminster. There is only one Chanel." Indeed. And this singular woman went her own way, start to finish, forging an image and brand that were such that, when *Time* magazine got around to choosing its 100 Most Influential People of the 20th Century, she was the lone representative from the world of fashion. She was born in 1883 into, believe it or not, less than modest circumstances: the second daughter of a traveling salesman in the French peasant village of Saumur in the Loire valley. Her mother died when she was 12, her father left the family shortly thereafter and Gabrielle (her given name) was sent as a ward of the state to a Catholic orphanage 200 miles south in Aubazine. At 17 she was sent to a convent school, where she learned the skills of a seamstress. She tried her hand as a cabaret singer when she was 18, and while that didn't take, she did attract the attention of a playboy textile heir, Etienne Balsan, who helped set her up with her first millinery shop in Paris. She made her earliest mark designing hats, but not long thereafter she was revolutionizing fashion. She mixed and matched male and female attire, appropriating not only styles but fabrics from menswear, and brought sportswear to women. No feminist herself, she greatly influenced—even spurred—20th century feminism. She changed everything, as her fellow modernist, the French writer Jean Cocteau, once acknowledged: "She has, by a kind of miracle, worked in fashion according to rules that would seem to have value only for painters, musicians, poets." She fell precipitously out of fashion herself after cozying up to the occupying Nazis during World War II but made an astonishing comeback in her maturity when her sleek, strong Chanel suits became must-haves for the modern American woman. In fashion, there was only one Chanel.

ELEANOR ROOSEVELT 1884–1962

She was, quite simply, one of the most important people in both the civil rights and women's movements, and an activist for human rights everywhere in the world. All of this flowed from a terrible disappointment in her life. In 1905, Anna Eleanor Roosevelt was a shy 20-year-old from a prominent New York City family when she married her fifth cousin once removed, Franklin Delano Roosevelt, and began building her own family. In 1918 she discovered a cache of love letters clearly indicating an affair between her husband and her social secretary, Lucy Mercer. Eleanor considered divorce; finally, though, a deal was struck: Eleanor would stay but go her own way. Suddenly, she found inner strength she had not yet known, and she found her mission—indeed, many missions. As the historian Doris Kearns Goodwin wrote: "She turned her energies to a variety of reformist organizations, joining a circle of post-suffrage feminists dedicated to the abolition of child labor, the establishment of a minimum wage and the passage of legislation to protect workers. In the process she discovered that she had talents—for public speaking, for organizing, for articulating social problems . . . When Franklin was paralyzed with polio in 1921, her activism became an even more vital force. She became Franklin's 'eyes and ears,' traveling the country gathering the grass-roots knowledge he needed to understand the people he governed." She was particularly shocked by the overwhelming racism she witnessed in the South and essentially bullied her husband into signing executive orders barring discrimination in New Deal projects. During World War II she fought for and won increased opportunities for blacks in the workforce and in the military, and a decade before *Brown* v. *Board of Education* she articulated the situation clearly for her countrymen: "The basic fact of segregation, which warps and twists the lives of our Negro population [is] itself discriminatory." She spoke out on everything; as First Lady, she gave more than 300 press conferences. (She was, in fact, as Goodwin points out, the first woman ever to hold regular press conferences, as well as the first to address a national convention, the first to be paid for speaking, the first to write a syndicated column and the first to be a radio commentator.) After her husband's death, President Harry S Truman appointed her to the United Nations General Assembly, where she helped draft the Universal Declaration of Human Rights—"the international Magna Carta of all mankind," she called it—and then became the first chairperson of the U.N. Human Rights Commission. Never elected to office, she was arguably the most influential woman of the 20th century.

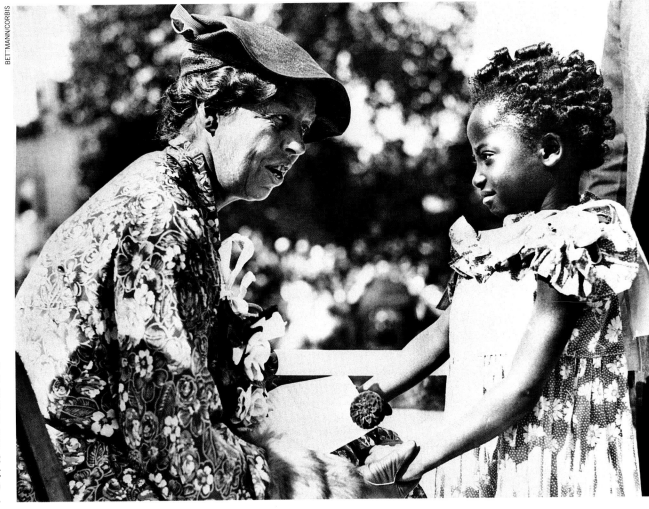

Active during the Depression in two of her earliest crusades—against racism and for equal rights—the First Lady talks with five-year-old Geraldine Walker at ceremonies launching a slum clearance in Detroit in 1935.

LE CORBUSIER
1887–1965

In 1955 in the French town of Ronchamp, dedication ceremonies are held for the chapel of Notre Dame du Haut. Opposite: Four years later, Le Corbusier reviews plans for another building with religious significance to be built for the La Tourette Dominican monastery in the Alps region.

He was in fact named Charles-Edouard Jeanneret-Gris upon his birth in Switzerland in 1887; he took a derivation of his maternal grandfather's name, Lecorbésier, as his *nom d'architecture* 33 years later when working in Paris. As the architect and author Witold Rybczynski wrote in his essay for *Time* magazine's list of the 100 Most Influential People of the 20th Century, the act of choosing a pseudonym was no accident, but rather a willful reinvention of self: "Jeanneret had been a small-town architect; Le Corbusier was a visionary. He believed that architecture had lost its way . . . Le Corbusier proclaimed that this new age deserved a brand-new architecture: 'We must start again from zero.'" A theorist at first, expounding in print and from the pulpit, Le Corbusier opened his studio in Paris and began building. He was not alone in his assessment of architecture's plight or in his readiness to dive in; Ludwig Mies van der Rohe and Walter Gropius, among others, were fellow travelers in what became known as the International Style or, even more broadly, Modern Architecture. Not everything Le Corbusier proposed worked; in fact, much didn't. His approach to urban planning in his so-called Radiant City is now widely regarded as having been a disaster, and critics have charged that the architect's interest in building his own cult tended to obscure the actual product. But in a way that is the point: A provocateur without peer, Le Corbusier forced architecture to look inward and be influenced by or strike out against his ideas. As Rybczynski wrote: "Le Corbusier was the most important architect of the 20th century. Frank Lloyd Wright was more prolific—Le Corbusier's built oeuvre comprises about 60 buildings—and many would argue he was more gifted. But Wright was a maverick; Le Corbusier dominated the architectural world, from that halcyon year of 1920, when he started publishing his magazine *L'Espirit Nouveau,* until his death in 1965 . . . Irascible, caustic, Calvinistic, Corbu was modern architecture's conscience."

No moviemaker in history has meant more. The achievements of the pioneering technicians were of course crucial, and the innovations of such directors as D.W. Griffith established the parameters of narrative storytelling on the screen. But the writer, director, editor, actor Chaplin—the auteur of all auteurs, with a film persona that resonated worldwide—*mattered,* and matters still. Born in London in 1889, Chaplin was raised in desultory fashion by a small-time actress who spent periods in mental hospitals. He left school at age 10 and went to work on the vaudeville circuit. A decade later he made his first trip to the United States as part of Fred Karno's Speechless Comedians, and on his first night in New York City he was awestruck by the bustling theater district: "This is it! This is where I belong!" He would not be right about that—his relationship with America would prove a tormented one, thanks to his leftist politics—but he was correct that his fast journey to fame and fortune would begin in Gotham. There, in 1913, he accepted a job with Mack Sennett's Keystone Studios and quickly became a star. But he had a yen to make films more sublime and meaningful than Sennett's chaotic comedies. His chance to mold his destiny came in 1919, when he and fellow silent-era legends Mary Pickford and Douglas Fairbanks, along with the powerful director Griffith, formed their own studio, United Artists. Chaplin was and remains the one person in film history to have controlled every aspect of filmmaking, from casting to cutting, from writing and scoring his movies to producing and directing them. His "little fellow"—more often called "the tramp"—became by far the most famous screen icon in the world, and Chaplin's movies, even more than Griffith's, showed the depth of human emotion of which the young art form might be capable. In his classics—the silents, including *The Kid* (1921), *The Gold Rush* (1925), *The Circus* (1928), *City Lights* (1931) and *Modern Times,* and the talkies, *The Great Dictator* (1940), *Monsieur Verdoux* (1947) and *Limelight* (1952)—Chaplin achieved something Shakesperian and transformed entertainment while delighting audiences around the globe.

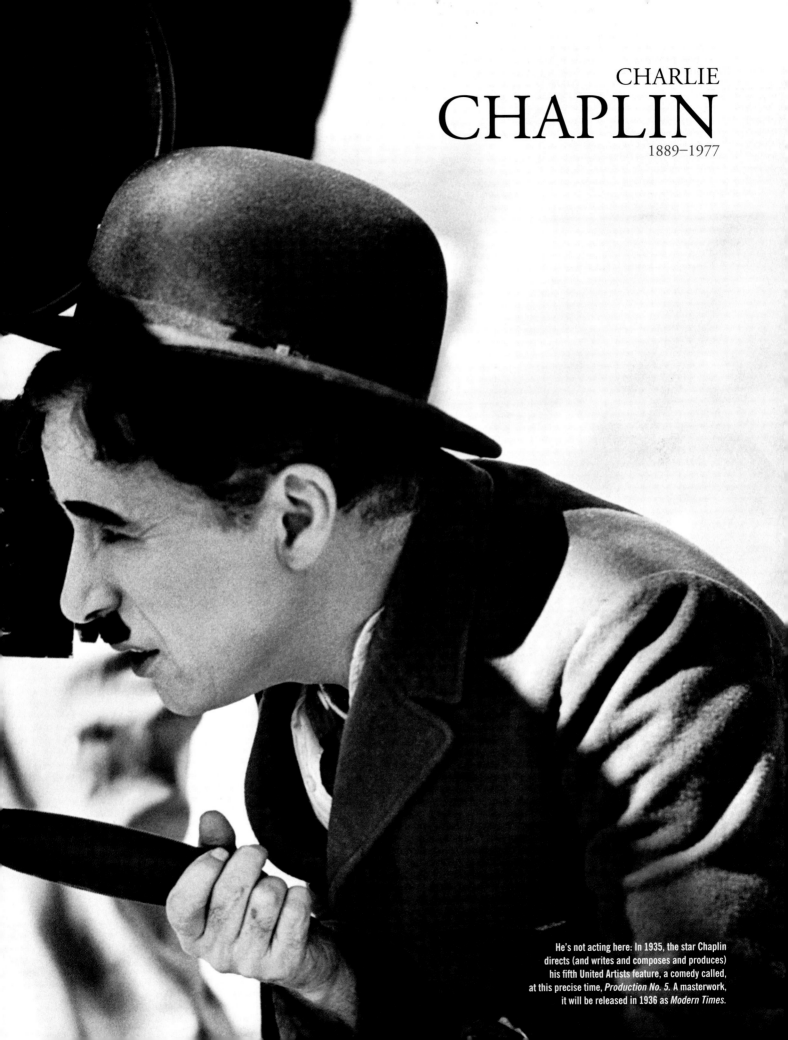

CHARLIE
CHAPLIN
1889–1977

He's not acting here: In 1935, the star Chaplin
directs (and writes and composes and produces)
his fifth United Artists feature, a comedy called,
at this precise time, *Production No. 5*. A masterwork,
it will be released in 1936 as *Modern Times*.

She didn't invent modern dance, she probably wasn't the greatest choreographer of modern dance ever, she certainly wasn't the best modern dancer . . . But Martha Graham, in her brazenness and risk-taking and courage in going ever deeper, *was* modern dance. And she remains modern dance today; anything that looks new and exciting—anything that looks bold—owes plenty to Graham. She was modern dance, and she was also American dance: Born into an upper class Presbyterian family in Allegheny, Pennsylvania, she wasn't raised to pursue any kind of career in the arts. But the Grahams moved to California, and at 17, Martha experienced something of an epiphany as she watched a recital in Los Angeles by Ruth St. Denis, an American pioneer of modern dance with an exotic, mystical bent. It seemed an impossible leap for Martha and she made that leap at an impossibly advanced age for a dancer, enrolling at St. Denis's school of dance just north of the Hollywood Bowl; she studied and performed there for seven years. She then moved to New York City, where she launched her own company in 1929. She was already choreographing and in 1935 had a breakthrough with the bleak vision of *Chronicle*, which was colored by events of the day, including the Great Depression and the Spanish Civil War. Collaborating with American composers such as Aaron Copland on *Appalachian Spring* and Samuel Barber on *Cave of the Heart,* and with the sculptor Isamu Noguchi, who designed her striking sets, she created fraught masterworks that were as startling as they were brilliant. As the theater and dance critic Terry Teachout wrote in *Time* magazine, "[*Cave of the Heart*] contains a horrific solo in which the hate-crazed Medea gobbles her own entrails—perhaps Graham's most sensational coup de théâtre and one recalled with nightmarish clarity by all who saw her bring it off." She continued to write herself starring roles until she was in her seventies, which some saw as unfortunate. But no matter, she had already made her mark with her creations and her boldness, and had challenged all dancers to do what she tried to do: "Chart the graph of the heart."

MARTHA GRAHAM
1894–1991

In 1948, the dancer and choreographer is at the height of her powers and, here, in full glory during a photo session in her New York City studio for the great photographer Philippe Halsman.

MAGNUM

In 1965, the trumpeter and singer is captured by LIFE's John Loengard belting out "Hello, Dolly!" during a gig at a New York City nightclub.

LOUIS
ARMSTRONG
1901–1971

The music and cultural critic Stanley Crouch once wrote of the musician known as Satchmo: "The extent of his influence across jazz, across American music and around the world has such continuing stature that he is one of the few who can easily be mentioned with Stravinsky, Picasso and Joyce. His life was the embodiment of one who moves from rags to riches, from anonymity to internationally imitated innovator. Louis Daniel Armstrong supplied revolutionary language that took on such pervasiveness that it became commonplace, like the lightbulb, the airplane, the telephone." And he supplied that revolutionary language principally through a genre of music that is America's gift to the world, and that was born not long before Armstrong was, and in the same place. When precisely jazz—which evolved in many places in the American South as a blend of African, Caribbean island and European rhythms—coalesced in the Dixieland sound that came to fill the streets, social clubs and brothels of New Orleans isn't precisely known, but by the time Armstrong was a boy, jazz (not yet called that) was in the air. Raised in poverty, young Louis would scrounge on the streets and found himself in the occasional spot of trouble; during a stint at the Home for Colored Waifs, a reform school, he got his first opportunity to try a cornet. He was preternaturally gifted and particularly suited to imbue the music he played with his personality—one of the essentials of jazz. In New Orleans, Chicago, New York and then the wider world, he helped form the combinations of melodies and rhythms that would become jazz and to write the rules for a music that would, in turn, write new rules for style, culture and the way people lived their lives. He could sing, too, and boosted another of his nation's major contributions to the 20th century, the Great American Songbook. The duets he recorded with Ella Fitzgerald of standards by George Gershwin, Cole Porter, Irving Berlin and others are classics. Satchmo: one unique and irreplaceable individual.

CHARLES
LINDBERGH
1902–1974



What we see here is a victory lap of sorts: Lindbergh is hailed as he arrives at Croydon Airport outside London some days after completing his history-making transatlantic flight.

The argument can certainly be made that this spot belongs, by rights, to the Wrights. It's difficult—and depending upon one's opinion on the matter, even impossible or futile—to dispute their primacy. They did fly first and worked energetically in the pioneering days to popularize flight. But the timing of and circumstances surrounding Charles Lindbergh's feat made his success integral to the growth of the aircraft industry, and this feat both directly and indirectly affected his nation's status in the world community. In the first decade of the 20th century, the Wright brothers, Orville and Wilbur, had answered a centuries-old question: Will man ever fly? They took their invention on the road and wowed audiences in Europe as well as America. It was clear there would be a future for air travel, and it became evident during World War I that the airplane would be an instrument of war as well as peace. In 1919, a hotelier in New York, hoping to boost travel tourism, put up a cash award—$25,000—for the man or men who could complete the first nonstop transatlantic flight between New York and Paris. Eyes on the prize, Lindbergh, a fresh-faced aviator from the Midwest, piloted his *Spirit of St. Louis* across the ocean to considerable fortune and even greater fame in 1927. The young Lone Eagle, the bold Lucky Lindy proved perfect for his role as a Jazz Age hero, and his daring and charisma did indeed spur developments in the aircraft industry. The timing of this would prove crucial. When the United States entered World War II, it already had in place an aeronautic and technological know-how that would allow it, along with its Allies, to challenge and eventually defeat the formidable air forces of the Axis powers. It has been speculated by historians that if the inspiring Lindbergh had not come along as the right man at the right time, the outcome of that most consequential conflict might have been different—and speculation beyond that is too ghastly to contemplate.

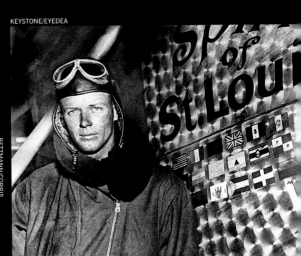

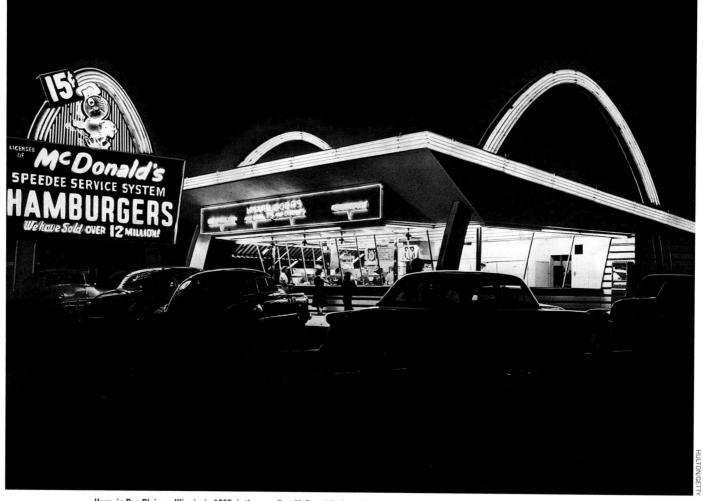

Here, in Des Plaines, Illinois, in 1955, is the very first McDonald's franchise outside California and, below, the man who made it happen.

RAY KROC
1902–1984

We do not eat today like our parents or grandparents did in the 1950s—and neither do the citizens of Paris or Beijing or Sydney—and we all have this man to thank (or blame) for it. He was not a chef (goodness knows) nor even a cook or a restaurant maker. He was a salesman, and therein lies an American tale. It cannot be said that he was an original: Reasonably fast and inexpensive food was a notion Howard Deering Johnson had when he launched Howard Johnson's in Massachusetts in 1925. The chain that grew in Johnson's name would feature more than 1,000 restaurants and 500 motor lodges by the 1960s. White Castle hamburgers predates McDonald's, too, if you want to look at a walk-up, buy-'em, eat-'em-on-the-way-out emporium. But Kroc, a salesman for the Lily-Tulip Cup Corporation as far back as 1922, wasn't even thinking about restaurants or food. He was thinking about product, and perhaps after meeting Earl Prince, who had invented the five-spindle Multimixer, which could keep several Lily-Tulip Cups spinning at once, he was thinking about the kind of mass production Henry Ford had pioneered. He gained marketing rights from Prince and went on the road selling the mixer—for 17 years. That led him eventually to the remarkable restaurant of Dick and Mac McDonald in San Bernardino, California. The brothers had no fewer than eight mixers going all day, making shakes to complement their burgers. This was fast food's $E=mc^2$ and Kroc was its

Einstein. He foresaw offshoots and franchises, and convinced the brothers he could sell the idea (he had already convinced himself he could sell just about anything). McDonald's was already a success in 1961 when Kroc talked the brothers into ceding him their share for $2.7 million. It's worth more than that today, as you might know, with restaurants in some 120 countries and the MILLION SERVED neon signs on the block as collectible antiques at the funkier auction houses.

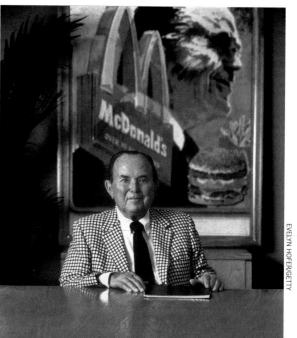

BENJAMIN SPOCK 1903–1998

For many decades in the United States and much of the rest of the world, the principal rule of child rearing seemed to be, "Spare the rod and spoil the child." Pediatricians dealt strictly with the medical aspects of a kid's health and well-being, and little attention was paid to the psychology of a parent-child relationship. Moms, if they were counseled at all, were generally advised to not pick up their babies every time they cried because this would only lead to more crying and, ultimately, a childhood of needfulness and disciplinary laxity. Then came, in the immediate postwar years when babies were booming across the land, Dr. Benjamin Spock, an entirely different kind of baby doc. As an adolescent growing up in Connecticut, Spock, the oldest of six children, was often charged with helping to care for his younger siblings. After college and medical school, he did a residency in pediatrics and a second in psychiatry. During World War II, Spock, who attained the rank of lieutenant commander in the U.S. Navy's Reserve Medical Corps, served mainly as a psychiatrist. After the war he was teaching in medical school when he published *The Common Sense Book of Baby and Child Care.*

The book was a revelation, eventually selling more than 50 million copies worldwide, and it started a revolution. "You know more than you think you do," Spock told mothers, whom he encouraged to befriend and nurture their children, and to treat them as individuals and not as items. Spock helped raise baby boomers and later, when his liberal politics became a flash point during the Vietnam War, was blamed by critics for the perceived moral and ethical shortcomings of these kids. His work was grossly misrepresented by such as the preacher Norman Vincent Peale, who said that "the U.S. was paying the price of two generations that followed the Dr. Spock baby plan of instant gratification of needs." Paying the price? The U.S. owed him a debt. One last, fun point: Dr. Spock represents the surprising answer to a perhaps odd trivia question regarding our 100 who changed the world: Who besides Muhammad Ali was an Olympic gold-medal winner for the United States? A strong, young Benjamin Spock, rower from Yale, who in 1924 was a member of the U.S. men's eight team that prevailed in Paris. When he was an old man he would still take his single scull out on the water in the morning for exercise.

In 1955, with the baby boom well under way and his calming advice needed by millions, the baby doctor consults with a mother and child.

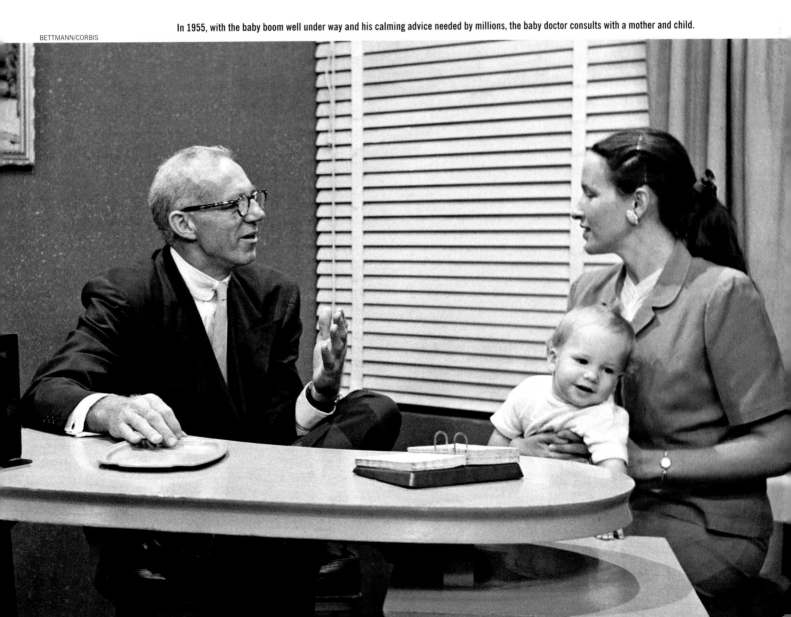

DR. SEUSS
1904–1991

JOHN BRYSON

In 1959, two years after launching his reading revolution with *The Cat in the Hat,* Geisel—sorry, *Seuss*—poses with his characters for a portrait to appear in LIFE, the magazine that issued the challenge that he so ably met.

BOB SACHA

Theodor Seuss Geisel will always be known by his *nom de nonsense.* It was in that guise that Geisel entertained America's young with his rollicking rhymes, nutty narratives and playful (but artful) pictures. And Dr. Seuss did even more than entertain. When Geisel was in mid-career in 1954, the noted writer John Hersey asked in a LIFE magazine article why America's schoolchildren were struggling with literacy and reading. One of his conclusions was that the materials given them—Dick and Jane and all that—were deadly dull. The article came to the attention of William Spaulding, director of the education division at the publisher Houghton Mifflin, who brought it to the attention of Geisel, whose books were anything but dull. Could he, Spaulding challenged, write a primer? Could he, using only a set number of words that a first grader needs to know, write one of his fanciful adventures that might educate even as it enthralls? Could he, Spaulding asked, "write me a story that first-graders can't put down?" Nine months later, Geisel handed him *The Cat in the Hat.* There were only 220 oft-repeated words in it but all the storytelling that Dr. Seuss's audience demanded. Kids were blown away, and when their parents learned of the subversive value of this intricately crafted "reader," they were, too; the book was a runaway best-seller in English, then traveled the world in a host of translations. Geisel would spend the rest of his long life alternating between his no-rules "novels," such as *The Lorax* and *Oh, the Places You'll Go!,* and books that grew ever more sophisticated, with word counts ever smaller to entice ever younger kids to read, including *Hop on Pop* and *One Fish Two Fish Red Fish Blue Fish.* He and his first wife, Helen, working with Random House's top editor Bennett Cerf and his wife, Phyllis, oversaw a new line of titles called Beginner Books: a place where educational science collided with whimsy. Dr. Seuss wasn't a real doctor—he didn't possess a Ph.D.—but he was something even better for the world's schoolchildren.

WILLIAM LEVITT
1907–1994

Before him, there had been towns and even what were called suburbs. But Levitt changed the face of exurban America. He described for the returning veterans of World War II the good life they had earned by prevailing "over there." Bill Levitt was in fact one of them, a member of their fraternity, and his experience in the Navy during the war informed his ideas for Levittowns. He had already worked in his father's development company, Levitt & Sons, which in the 1930s built mostly high-end housing on New York's Long Island. Now Levitt was observing the way the military mass-produced housing quickly, employing uniform parts and materials and throwing up a barracks overnight. He knew that when the war ended the building moratorium in the U.S. would end as well, and there would be a surge in demand for affordable housing. Returning home, he convinced his father and brother that they could do for home-building what Henry Ford had done for auto manufacture. His brother, Alfred, was the principal designer of the simple, look-alike Cape Cod and ranch houses that quickly lined the streets of the Long Island community, which would be named for the family (as would subsequent Levittowns in Pennsylvania, New Jersey and Puerto Rico). The Levitts couldn't build fast enough to keep up with would-be homeowners, though they built plenty fast: 30 houses a day being completed by mid 1948, each constructed with precut lumber and nails from Levitt factories. As Ford had been able to, the Levitts kept prices low—under $8,000 for a 1949 ranch, for instance—and the town continued to grow, eventually to more than 17,000 Levitt houses, including some spillover into neighboring communities. Schools were needed, and postal service, and Bill Levitt saw to these issues, too. Developers around the country took note of Levittown's success, and soon other by-the-numbers communities were sprouting, and this kind of affordable suburban housing began to spread globally. Today, many consider the word *Levittown* to be derogatory, connoting blandness, homogeneity, sterility. Back in the 1940s, it meant heaven. Bill Levitt built an attainable dream for his fellow enlisted men. They deserved at least that.

Left: Levitt (at right) assesses the site of the new town with his superintendent Jim Lee in 1948. Above: Only two years later Bernard Levey, a truck supervisor, and his young family proudly stand in front of the cherished symbol of the life Levitt has helped make possible for them.

BERNARD HOFFMAN

TONY LINCK

RACHEL CARSON 1907–1964

It can be claimed that the impact of Rachel Carson's most famous book, an impact that extends to this day, was beyond even what was hoped. In *Silent Spring*, the author urged prudence when using pesticides, warning that in the postwar era, the booming United States was being negligent in ignoring the damage humans were visiting upon nature and the many ramifications of that damage. There were social prescriptions in the book, to be sure; it was certainly meant as an argument. But Carson, her publishers and supporters never could have dreamed where it would lead. What happened was: A great drama preceded and then greeted the book's publication in 1962; frantic efforts to discredit Carson backfired miserably; and then the sympathetic author died young, of a heart attack suffered after cancer treatments had led to anemia. Forces had been unleashed and passions aroused that simply couldn't be contained, and Carson and her work only grew to be more important after she was no longer with us. Rachel Louise Carson was born and raised in Pennsylvania's rural Allegheny Valley and loved two things from the first: writing and the natural world. She was smart and talented, and her twin interests eventually found an outlet in, of all places, the federal government, where, beginning in 1936, Carson worked as a junior aquatic biologist for the agency that would become known as the Fish and Wildlife Service. She produced pieces for government publications, then magazines, and then she wrote books; her trilogy on the sea, written in the 1940s and '50s, secured her reputation. She had first become interested in writing about the effects of synthetic pesticides in the 1940s, but couldn't get publishers to bite. Now was the moment. Carson spent four years investigating how the insecticide DDT, widely used by farmers at the time, not only killed pests but invaded the ecosystem. Her work was not secret, and everyone knew a firestorm was coming when *Silent Spring* was set to appear in 1962—in book form and serialized in *The New Yorker*. The chemical companies threatened lawsuits to block publication, and when that failed they geared up their assault on Carson's veracity; her side marshaled support from the scientific community and from lawmakers. She herself got Supreme Court Justice William O. Douglas to write a commentary that would accompany the Book of the Month Club mailing. When the demure, steady Carson, who was already ill with breast cancer, appeared on television opposite histrionic representatives of the chemical companies, the public tide was turned and, unbeknownst to all, the modern environmental movement had begun. Carson died in 1964 and that movement had its patron saint. Within a decade, DDT had been banned, the Environmental Protection Agency had been created and crucial laws—the Endangered Species Act, the Clean Air Act, the Clean Water Act—had been passed. In 1980, Rachel Carson was posthumously awarded the Presidential Medal of Freedom, the nation's highest civilian honor.

In 1962, Carson, a most unlikely American celebrity, is photographed at her home in Maine by LIFE's storied shooter Alfred Eisenstaedt.

SIR EDMUND
HILLARY
1919–2008

MICHAEL S. LEWIS/CORBIS

Sir Ed, as his friends called him, is pleased with what he sees in 1989 as he visits a site in Thame, Nepal (a childhood village of Tenzing Norgay), where his foundation is doing good works. Since the 1960s, the Himalayan Trust has built more than two dozen schools, two hospitals, an airport and pipeline systems in the region, and in 2003, Hillary was made an honorary citizen of Nepal.

The son of a beekeeper in Auckland, New Zealand, Hillary grew to be a great and successful mountain climber—but that is not the only reason he is included in our book. Yes, his seminal achievement, becoming, along with his Sherpa mountaineering companion Tenzing Norgay, the first to reach the summit of the world's highest peak, encouraged all of mankind to reconsider the limits of human possibility—and thus could be said to have changed the world. But Hillary proved also to be a man who, once he had stumbled into fame, used his newfound celebrity to do good: He is an example of the individual who asks, when given a certain power, "What might I accomplish with this?" By 1953, when Norgay and the 33-year-old Hillary registered their great success as part of the ninth British expedition to Mount Everest on the Tibet-Nepal border, many previous expeditions had failed and the world's

attention was riveted. The global response was much like the reaction following Lindbergh's landing in Paris, or the one that would later attend man's stepping foot on the moon; Hillary learned at base camp that he had already been knighted by Queen Elizabeth. A confident but modest man, he thought the outsize fuss was unwarranted. But while he continued with his adventuring—he reached the South Pole overland in 1958 and visited the North Pole as well—he dedicated much of his time to helping the Sherpas of Nepal. He founded the Himalayan Trust, which built schools and hospitals throughout the region, and served as his nation's ambassador to India, Nepal and Bangladesh. He lent his name and effort to many other philanthropies as well. None of this would have been possible without the feat on Everest, but none of it would have been possible if Hillary had been a different kind of man.

ELVIS PRESLEY
1935–1977

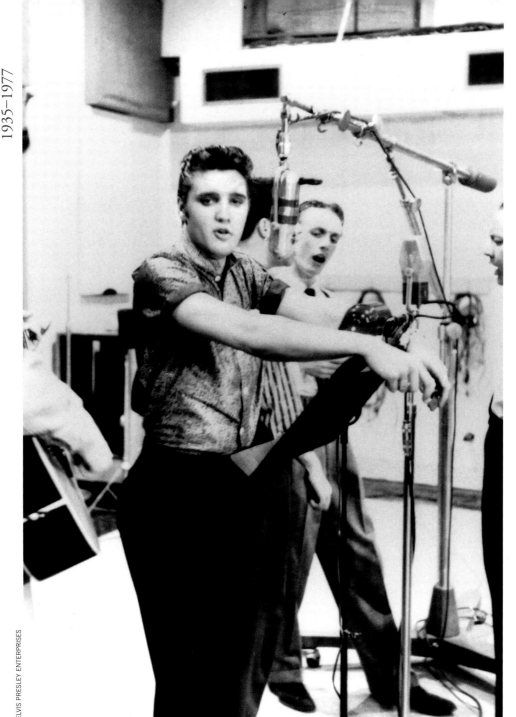

ELVIS PRESLEY ENTERPRISES

Where it all began: The man who will (very soon) be King croons during an early-career session at Sam Phillips's Sun Records recording studio in Memphis.

In the 20th century, only a few individuals in the world of popular music were so far above and beyond their milieu that they became stars of a different, greater magnitude. Bing Crosby was one, Frank Sinatra was another. The third American member of that tiny but brilliant constellation, a young man who emerged from a hardscrabble Mississippi background, may have been the biggest of them all—Elvis. He, unlike Der Bingle and the Chairman, not only provoked screams of delight from his female fans but encouraged a generation—worldwide—to change, to change its tastes and style, to rebel. Later, four Brits would do the same (and we'll get to the Beatles), but first there was Elvis. In his early years he was a sponge to the music that surrounded him, taking in gospel and rhythm and blues, the Grand Ole Opry and Dean Martin. Young Elvis was fawned over by his beloved mother, who knew that hers was a special boy: His twin brother had died at birth. Elvis, too, felt different, somehow *other*. As an 18-year-old truck driver, he went to the Memphis Recording Service to cut an acetate disc for his mom. The studio's owner, Sam Phillips, eventually heard the voice and realized that he had found his dream, "a white man with the essence of the Negro sound and feel." Yes, a genuine, unfeigned soulfulness, but melded with country and pop sensibilities. It all worked, as we know, and soon Elvis was everywhere, and everywhere his look and sound were imitated. For most teenage boys, he was cooler than cool. For the girls, one look was enough. For adults, however, his hair, hips and lips were an alien presence that rankled, incurring above-the-waist TV images and the wrath of teachers and clergy. Of course, Elvis won the day and was a monster success, measured, for example, by record sales that topped one billion. Measured also by the fact that he changed youth culture forevermore.

TED TURNER BORN 1938

The gregarious and never self-effacing Robert Edward Turner III, the legendary "Mouth of the South" from Atlanta who has done everything from winning the America's Cup in sailing to launching the Ted's Montana Grill restaurant chain, would no doubt admit that he always wanted to be included in a book entitled *100 People Who Changed the World*. It has long been a goal of his—to change the world—and he would be pleased that he was being recognized for, say, pledging $1 billion of his considerable fortune to underwrite the United Nations Foundation and forward the causes of peace and equality in the world. But that is not the reason he is being cited here, nor is his environmentalism, nor his estimable philanthropy in other realms, nor his status as America's largest private landholder, nor his even more impressive status as a winner of the Albert Schweitzer Gold Medal for Humanitarianism, nor his past ownership of the Atlanta Braves, nor the decade he spent as Jane Fonda's husband—fine as all of those achievements may be. Ted Turner changed the world by founding CNN, the world's first 24-hour cable news network, in a former country club outside Atlanta in 1980, pledging "We won't be signing off until the world ends."

Disregarding for a moment the dreams that Fox News might have of burying CNN well before doomsday, that is still to be hoped. CNN merits the oft-overused term *phenomenon*. It reaches 93 million U.S. households today, but even more important, it can be seen in 212 countries and territories. It is the commercial vehicle that Voice of America always sought to be, without the obvious bias and taint of propaganda. It is testimony to CNN's might that the Web site dedicated to defending the Beijing party line in situations such as China's recent censorship dustup with Google is called anti-cnn.com. And when a thousand tweets are sent from the streets of Tehran during protests against the government in Iran, not only Twitter but all of the world's free thinkers owe a debt to CNN for getting in there first. CNN, well before the Internet, compressed the world's information-dissemination schedule; while monitoring coverage of the first Gulf War in the early 1990s, the Pentagon came up with the term *the CNN effect* to describe the way instant news was influencing decision-making procedures among American government officials. So, Ted: You made the list. You changed the world. And thanks for the U.N. thing, too.

Though the term could be applied to either man pictured on these pages—or to the fellow seen on the next two, for that matter—it was Turner, posing here in his Atlanta office in 1991, who was indelibly dubbed the Mouth of the South.

CULTURAL ICONS 123

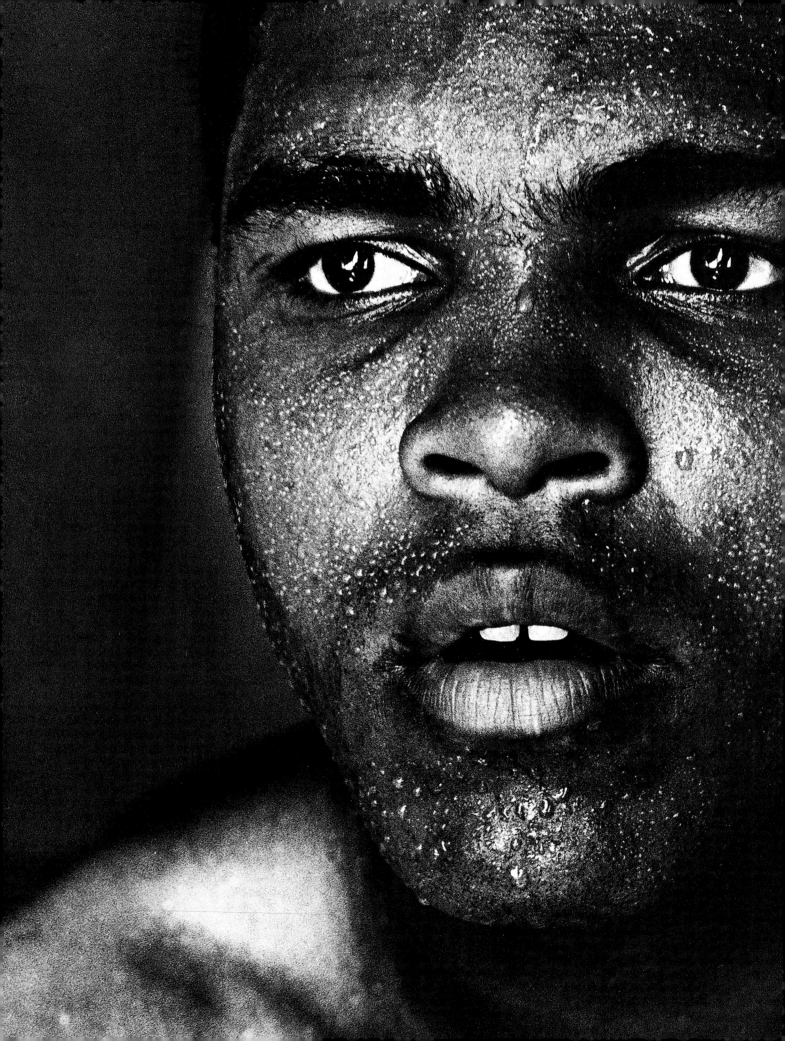

MUHAMMAD ALI

BORN 1942

In this book we include just two athletes, Sir Edmund Hillary and Muhammad Ali, among 100 individuals who changed the world (and frankly, neither is included for his athletics). Certainly claims can be made for others: It could be said that the French aristocrat Baron Pierre de Coubertin changed the world when he introduced the modern Olympic Games at Athens in 1896, hearkening back to ancient Greece and asking mankind to contemplate whether global goodwill could spill forth from an arena. The boxer John L. Sullivan was an early superstar, and the notion of the jock-as-celebrity changed things, as did the attention-grabbing feats of Babe Ruth. When Jackie Robinson became the first black person to play in the major leagues in 1947, America was forced to ask whether segregation in society at large was just. And when Englishman Roger Bannister broke the four-minute mile seven years later, everyone everywhere wondered at the limits of human possibility. But it takes a lot to "change the world," and the argument here is that Hillary and Ali had what it takes. The boxer from Louisville was a charismatic kid as Olympic champion in 1960, then the brash but ever-engaging king of the heavyweight class, vanquishing his foes to take the world title three separate times between 1964 and 1979. In the interim he was a cultural figure at the eye of various significant storms and a world citizen without peer; it was asserted that he was the most famous (and later in life, the most beloved) figure on the planet. He became a Black Muslim shortly after turning pro, changing his name from Cassius Clay to Muhammad Ali. Refusing to enter the draft during the Vietnam War, he was stripped of his boxing titles, banned from the sport for a time and prosecuted by the government all the way to the Supreme Court, which exonerated him as an earnestly conscientious objector. After retiring from the ring, Ali, even while suffering from Parkinson's, became a global ambassador for his country and the United Nations. As if saying, "You were right all along," the United States Olympic Committee asked Ali to light the cauldron to open the 1996 Games in Atlanta.

REX USA

KIM LUDBROOK/EPA/CORBIS

Left: Oprah has already overcome much when she is named Miss Fire Prevention in Nashville in 1971. Below: In 2007, she looks back, and forward, as she cuts the ribbon on the Oprah Winfrey Leadership Academy for Girls in Henley-on-Klip, South Africa. Nelson Mandela had approached her about helping with education in his country, and Winfrey founded the school with a $40 million contribution, stipulating that its mission was to support girls from impoverished backgrounds who might succeed if only given the chance.

OPRAH

WINFREY
BORN 1954

She has been credited with changing millions of lives—mostly women's—not only in America but globally. Magazines have called her the most powerful woman in entertainment and, indeed, the world. In 2008, her support of Barack Obama influenced votes in the U.S. presidential election. She can make a book a best-seller or turn a personal inclination into a trend. She has done all this from the platform of a talk show and by dint of her candid, deeply engaging personality. *The Oprah Winfrey Show* is syndicated in nearly 150 countries, and everywhere its fans are legion. Winfrey preaches personal empowerment and resolve when faced with daunting prospects, and her biography certainly adds resonance to her words. She was born to unwed parents in Mississippi and suffered sexual and physical abuse; she has been open about mistakes she made as a teen and about difficulties she had in finding her way. She did find it, though, after enrolling at Tennessee State University, then developing careers as a TV newswoman,

a dramatic actress and, above all, an empathetic and vastly influential talk show host (which led to her offshoot position as a publisher; *O The Oprah Magazine* is a monthly must-read for her fans). How Winfrey is changing the world on a daily basis is hard to calculate, but consider this extreme: In November 2004, Oprah's show was first broadcast on a Dubai-based satellite channel and became an instant hit with young Saudi Arabian women. It is now the highest-rated English-language program among those ages 25 and younger, a group that constitutes a third of the Saudi population. *The New York Times* reported on the phenomenon of Winfrey's reach into a land where women cover their faces in public, if they go out at all, and asked a young woman named Nayla to explain the Winfrey magic. "I feel that Oprah truly understands me," came the response. "She gives me energy and hope for my life. Sometimes I think that she is the only person in the world who knows how I feel." Oprah's is a rare power.

THE BEATLES 1957–1970

This last entry is different: a group of four men, not a single individual. The birthdate at left marks the year that bass player Paul McCartney first fell in with guitarist John Lennon and the date of death refers to the announcement by McCartney that the Beatles were disbanding. In the interim, the two young Englishmen—songwriters, singers, instrumentalists—along with George Harrison on lead guitar and Ringo Starr on drums, made some of the most popular music the world has ever heard. But they made more than just rock 'n' roll history; they altered, as Elvis had, youth culture altogether, and they became political and philosophical leaders of a generation that was shaking the world. At first, it was about the tunes: "I Want to Hold Your Hand," "She Loves You," all the head-shaking and yeah-yeah-yeahing. The Beatles "invaded" America in 1964 and conquered immediately; they repeated the phenomenon around the globe. They began to stretch the boundaries of music. As had Beethoven with the classical form, the Beatles redefined what a pop song or album could be in terms of length and structure, and what a band could be in terms of instrumentation. Wherever they led, the young followed. When they studied with the Maharishi Mahesh Yogi in 1967, Transcendental Meditation received a large boost; when they seemed to be experimenting with or singing about drugs, their followers felt they were given license; hair and clothing styles changed in an instant with the appearance of each new Beatles album cover. The group preached love and tended toward pacifism; Lennon was more overt ("Give Peace a Chance") in his solo career, which had begun before the Beatles splintered. They doubtless, in this way, contributed to the antiwar movement in the United States and abroad at the time, and to upheavals on college campuses here and elsewhere. Rarely if ever has an entertainment act enjoyed the kind of power the Beatles did. Whether they truly enjoyed it in all senses of the word is doubtful, and whether they wielded that power wisely is still debated.

Changing the world usually takes time, and it is difficult if not impossible to take a photograph of the precise moment when someone (or perhaps four someones) changes the world. But this image by Harry Benson comes close to fitting that bill: The Beatles arrive in America on February 7, 1964.

JUST ONE MORE

> Gentlemen of the Senate, and
> Gentlemen of the House of Representatives,
>
> The Letter herewith transmitted, will inform you, that it has pleased Divine Providence to remove from this Life our excellent Fellow Citizen George Washington, by the Purity of his Character and a long Series of Services to his Country, rendered illustrious through the World. It remains for an affectionate and grateful People, in whose Hearts he can never die, to pay suitable Honours to his Memory.
>
> United States
> December 19. 1799.
>
> John Adams

We have spent the past many pages telling you why we think these 100 people changed the world. But why believe us? Let's go to none other than John Adams, founding father and our second President, who wrote this eloquent memo to Congress in 1799. It accompanied a letter from George Washington's personal secretary, which had been sent from Mount Vernon with news that the great man had passed away.

Note Adams's pride not only in Washington's contributions to the fledgling United States but in his stature as a luminary of global importance. If it can be speculated that the first American ever to change the world was the anonymous nomad who traveled, eons ago, across the land bridge from Asia and began the population of our continent, then Washington was the second. There would be many more. No doubt, there are many more to come.